Lecture Notes in Computer Science 9317

Commenced Publication in 1973
Founding and Former Series Editors:
Gerhard Goos, Juris Hartmanis, and Jan van Leeuwen

More information about this series at http://www.springer.com/series/7412

Yaxi Chen · Marc Christie
Wenrong Tan (Eds.)

Smart Graphics

13th International Symposium, SG 2015
Chengdu, China, August 26–28, 2015
Revised Selected Papers

 Springer

Editors
Yaxi Chen
Southwest University for Nationalities
Chengdu
China

Wenrong Tan
Southwest University for Nationalities
Chengdu
China

Marc Christie
Inria/IRISA Rennes
Rennes
France

ISSN 0302-9743 ISSN 1611-3349 (electronic)
Lecture Notes in Computer Science
ISBN 978-3-319-53837-2 ISBN 978-3-319-53838-9 (eBook)
DOI 10.1007/978-3-319-53838-9

Library of Congress Control Number: 2017932128

LNCS Sublibrary: SL6 – Image Processing, Computer Vision, Pattern Recognition, and Graphics

Printed on acid-free paper

This Springer imprint is published by Springer Nature
The registered company is Springer International Publishing AG
The registered company address is: Gewerbestrasse 11, 6330 Cham, Switzerland

Preface

This volume contains the papers presented at SG 2015: the 13th International Symposium on Smart Graphics held during August 26–28, 2015, in Chengdu, China.

This year, the committee decided to accept 16 full papers organized in four technical sessions, together with four posters and live demonstrations. Each submission was reviewed by at least three, and on average 3.1, Program Committee members. The program also included two invited talks from leading researchers – Xiang Cao, CEO of Xiaoxiaoniu Creative Technologies, China, and Shigeo Takahashi from the University of Aizu, Japan, whom we would like to thank again for their participation.

Originally, Smartgraphics started as a satellite event of the American Association for Artificial Intelligence AAAI Spring Symposium back in 2000, and then continued as its own conference series with Springer LNCS publications, in cooperation with SIGCHI, SIGGRAPH, Eurographics and AAAI. By building its foundations on a strong pluridisciplinary approach mixing computer graphics, artificial intelligence, human–computer interaction, and cognitive sciences, Smartgraphics has always been a unique venue and a unique experience in collectively trying to define the essence of what makes graphical applications smart. How to better understand the user, to analyze the tasks, to display the relevant information, to let the computer take decisions without taking power? And the advent of new interaction modalities in everyday applications such as tactile surfaces or 3D interfaces makes the interest in *smart* graphics even stronger. Fifteen years after the first AAAI event, the conference has kept the same spirit: a lively place where it is nice to meet, expose, and exchange new ideas.

While the event has been mostly held in European countries and in the USA, it is interesting to witness how its center of gravity has recently shifted toward eastern countries, Kyoto in 2007, Taipei, in 2014, and this year Chengdu. The strong interest in graphics and interaction from Chinese research and industrial communities makes China and the Southwestern University for Nationalities an ideal place to host such an event.

August 2015

Yaxi Chen
Marc Christie
Wenrong Tan

Organization

Smart Graphics 2015 was organized by Southwest University for Nationalities.

Steering Committee

Pierre Boulanger University of Alberta, Canada
Roberto Theron University of Salamanca, Spain
Tsai-yen Li National Chengchi University, Taiwan
Marc Christie Inria/University of Rennes 1, France

Organizing Committee

Marc Christie Inria/University of Rennes 1, France
Yaxi Chen Southwest University for Nationalities, China

Program Committee

Elisabeth Andre University of Augsburg, Germany
William Bares College of Charleston, USA
Andreas Butz University of Munich, Germany
Lutz Dickmann University of Bremen, Germany
David S. Ebert Purdue University, USA
Tracy Hammond Texas A&M University, USA
Hiroshi Hosobe Tokyo National Institute of Informatics, Japan
Hung-Hsuan Huang Ritsumeikan University, Japan
Christian Jacquemin LIMSI-CNRS, France
Tsvi Kuflik University of Haifa, Israel
Tong-Yee Lee National Cheng-Kung University, Taiwan
Wen-Hung Liao National Chengchi University, Taiwan
Kwan-Liu Ma University of California at Davis, USA
Carlos Delgado-Mata Universidad Panamericana campus Bonaterra, Spain
Shigeru Owada Sony CSL, Japan
Jian Peng Sichuan University, China
Roberto Ranon University of Udine, Italy
Mateu Sbert University of Girona, Spain
Tevfik Metin Sezgin Koç University, Istanbul, Turkey
Shigeo Takahashi University of Aizu, Japan
Wenrong Tan Southwest University for Nationalities, China
Peng Wang Chengdu University of Information Technology, China
Xiaojing Wang Chengdu Information Technology of Chinese Academy
 of Sciences Co., Ltd., China
Thomas Rist University of Applied Sciences, Germany

Additional Reviewers

Daniel Buschek	University of Munich, Germany
Jia-Kai Chou	University of California at Davis, USA
Axel Hösl	University of Munich, Germany
Henri Palleis	University of Munich, Germany
Min Shih	University of California at Davis, USA
Simon Stusak	University of Munich, Germany
Chuan Wang	University of California at Davis, USA
Lin Zheng	University of California at Davis, USA

Supporting Institutions

The Smart Graphics Symposium 2015 was held in cooperation with AAAI, ACM, ACM SIGGRAPH, ACM SIGAI and ACM SIGCHI.

Contents

Image Processing

Posters and Demo Session

Graphics

Designing Mini Block Artwork from Colored Mesh

Man Zhang[1(✉)], Yuki Igarashi[2], Yoshihiro Kanamori[1],
and Jun Mitani[1]

[1] University of Tsukuba, Tsukuba, Japan
{eelzhang,kanamori,mitani}@npal.cs.tsukuba.ac.jp
[2] Meiji University, Tokyo, Japan
yukim@acm.org

Abstract. Mini block artwork is a kind of well abstracted low-resolution block construction with aesthetically pleasing block layout. Similar with previous LEGO constructions, mini block artwork requires strong interconnection among blocks, i.e., a stable layout. However, what make mini block artwork different are the new requirements on highly abstracted shapes and colors and the regularity in block layout considering symmetry in the model itself. We focus on these requirements by first integrating quantization of colors into abstraction. We further explore layout generation method satisfying both stability and symmetry to support our prototype design system. Mini block artwork generated using different methods are evaluated on both stability and symmetry of the block layout. To facilitate a justified and discriminating layout comparison using stability, though we consider factors similar to classical heuristics, we experimentally optimize the weight of each factor for mini block artwork.

Keywords: LEGO® · Mini block artwork · Layout stability

1 Introduction

A block is a convenient tool for fabricating physical objects. A well abstracted low-resolution design can save many block resources and much time for real block artwork. In this paper, we only focus on *brick pieces* considering the regular shape of a block. A Japanese product called Nanoblock [4], whose block length is almost half of the LEGO® block, has become popular in recent years. Examples of low-resolution block artwork can be found in the "Nanoblock mini collection [4]". Each design is assembled with approximately 200 blocks. The average voxel resolution we have observed is around 20 along the longest axis and around 4 along the depth axis. In these Nanoblock products, regularity in layout is emphasized to make the design aesthetically pleasing as well as facilitating an easy building of real block artwork. A basic regularity is that blocks are placed symmetrically for symmetrical parts.

We face challenges with three aspects when designing mini block artwork. Firstly, block design aided by computers generally requires voxelizing an input mesh model. However, voxelization for generating a high-quality low-resolution color model is challenging. Moreover, state-of-the-art methods search for a constructible layout with

© Springer International Publishing AG 2017
Y. Chen et al. (Eds.): SG 2015, LNCS 9317, pp. 3–15, 2017.
DOI: 10.1007/978-3-319-53838-9_1

higher stability, while new restrictions due to low-resolution, color, and symmetry require more than that, i.e., an ingenious balance between stability and regularity in the block layout. Finally, current LEGO design systems are not yet sufficiently convenient enough for the exploration of highly abstracted designs. Based on the challenges above, we briefly review the related work on these aspects below.

Low-Resolution Sampling from Colored Mesh. Most voxelization applications [9, 13, 14] are not optimized for low-resolution in terms of either shape or color. A recent approach called Binvox [6] improves the final low-resolution shape. However, color information is not used. Moreover, basically block colors are limited. Quantization [1, 5] has proved to be effective in reducing the number of colors. For our research, we use Binvox [6] to generate a relatively "qualified" low-resolution voxel model. We further color voxels by optimizing the nearest-neighbor sampling process, and apply a color quantization to satisfy the color restriction in the block set.

Layout Generation for LEGO Models. Previous research [3, 10, 11, 14, 15, 17], have mainly focused on automatic optimization of block placement. Heuristic-driven merging which originated in a group of mathematicians [3], is a classical layout optimization method. A more stable block layout encourages classical factors [3, 11], such as larger blocks, more connections, less collocated block edges, and more perpendicularly placed blocks in successive layers (long axes of two overlapped blocks toward differently). Moreover, graph theory is applied in recent studies [8, 10, 14], and promotes another layout optimization method based on the detection and the repairing of flaws in layout. State-of-the-art studies [8, 14], optimize layout considering both heuristics and graph theory. They use a random greedy merging algorithm to increase connections and larger blocks in the initialized layout. For constructability and more solidity, they further use an iterative local random re-layout to cope with disconnected block groups and weak articulation points, which are detected in a connectivity graph representing the initialized layout.

However, since classical factors for stable layout are not independent, it is difficult to maximize all these factors in a layout at the same time. In some cases, random greedy merging algorithm fails in generating layout encouraging perpendicularity (an indicator [3] describing how well each block covers the previous layer perpendicularly). To handle this, we explore another layout merging algorithm to increase perpendicularity, as well as encouraging larger blocks especially near the surface. For specific model, both of these two merging algorithms are tested in our system for an optimal choice. On the other hand, current re-layout based on random merging is too unpredictable to control the optimized layout. Considering the symmetry in mini block artwork, we introduce a layout symmetrization method and a mild reconnection method for disconnected block groups. Combining these layout processing algorithms, we discuss a layout generation method satisfying both stability and symmetry.

Design System for LEGO Models. Previous designer systems for LEGO blocks can be roughly categorized into three types: mouse based (e.g., LEGO Digital Designer, BlockCAD, Mike's LEGO CAD, Leo CAD, LSketchIt [12], Build with Chrome, Blocklizer [16], and faBrickator [8]), multi-touch based [7], and immersive [2].

We propose a designing flow for mini block artwork and develop a prototype system as well. Our system automatically generates a colored low-resolution voxel model from an input mesh model, as shown in Fig. 1. The user can also recolor the model by mapping sampled colors to block colors supported in a block set. After that, repeated manual-editing and optimization are allowed to generate a constructible block model considering both stability and symmetry. We define an illegal voxel as a badly placed or colored voxel resulting in a non-constructible layout theoretically. Editing on the surface of a voxel model can be done to erase illegal voxels like those at the joint of the cat's left hind leg in Fig. 1(b). Such manual editing is also used for surface decoration. After new decoration, layout is re-optimized. We also provide block layout editing, during which disconnected block groups are automatically detected and the user is notified by contrasting colors rendered for the model. Finally, it takes us 19 min to build a cat in Fig. 1(e) using real blocks.

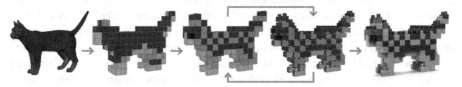

(a) input mesh model (b) sampling & recoloring (c) surface editing (d) brick generation (e) block work construction

Fig. 1. Overview of our mini block artwork designing system (Color figure online)

2 Voxelization and Coloring

To better preserve shape features in the original mesh model, we choose the voxelization [6] revised for low-resolution shapes. Because a voxelized low-resolution model is largely transformed from its original shape, as observed in the head, legs and tail in Fig. 2, finding an appropriate color for each surface voxel is a challenging task. We found that point sampling of a certain triangle color based on Euclidean distance causes many unexpected colors, depending on the quality of the mesh. To inhibit this dependence, we employ *color sampling* based on Manhattan distance. We first find triangles intersecting rays emitted from the center of a target voxel to the centers of 26 neighboring voxels. We calculate colors of not only voxels visible from outside but

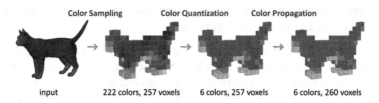

Color Sampling Color Quantization Color Propagation

input 222 colors, 257 voxels 6 colors, 257 voxels 6 colors, 260 voxels

Fig. 2. Automatic color processing flow for the cat in Fig. 1. The numbers of valid colors and colored voxels in each voxel model are noted. (Color figure online)

also their neighbors lying one voxel inwards; we experimentally found that regarding surface voxels as two-voxel thick works well in the subsequent process. For each surface voxel, we select the most common color among the triangles as a voxel color. If two or more colors have the same counts, we randomly choose one. Due to the variation in shape, some surface voxels can get one or more correlated triangles, but some may not get any. We refer to the former as an *occupied voxel* and the latter as an *empty voxel*. A step of *color propagation* finally assigns each *empty voxel* a color chosen from neighboring *occupied voxels* (inside a $3 \times 3 \times 3$ cube centered at this *empty voxel*). To calculate the color of *empty voxel*, each neighboring voxel is initially assigned a weight $w = 4 - d$, where d is the Manhattan distance from the voxel's center to the cube's center. Such a weight is then accumulated for each color. The color weighted most is chosen. If two colors have the same weight, we randomly choose one.

To reduce the number of colors in voxelized model, we use a *color quantization*. We implement *color sampling* earlier than *color quantization* in order to sample more original colors. Our *color quantization* clusters sampled colors into an N-color set, where N is the maximal number of colors allowed in the current design. The N-color set is calculated according to whether the voxel color is sampled from texture or surface color. For a textured model, N colors are extracted from the texture using the method by Gerstner et al. [1]. For a mesh model with surface color, we simply select N sampled colors processed by most voxels. Note that we select N colors as our clustering centers, but not necessarily use all these N colors for the block artwork. After clustering, these N colors can be remapped to any color in the block set. With our prototype system, N is set to six by default because the standard color set for Nanoblock contains six colors.

In summary, as shown in Fig. 2, our color-assigning for voxelized result is composed by: (1) coloring *occupied voxels* using *color sampling*; (2) reducing the number of colors among *occupied voxels* using *color quantization* (implemented in LAB color space); (3) coloring *empty voxels* using *color propagation*.

3 Block Layout Generation

In Sect. 3.1, we introduce newly explored layout processing algorithms. By combining them with state-of-the-art method [14], our proposed design system finally generates an optimized layout for mini block artwork.

3.1 Layout Processing Algorithms

We introduce three layout processing algorithms: perpendicularly ordered merging, subpart connection, and layout symmetrization.

Perpendicularly Ordered Merging. A merging is legal if it ensures the original voxel colors visible outside and generates a block in the block set. In a low-resolution model, the first seed voxel chosen to be merged (white rectangle in Fig. 3) will greatly affect the merging trend in the entire layer. Therefore, seed voxels need to be ordered. We introduce two ordering principles both used in this algorithm, "surface-voxel preceding" and "layout alternating". The former merges surface voxels into larger blocks prior

to invisible voxels. The latter encourages perpendicularity in successive layers. For each layer, we merge voxels into blocks as follows.

1. Store voxels in the model in an unmerged voxel list L.
2. Sort L using both principles, and choose, erase a seed voxel from top of L.
3. Find the legal set of neighbors with which the seed voxel can be merged.
4. Calculate the cost value developed by Testuz et al. [14], merge, and erase neighbors from L.
5. Goto Step 3 unless no neighbor can be legally merged with the seed voxel.
6. Goto Step 2 unless L is empty.

In Step 2, according to our two ordering principles, the unmerged voxel list L is sorted by considering two scores. One score is the number of neighbors able to be merged with this voxel. Since surface voxels have fewer neighbors, the first principle can be applied. The other score for the second principle involves a voxel's coordinate in a 3-dimensional array representing the voxel model. The score for voxel (x, y, z) equals x for layer $y = m$ and equals z for layer $y = m + 1$. An example of choosing a seed voxel using these two scores is illustrated in Fig. 3. Based on the two scores used for the sorting, the voxel with fewer neighbors will be assigned a higher priority. For two voxels with the same number of neighbors, we preferentially choose that with smaller x or z. A *naively ordered merging* considering only the first principle is compared with our *perpendicularly ordered merging* in Fig. 3.

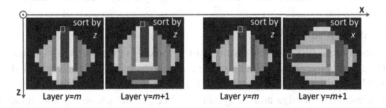

Fig. 3. A comparison of layouts in successive layers generated by *naively ordered merging* (two layers on the left) and *perpendicularly ordered merging* (two layers on the right). The first merging seed voxel is marked by a white square. (Color figure online)

Subpart Reconnection. We rename disconnected block group as subpart for short. Our reconnection for subparts is achieved by manipulating the *separating section* in the layout. A *separating section* separating two blocks into disconnected subparts is a small section equivalent to the side face shared by both blocks. Unlike the state-of-the-art method involving locally-repeating random remerging [14], we first detect all the *separating sections* in the current block layout then create a new link across each *separating section* to connect the neighboring subparts. To change a *separating section* (orange line) into a link (orange arrow), as shown in the local layouts in Fig. 4, the following three steps are required.

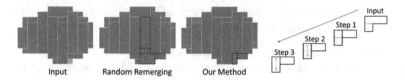

Fig. 4. Combining subparts using random remerging algorithm [14] and our subpart reconnection algorithm. To reconnect orange block, by using three steps, our method results in less change in layout (black rectangles with dotted border). (Color figure online)

1. Between the two separated blocks, divide the larger block along edges of the smaller block. Note that new edges (red lines) are created during this step.
2. Legally merge separated blocks to erase the *separating Section*.
3. Erase new edges created in Step 1 by legally merging separated blocks.

Figure 4 shows that our subpart reconnection algorithm has an advantage in changing little of the original layout. This elegant manipulation is suitable for subpart handling in a symmetric layout because fewer layout changes are preferred when maintaining symmetry in the layout.

Layout Symmetrization. With this algorithm, symmetry in shape is automatically detected considering an assumed axis of symmetry. Assumed axis of symmetry is simply calculated as the medial axis of a bounding box for voxels in the current layer. Our layout symmetrization algorithm for mirror symmetry can be summarized as follows.

1. Detect the axis of symmetry.
2. Scan and record block edges parallel to the x-axis (x-edge) or z-axis (z-edge).
3. If the axis of symmetry is parallel to the z-axis (or x-axis), for each recorded z-edge (or x-edge), add a symmetrical z-edge (or x-edge) to split blocks.
4. If the erasing of an edge and its symmetrical edge both cause legal merging, do it.

Our layout symmetrization algorithm can be used for beautifying layouts visible outside and those invisible inside, as shown in Fig. 5. It focuses mainly on mirror symmetry; however, it may not ensure rotational symmetry. In this case, the user must modify it manually to improve the layout.

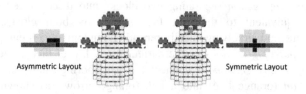

Fig. 5. An asymmetric layout (left) is modified to a symmetric layout (right)

3.2 Layout Generation Method

In this section, we introduce our layout generation method satisfying both stability and symmetry for mini block artwork. The first step is to optimize for a more stable layout. What we need is a reliable stability measure sensitive to layout change to help make the optimal choice.

Stability. To facilitate an intuitive layout evaluation, we introduce a layout stability measure calculated as the average stability of all the blocks in the layout. The following stability for each block is normalized to the range of 0 to 1.

$$Stability = 1 - \frac{Cs/Ns + Co/(1+No) + CeRe + CuRu + Cp/Rp + CnRn}{Cs + Co + Ce + Cu + Cp + Cn} \qquad (1)$$

Our stability measure for each block is modified from that defined by Petrovic [11]. Petrovic defined a stability measure calculated for the block model, assuming the shape of the model remains unchanged; therefore he minimized an index of total number of blocks to encourage larger blocks in layout. However, since we prefer larger blocks, we favor an index more sensitive to the change in block size. Compared with Petrovic's definition, indices used in Eq. (1) for each block remain almost unchanged except for that of the total number of blocks. We define an index of block size N_s instead, calculated as the volume of a block in voxel units. The notations C_s, C_o, C_e, C_u, C_p, and C_n are the weight parameters for the six indices of N_s, connection with other blocks N_o, block edge R_e, uncovered block surface R_u, perpendicularity R_p, and alignment of neighboring blocks R_n, respectively.

Let C_i be index i's weight parameter $(i \in \{s, o, e, u, p, n\})$. Here we determine each C_i so that stability values become as discriminating as possible among different layouts. The Eq. (1) shows that stability value is decided by the index i's importance which is proportional to C_i. Therefore, we define index i's importance as the multiple of C_i and a corresponding coefficient R_i. Because preference on each index is not known, for fairness among indices, we simply assume that each index's importance is identical, i.e., $C_i R_i = 1$ for $\forall i$. We further define index i's discrimination as D_i, and then have $C_i R_i = D_i$, i.e., $C_i = D_i / R_i$. From a statistical point of view, R_i and D_i are better to be averaged among different layouts. During our experiment, we tested layouts generated for 11 low-resolution color models, considering different merging methods (random greedy merging [14], naively ordered merging and perpendicularly ordered merging in Sect. 3.1). To separate the effect of each index, we calculated the stability as Eq. (1) assuming one weight parameter as 1 and the other five as 0. For index i, R_i and D_i are selected separately as the average and standard deviation of stabilities calculated for all the layouts. The values calculated for C_s, C_o, C_e, C_u, C_p, C_n are 0.866, 0.266, 0.850, 0.163, 1.778, 0.275 respectively. For our tested layouts, the range of stability is widened from [0.569, 0.728] (using naive weight parameter equaling 1) to [0.396, 0.714] (using above weight parameters).

Layout Generation Method. We use the following steps to optimize the layout based on our modified stability measure. In the first step for layout initialization, we test for both random greedy merging [14] and perpendicularly ordered merging and choose the layout with larger stability. In the next step for layout constructability, we prefer a layout with fewer subparts. However, considering the illegal voxels in the model, it is not guaranteed that during this step all the subparts can be connected. After manually erasing the illegality, random remerging [14] can well achieve a constructible layout. However, due to the randomness, sometimes a great effort is needed for random remerging (e.g., 67 loops tested for our flower model) but not for *subpart reconnection*. Therefore, our optimization first iteratively performs *subpart reconnection* L_1 times ($L_1 \leq 5$). If it fails in constructability, the smaller block beside each *separating section* is split smaller for extra L_1 times of *subpart reconnection*. To further explore a constructible layout with larger stability, we segment and remerge around weak articulation points, the same as done by Testuz et al. [14].

Especially for a symmetric layout, we aim at a final symmetrization resulting in less reduction of stability and fewer subparts. Subparts created in this step are further connected using the *subpart reconnection*. To maintain symmetry as well, layout change due to *subpart reconnection* is also handled symmetrically.

4 Results

We developed a prototype interactive system to facilitate the design of a mini block artwork. The prototype system was implemented using C++ and tested on a laptop with a 2.40-GHz, Intel Core (TM) i5-2430M processor, 8 GB RAM, and NVIDIA NVS 4200M GPU. We evaluated our system in different steps of the processing flow. Test mesh models, including those with texture (e.g., cat, flower and camera) and surface color (e.g., Legoman, headphone, and sunglass), were taken from free sources available online. Binvox [6] was used for low-resolution voxelization. For coloring, we compared our algorithm with naive alternatives. For layout generation, we compared our method with the state-of-the-art method [14].

Coloring. To evaluate our system based on quantization and sampling, we tested meshes with texture and surface color. Table 1 shows that our quantization can efficiently decrease the number of colors in a model; therefore, contributing to a more stable layout. When implementing the nearest-neighbor sampling, color results can vary when considering different searching areas and different distance measures. Figure 6 shows the comparison of three strategies: (a) Manhattan distance/6 neighbors,

Table 1. Layouts initialized for voxel models with (w/) or without (w/o) color quantization

w/quantization	Color	Stability	Subpart	w/o quantization	Color	Stability	Subpart
Cat	6	0.583	5	Cat	222	0.564	21
Flower	5	0.643	1	Flower	37	0.576	18
Camera	6	0.621	2	Camera	15	0.588	3

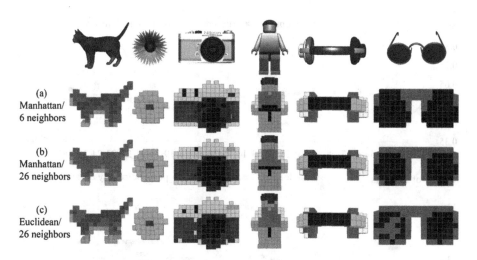

Fig. 6. Automatically abstracted voxel models without manual editing, considering three naive alternatives for color sampling strategy. (Color figure online)

(b) Manhattan distance/26 neighbors, (c) Euclidean distance/26 neighbors. We can find that, results of (c) contain many artifacts, which might be caused by the mesh quality in the input model, such as the mesh difference between the left and right eyeglasses. However, this artifact can be removed using Manhattan distance instead, as shown in the results of (a) and (b). Compared with (a), by searching more neighbors, (b) avoids obviously wrong samplings. Therefore, (b) is finally adopted for our system.

Layout Merging. We used nine colored mesh models as our test models. To show the influence of color and low-resolution, we processed test models in two ways separately for "Color/Low" (Model ID "1–11" in Fig. 7 for the 9 test models, voxelized in a resolution of no larger than 16 and well corrected, with 2 test models corrected both symmetrically and asymmetrically for comparison) and "Black/High" (Model ID "12–26" in Fig. 7 for 5 test models, colored in black and voxelized in resolutions of 16, 24, and 32). With these processed models, we then applied the following three merging algorithms: the state-of-the-art algorithm of random greedy merging [14], and two of our layout merging algorithms (naively ordered and perpendicularly ordered introduced in Sect. 3.1). Figure 7 shows the stability and number of subparts for each voxel model. We can find that naively ordered merging greatly reduces the subparts and layout alternating further increases stability, especially for "Black/High". For "Black/High", our perpendicularly ordered merging performs better than the random greedy merging method. However, for "Color/Low", it is difficult to judge which algorithm performs better. Therefore, in our optimization for mini block artwork, both of these merging algorithms are tested for choosing a more stable layout.

Theoretically, the coloring of voxels should only matter for those that are visible on the exterior. By keeping the interior color variable, there should be the greatest number of possible block layouts. However, our experimental results (Table 2) show that

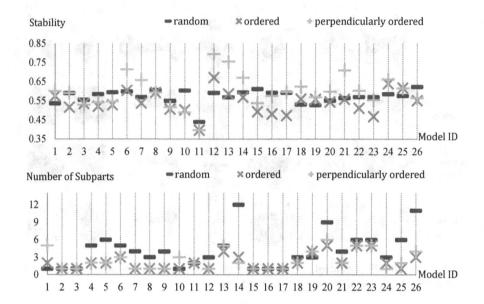

Fig. 7. Statistics of stability and number of subparts for layouts of different models created using different merging methods. Each model ID is shown along the horizontal axis. (Color figure online)

among layouts created for different thicknesses, layouts generated considering the surface color (thickness 1) are not always the most stable ones. This means that if we can find a heuristic coloring of inner voxels, there will be still room for improvement on stability of the initialized layout.

Table 2. Statistics (stability, number of subparts) for layouts merged considering different color restrictions (thickness of colored surface). Layout with highest stability for each model is marked in red. Note that blank cells indicating large thicknesses can not be set for thin models.

	Thick. = 1	Thick. = 2	Thick.= 3	Thick. = 4	Thick. = 5	Avg.
nightstand	0.600, 5	0.600, 5	0.600, 5	0.600, 5	0.600, 5	0.600, 5
soccer ball	0.591, 1	0.618, 1	0.622, 1	0.616, 1	0.622, 1	0.614, 1
camera	0.555, 1	0.557, 1	0.531, 1	0.531, 1	0.531, 1	0.541, 1
Legoman_sym	0.584, 5	0.535, 2	0.535, 2			0.551, 3
Legoman_asym	0.594, 6	0.541, 2	0.541, 2			0.559, 3
dolphin_sym	0.714, 3	0.714, 3				0.714, 3
dolphin_asym	0.658, 1	0.658, 1				0.658, 1
flower	0.606, 3	0.646, 3				0.626, 3
headphone	0.550, 4	0.526, 1				0.538, 3
cat	0.604, 1	0.595, 1				0.600, 1
sunglass	0.439, 2					0.439, 2

Layout Optimization. In regards to a comprehensive optimization for constructability and symmetry, we compared our layout generation method discussed in Sect. 3.2 with the state-of-the-art method [14]. In our experiment for the models in Table 3, we found that re-layout of 50 times did not ensure the removal of all the weak articulation points. However, the final constructability was guaranteed by ensuring one subpart in a model. Besides stability, we calculated another index involving all the edges in a layout, called layout symmetry, to show the percentage of edges having a paired edge in layout symmetrical to the assumed axis of symmetry parallel to the z-axis or x-axis. We can find that symmetry of the original input model is better maintained in the layout optimized with our method than that with the state-of-the-art method [14]. Though symmetrization is normally at the cost of stability, we can also find that almost half of our optimization results (rows in Table 3 from "dolphin_asym" to "dolphin_sym") exhibit larger stability than those of the state-of-the-art method [14]. Some intuitive layout comparison can be viewed in Fig. 8.

Table 3. Comparison of stability and symmetry between two layout optimization methods. A 2-tuple for layout symmetry is shown considering that different models may have different degrees of symmetry along z-axis and x-axis.

Model	Stability			Symmetry (z-axis, x-axis)		
	Our method	Testuz et al.	Avg.	Input	Our method	Testuz et al.
dolphin_asym	0.684	0.619	0.652	0.911, 0.862	0.739, 0.333	0.582, 0.448
nightstand	0.580	0.529	0.555	1.000, 1.000	1.000, 0.481	0.726, 0.653
cat	0.624	0.593	0.609	1.000, 0.904	1.000, 0.542	0.952, 0.649
sunglass	0.454	0.433	0.444	1.000, 0.636	1.000, 0.357	0.581, 0.387
dolphin_sym	0.700	0.683	0.692	1.000, 0.910	1.000, 0.568	0.876, 0.528
camera	0.555	0.555	0.555	0.845, 0.668	0.471, 0.466	0.471, 0.466
flower	0.643	0.647	0.645	0.855, 0.773	0.643, 0.690	0.595, 0.690
headphone	0.536	0.544	0.540	1.000, 1.000	1.000, 1.000	0.632, 1.000
Legoman_asym	0.549	0.560	0.555	1.000, 0.889	0.997, 0.676	0.668, 0.732
soccer ball	0.571	0.590	0.581	1.000, 0.990	1.000, 0.782	0.746, 0.642
Legoman_sym	0.550	0.583	0.567	1.000, 0.891	1.000, 0.647	0.714, 0.684

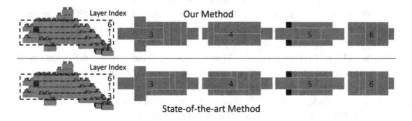

Fig. 8. Layouts layer by layer optimized using our method and state-of-the-art method [14]

5 Conclusions and Future Work

We have proposed and developed a block design system considering various features such as stability, symmetry, and color separation, to assist in the generation of mini block artwork based on an input of 3D mesh. To facilitate our layout optimization and the additional manual decoration, we have quantitatively calculated an intuitive stability measure, as well as having experimentally tuned its weight parameters to make this measure more justified and discriminating. Some of the experimental conclusions about layout merging are thought provoking in exploring more effective layout generation method. Finally, we have discussed the feasibility and effectiveness of our method by comparing it with naive alternatives and state-of-the-art method.

In the future, to automatically create a better abstracted sampling, shape and color can perhaps be sampled in a way that adds to certain measures based on perception. The manual editing can be improved by a skilled surface decoration (e.g., character sculpture), an intelligent fixing for illegal voxels, and a heuristic coloring of inner voxels for a more stable layout. Moreover, perpendicularity in a layout can be further strengthened. Layout generation might also benefit from a proper classification considering features in model. To improve color selection, colors should probably be limited to real Nanoblock colors that are available to the builder. Constraints on the number and/or types of blocks can be incorporated into our system as well.

References

1. Gerstner, T., DeCarlo, D., Alexa, M., Finkelstein, A., Gingold, Y., Nealen, A.: Pixelated image abstraction. In: Proceedings of the Symposium on Non-Photorealistic Animation and Rendering, pp. 29–36 (2012)
2. Gupta, A., Fox, D., Curless, B., Cohen, M.: DuploTrack: a realtime system for authoring and guiding Duplo Block assembly. In: Proceedings of the 25th Annual ACM Symposium on User Interface Software and Technology, pp. 389–402 (2012)
3. Gower, R., Heydtmann, A., Petersen, H.: LEGO Automated Model Construction. Jens Gravesen and Poul Hjorth, Lyngby (1998)
4. Kawada Co., Ltd. Nanoblock. http://www.diablock.co.jp/nanoblock/catalog/minicollection
5. Kopf, J., Shamir, A., Peers, P.: Content-adaptive image downscaling. ACM Trans. Graph. **32** (6), 173:1–173:8 (2013). (Proc. of SIGGRAPH 2013)
6. Min, P., Binvox. http://www.cs.princeton.edu/~min/binvox/
7. Mendes, D., Lopes, P., Ferreira, A.: Hands-on interactive tabletop LEGO application. In: Proceedings of the 8th International Conference on Advances in Computer Entertainment Technology, pp. 19:1–19:8 (2011)
8. Mueller, S., Mohr, T., Guenther, K., Frohnhofen, J., Baudisch, P.: faBrickation: fast 3D printing of functional objects by integrating construction kit building blocks. In: CHI 2014 Extended Abstracts on Human Factors in Computing Systems, pp. 187–188 (2014)
9. Nooruddin, F.S., Turk, G.: Simplification and repair of polygonal models using volumetric techniques. IEEE Trans. Vis. Comput. Graph. **9**(2), 191–205 (2003)
10. Ono, S., Andre, A., Chang, Y., Nakajima, M.: LEGO builder: automatic generation of LEGO assembly manual from 3D polygon model. ITE Trans. Media Technol. Appl. **1**(4), 354–360 (2013)

11. Petrovic, P.: Solving LEGO brick layout problem using evolutionary algorithms. In: Proceedings of Norsk Informatik Konferanse, pp. 87–97 (2001)
12. Santos, T., Ferreira, A., Dias, F., Fonseca, M.J.: Using sketches and retrieval to create LEGO models. In: Proceedings of the Fifth Eurographics Conference on Sketch-Based Interfaces and Modeling, pp. 89–96 (2008)
13. Silva, L., Pamplona, V., Comba, J.: Legolizer: a real-time system for modeling and rendering LEGO representations of boundary models. In: Proceedings of the 2009 XXII Brazilian Symposium on Computer Graphics and Image Processing, pp. 17–23 (2009)
14. Testuz, R., Schwartzburg, Y., Pauly, M.: Automatic generation of constructable brick sculptures. In: Proceedings of Eurographics 2013 (short paper), pp. 81–84 (2013)
15. Winkler, D. V.: Automated brick layout. BrickFest 2005 (2005)
16. Zhang, M., Mitani, J., Kanamori, Y., Fukui, Y.: Blocklizer: interactive design of stable mini block artwork. In: Proceedings of SIGGRAPH 2014 Posters, p. 18:1 (2014)
17. Zijl, L.V., Smal, E.: Cellular automata with cell clustering. In: Proceedings. of Automata 2008, pp. 425–441 (2008)

Interactive and Procedural Modeling
of Featured Chinese Architectures

Chun-Yen Huang[1(✉)], Yang-Siu Sheng[1], and Wen-Kai Tai[2]

[1] Department of Computer Science and Information Engineering,
National Dong Hwa University, Hualien 97441, Taiwan
nschuang.tw@gmail.com, asdzxcl23g@gmail.com
[2] Department of Computer Science and Information Engineering,
Nation Taiwan University of Science and Technology, Taipei, Taiwan
wenkaitai@gmail.com

Abstract. The traditional Chinese garden contains many types of tings, corridors, walls, etc. For artists, it is tedious work to model these kinds of featured Chinese architecture due to the strict and complex construction rules. We propose an interactive and procedural tool to modeling featured Chinese architectures that appear in the Chinese garden. Based on the previous research about modeling basic structures of Chinese architecture, we extend to model more featured Chinese architectures, such as double-eave ting, combined ting, corridor, and wall effectively and efficiently, and combine them into a complete Chinese garden. By adjusting the overlapped components, we can combine two single tings into a combined ting. By modifying ting's structure, we can construct a variant of corridors or garden walls upon few input parameters. In addition, the result 3D model can be exported in different LODs, making the use of the model more practicable and flexible. As experimental results shown, complex 3D models of a Chinese garden with several different featured Chinese architectures can be created in minutes.

Keywords: Ting · Corridor · Garden wall · Chinese pavilion · Procedural modeling · Interactive modeling · Chinese architecture · Chinese garden

1 Introduction

Featured Chinese architectures, such as ting, palace, and pagoda, have been becoming increasingly significant in the fields of cultural heritage preservation, restoration of ancient civilization, and digital entertainment with their complex structure and decoration. However, the strict rules of proportions in traditional construction of featured Chinese architectures [1–3] make it too complex to construct using a number of simple grammars (grammar-based approach) and sketches (sketch-based approach). Huang and Tai [4] proposed a method to modeling ting by exploring the parameter relationships and summarizing them in association with two principal parameters.

In this paper, we extend the method Huang and Tai [4] to modeling more types of featured Chinese architectures structure: (1) extended roof structures, such as

Y. Chen et al. (Eds.): SG 2015, LNCS 9317, pp. 16–28, 2017.
DOI: 10.1007/978-3-319-53838-9_2

gable-and-hip roof, double-eave structure, and pagoda, and (2) extended ting structure, such as combined ting, corridor, and garden wall, with the level-of-detail technique to reduce the number of polygon used of the resultant 3D model. It is more practicable and flexible to use in various applications of virtual Chinese architectures, such as digital content industries, including computer/video games, animations, and movies.

The rest of this paper is organized as below. In Sect. 2, we briefly review the related work on procedural modeling approaches. Section 3 gives an overview of the featured Chinese architecture's structures. Section 4 specifies the extended approach of the featured Chinese architectures. The simplification & Level-of-Detail will be described in Sect. 5. In Sect. 6, the experimental results are shown. Finally, we conclude with a discussion about future work in Sect. 7.

2 Related Work

Procedural modeling approaches [4, 6] allow users to produce a high degree of complexity with, relatively speaking, a few simple inputs. For increasing the variations of the results, more control parameters need to be added to the procedure. However, it would be complex and less intuitive for users to predict the effects by adjusting particular parameters and the combinations of the parameters as the number of input parameters grows.

Some recent work in architecture modeling is based on grammars. The approaches based on L-systems [7–10] have achieved impressive results on branching objects such as plants and streets. Even so, there are numerous types of buildings that are constructed with quite different structures from branching objects.

Shape grammar is a powerful modeling tool. Wonka et al. [11] proposed split grammars that allow automatic derivations are useful for various building styles. Müller et al. [12] introduced CGA shape, which extends the split grammars. Müller et al. [13] proposed a specialized generation rule for reconstructing Puuc-style architecture at Xkipché in Mexico based on CGA Shape. Bokeloh et al. [14] proposed an inverse procedural modeling approach that analyzes the input 3D model to build a shape grammar and synthesizes a similar one with the assistance of the user's interactions. Nevertheless, still, there are revelations of insufficient reasons for the method to support curved surface due to the restrictions of CGA shape.

Another method to modeling architectures is the sketch-based approach. Chen et al. [15] proposed a system of freehand sketch-based modeling of architectures. The system periodically interprets its 2.5D-geometry as the sketch has been drawn by users. However, drawing the sketches of architecture for novice users is difficult. As a result, it is even harder to produce a correct projection concept. We take advantage of the previous approach [4], which created an initial frame of feature Chinese architecture for users to adjust the shapes in the directions they wish rather than starting from nothing, and extend it for more types of featured Chinese architecture.

3 Featured Chinese Architectures in a Chinese Garden

Referring to the construction guides of ancient featured Chinese architecture [1–3], a Chinese garden is composed by several featured Chinese architectures. These architectures come in several types, such as ting, palace, and pagoda, are majorly classified by the roof types. These basic roof types are: round, pyramidal, hollow, hip, gable, overhanging-gable, gable-and-hip, round-ridge, and helmet types as shown in Fig. 1. The hip, gable, overhanging-gable, gable-and-hip, and round ridge types only appear on the rectangular platform.

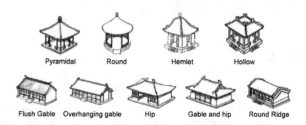

Fig. 1. The nine roof types

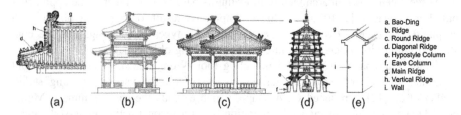

Fig. 2. Exemplar structures of (a) A left-half gable-and-hip roof in front-view, (b) A double-eave, (c) A combined ting, (d) A pagoda, and (e) A garden wall.

Figure 2 shows exemplar structures of the gable-and-hip roof, double-eave, combined ting, pagoda, and garden wall. Figure 2(a) shows a half gable-and-hip roof in front-view. Double-eave structure means there is an extra eave as a veranda around the main structure, below the main roof of the building [3], as shown in the Fig. 2(b). A combined ting structure is shown in Fig. 2(c); it is combined by two single tings. The structure of Pagoda is shown in Fig. 2(d), and usually stacks three or more layers [1]. The overall size of each layer decreases from bottom to top. Figure 2(e) shows the structure of a garden wall. A garden wall is assembled by a gable roof and a solid wall. The structure of a corridor is the same as a single ting.

4 Chinese Garden Architectures Modeling

The previous work [4] is improved to model gable-and-hip roof, double-eave ting, and pagoda, and extended ting structures: combined ting, corridor, and garden wall. In this Section, we specify the methods for modeling these structures. Figure 3 shows the structural frame and control points we use.

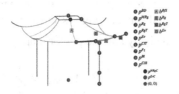

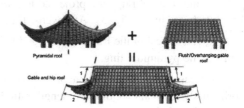

Fig. 3. An illustration for control points on a structure frame. The blue dots show the position control points PCPs, and the bending control points BCPs are shown in colored squares. Additionally, the blue line shows the straight part of the eave while the green curve shows the curved part of the eave. (Color figure online)

Fig. 4. An illustration of the combination of gable-and-hip roof. The red part of the gable-and-hip roof is from the pyramidal roof, while the green part is from the overhanging roof. (Color figure online)

4.1 Extended Roof Structures

Gable-and-hip Structure. Gable-and-hip roof can be considered as a combination of the pyramidal and overhanging roof. Figure 4 shows an illustration of the concept of this combination. Therefore, we construct the frame of gable-and-hip roof by editing the pyramidal roof on a rectangular ting as shown in Fig. 5.

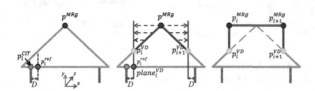

Fig. 5. An illustration in front view of creating the frame of a gable-and-hip roof. The purple lines indicate the plane $plane_i^{VD}$ obtain by a reference point p_i^{ref} of the corresponded columns' position p_i^{CIT}. The red, brown, orange, and green lines represent the main-ridge, vertical ridges, diagonal ridges, and eave line, respectively. (Color figure online)

Given a segmented single ridge curve in the frame of a pyramidal structure (orange curve on the left of Fig. 3), we first decide the position of the joint point p^{VD} between

the vertical ridge (legend h in Fig. 2) and the diagonal ridge (legend d in Fig. 2) on the original ridge as shown on the middle of Fig. 5. To help us deciding the position of the joint point p^{VD}, we need a reference point p_i^{ref}, as shown on the left of Fig. 5, whose initial position is set to be $p_i^{ref} = p_i^{CIT} - (D,0,0)$ [1]. Thus, the i^{th} joint point p_i^{VD} can be decided as the intersection point of the i^{th} ridge and a plane $plane_i^{VD}$ as default position, where the plane $plane_i^{VD}$ shown by the purple line on the middle of Fig. 5 is defined by the reference point p_i^{ref} and x-axis. Then, the segment points from p_i^{VD} to p_i^{MRg} on the original ridge are projected to $plane_i^{VD}$ to create the vertical ridge (brown lines at the right of Fig. 5). Afterward, the frame of the main ridge is created by $\overline{p_i^{MRg} p_{i+1}^{MRg}}$. The rest of the frames, PCPs and BCPs of the body and the platform are the same as the pyramidal ting.

User can adjust the position of p_i^{VD} by moving the PCP p_i^{MRg} along $\overline{p_i^{MRg} p_{i+1}^{MRg}}$ horizontally to obtain the different length ratio between the vertical and diagonal ridges on the original ridge.

Double-eave Structure. The double-eave structure is modeled by assembling a shorter hollow roof structure to a taller structure. The length of the hollow roof's main ridge corresponds to the width or depth of the taller structure.

For a given basic structure as the lower part of the double-eave structure, we first change the roof type to hollow roof for adding the upper structure. The main ridge length in width and depth direction are set to be $width - 2x$ and $depth - 2x$, respectively, where x is raising step [4], to fit the upper structure [3]. We then take the ratio of original to the adjusted width/depth to decrease the scale the upper structure.

Double-rounding. Figure 6 shows two kinds of column layout in the double-eave structure: single-rounding and double-rounding [3]. As the double-rounding column structure shown in Fig. 6(a), the columns of the upper structure (orange dots) extend to the lower platform, which become hypostyle columns.

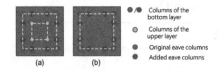

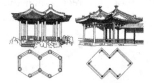

Fig. 6. The top-view of the two column layouts: (a) double-rounding column structure, and (b) single-rounding column structure. (Color figure online)

Fig. 7. The structures and layouts of an edge-aligned and a ridge-align combined ting.

Single-rounding. In the opposite, if the columns of the upper structure do not extend to the platform, it is called the single-rounding column structure as shown in Fig. 6(b). Therefore, as to the double-rounding structure, we set the column's height to $1.8 \times (original\ column\ height)$; as to the single-rounding structure, we set the

column's height to $0.4 \times$ (*original column height*) with the upper structure be lifted $1.4 \times$ (*original column height*).

The diameter of the hypostyle column is $D + 1$, where D is the diameter of the eave column [2]. Finally, for each eave column, two more extra eave columns are added along the width and depth direction with an offset distance x inward as shown in Fig. 6(b).

Pagoda Structure. We stack multiple layers in y direction and scale down the size (in our implementation, 0.75) of each layer from bottom to top to model the pagoda. Same as double-eave structure, the roof type of the lower layers except the top layer is set to be the hollow roof, which the length of the hollow roof's main ridge is equal to the corresponding width or depth of the upper layer structure.

4.2 Extended Ting Structures

The following subsections introduce the extended ting structures, including combined ting and corridor and garden wall.

Combined Ting Structure. The width, depth, platform shape, and roof type of the two single tings should be the same when combining these two single tings to a combined ting [18, 19]. As described in [3, 16], there are two kinds of alignment structure when combining two single tings: edge-aligned structure, as shown in the left of Fig. 7, and ridge-aligned structure, as shown in the right of Fig. 7. Also, for symmetry, combining different roof types should be limited to the following rules:

(1) **Pyramidal and Hollow** - can be combined by edge-aligned or ridge-aligned structures.
(2) **Gable and Hip** - can be combined only by edge-aligned structure.

Accordingly, we can obtain a combined ting by the following steps: (1) align two tings with the edge/ridge, (2) decide the distance between the centers of the two tings, (3) calculate the intersected plane, and (4) process the intersected region. The first two steps are straight forward, so the following describes the details of the last two steps.

Intersected Plane Calculation. Two aligned tings $ting_A$ and $ting_B$ can be regarded as been mirrored from one to another by a mirror plane. This plane can be considered as the intersection plane $plane^M$ which lies in the middle of $\overline{p_A^{BD} p_B^{BD}}$ with its normal parallels to $\overline{p_A^{BD} p_B^{BD}}$ as shown in the left of Fig. 8. Thus, the distance d_{plane^M} from p^{BD} to $plane^M$ will be less than $\|\overline{p^{BD} p^{EvC}}\|$ (edge-aligned) or $\|\overline{p^{BD} p^{Rg}}\|$ (ridge-aligned).

Intersection Processing. After obtaining the intersected plane $plane^M$, we can place the two same ting $ting_A$ and $ting_B$ along $\overline{p_A^{BD} p_B^{BD}}$ at the distance of $2d_{plane^M}$ to obtain the combined ting. However, there are several components and tiles will be intersected to each other when combining these two single tings. Therefore, we have to deal with these intersected components and tiles to obtain a complete single combined ting.

Body Structure. According to the description in [4], the rest of PCPs can be calculated as soon as the column bottom control point p^{CIB} has been decided. Thus, we have to adjust the p^{CIB} first for processing the intersection. The p_i^{CIB} that underneath the interior area of the other roof should be move to the intersected plane $plane^M$ along the edge towards p_{i+1}^{CIB} (rectangle ting) or p_{i-1}^{CIB} (otherwise, if p_{i+1}^{CIB} is still at the same side of p_i^{CIB}) as shown in the left of Fig. 8. The rest of the components of the body structure are adjusted accordingly as stated in [4].

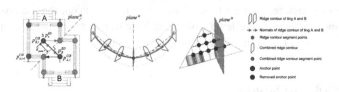

Fig. 8. An illustration of intersected plan calculation and intersection processing. Left: the top view of a ridge-align combined ting. Calculate the intersected plane $plane^M$ by the blue reference line defined by $\overline{p_A^{BD} p_B^{BD}}$, and then move the column bottom control point lies at the opposite side of $plane^M$ (related to p^{BD}) back onto the $plane^M$. Middle: adjust the ridge contours onto the intersected plane $plane^M$. Right: remove the anchor points that lie at the opposite side of $plane^M$ (related to p^{BD}). (Color figure online)

Roof Structure. For the ridges, since the 3D model of ridges is generated by sweeping [4], we adjust the last slice of the model of one ting onto the intersected plane to be connected to the other ting as shown in the middle of Fig. 8. For the tiles, we calculated the anchor points at the different side of the intersected plane related to p^{BD} respectively. These anchor points are removed to avoid intersected into the other ting's roof since they will be at the structure of the other ting to be combined as shown in the right of Fig. 8. The tiles then can be placed at the remaining anchor points by the method described in [4]. After the processing of the ridge and tiles, we can obtain a combined ting.

Corridor & Garden Wall. In Chinese garden architectures, corridors are used to connect the main building, while garden walls surround the whole area. The structure of corridor and garden wall both have platform and roof in gable type, but there are columns and/or wall in corridor and no columns in garden wall. We focus on building the basic single layer and straight corridor/garden wall.

By the width and length from user input parameters, we can obtain a corridor by extending the width of a gable ting [4] and introduce extra columns. Liang and Heh [2] describe that the columns should be placed in the distance of a *room width* along the width. We restrict the user input width in the integer multiple of the room width, so the placement of each column can be easily decided. A garden wall is obtaining by the method of gable roof ting without the columns, but with a wall beneath the roof and along the main ridge, as shown in Fig. 2(e).

Intersected Region Detection. There are three types of intersected region in corridor and garden wall: L-type, T-type, and cross-type [3] as shown in Fig. 9(a), (b), and (c), respectively. We take each corridor or wall as a rectangle projected onto the floor to illustrate the concept.

As the L-type, the two corridors/garden walls will be extended towards the intersected area to cover the hole as shown in the rectangle area on the top-left of Fig. 9(d). In our implementation, we restrict the direction of the corridor and wall along x- or z-axis only to apply an intersection-test method to get the intersection area between every two AABB rectangles as the rectangles shown in the middle row of Fig. 9.

Fig. 9. An illustration of intersection types and processes of corridor and garden wall. (a) \sim (c): three intersected types: L-, T-, and cross-type. (d) \sim (f): intersected region detection (with extended region of L-type). (g) \sim (i): region that roof component (anchor points) to be removed for each type, respectively

Intersection Processing. In the intersected region, we process the intersection in body and roof structures respectively.

Body Structure. For the corridor, the body structure is almost the same with the gable roof ting. The difference is that we have to add extra columns along the width direction with the *room width* as shown in Fig. x. For the garden wall, we construct a 3D mesh beneath the roof and along the main ridge by the thickness of the wall *wall.thickness* = $\frac{wall.height}{3} + \frac{wall.height-9}{3}$ [1, 16, 17], as shown in Fig. x.

Roof Structure. As mentioned above, the L-type corridors/garden walls will be extended towards the intersected area to cover the hole as shown in Fig. 9(d). The ridges that lie in the intersected area of the L-type intersection are ignored. Then, the roof components that lie in the area of the corner triangle (different color to the original rectangle) are removed as shown in the bottom row of Fig. 9. As the T-type and the cross-type, the process on roof components (anchor points and ridge) who lies in the area of the triangle is the same as those of combined ting. Finally, the corridor/garden wall is obtained.

5 Simplification and Level-of-Detail

The total amount of the polygons in the resultant model is too large to be used in the real-time applications. In this section, we propose simplification and level-of-detail methods to reduce the amount of the polygons while keeping the overall level-of-detail shape of the output 3D architecture models.

5.1 Roof Surface Simplification

For preserving the overall shape of architecture while simplifying its 3D model, we have to take the following information into account.

According to the previous method [4], the PCPs play an important role for deciding the overall shape of a featured architecture, while the components of the roof are placed according to the anchor points. We take advantage of these points by triangulating them to obtain the 3D mesh of whole roof, excluding the ridges. The points we try to triangulate are ordered due to the construction process of the roof frame [4]. Therefore, we can use the order to make the triangulation more efficient.

The order of points we obtain after the roof frame construction process is from p^{Rg} towards p^{EvC} along the eave curve (green line), and from eave curve towards the ridge (orange line) along roof surface curves (cyan lines) shown in the right of Fig. 8. Hence, the points can be triangulated according this order.

5.2 Other Components Simplification

Ridge and ridge tail models are generated by sweeping a complex contour in previous method [4]. The curvature of these components are crucial of a roof's shape, so we have to retain the curvature while perform the simplification simultaneously. To this end, we keep the number of the segment points of them while only replacing the complex contour with a simple rectangle instead when sweeping.

Other components, such as column, purlin, beam and tiebeam, are replaced using low-polygon template models (cylinder or box) to replace the corresponded components. Moreover, we use a rectangular plane to replace balustrade, frieze, and sparrow brace, letting artists to enrich the content using texture.

5.3 Level-of-Detail

The number of polygons is decreased significantly after the simplification process, but we would like to further control the number of triangles to a certain extent. We take advantage of the level-of-detail method. Level-of-detail techniques scale the detail of the 3D objects according to their visual importance within the scene [20].

The level-of-detail method we used is to evenly sample the anchor points before triangulating them with the critical points for maintaining the overall shape of the roof. Therefore, we keep these critical points (Fig. 3) and perform a uniform sampling on the rest anchor points with a sampling rate

$$s = \frac{d}{t} \times i/2 \tag{1}$$

where d is the distance between the camera and the model center, or an adjustable parameter given by user, t is the maximum value of d, and i is the number of segment of the eave curve. That is, we can control the number of polygon by adjusting the parameter d.

6 Results

We have implemented the proposed methods and developed an integrated modeling tool on a PC with a 3.20 GHz Intel Core i5-3470 CPU, 8 GB RAM and an NVIDIA GeForce GTX 550 Ti graphics card using C# and DirectX API.

The left of Fig. 11(a) shows a resultant 3D model of a ting with gable-and-hip roof. The two different column layouts, single-rounding column and double-rounding column, of double-eave structure are shown in the top-left and bottom-left of Fig. 11(c), respectively. The left of Fig. 11(b) shows a three-layer pagoda. It takes less than thirty seconds for a user to create with only three clicks of the keyboard and slightly adjust the control points by mouse.

The resultant 3D models of combined tings in edge- and ridge-aligned with hexagonal and rectangular platform are shown in Fig. 12(a) and (b), respectively, with comparison of the real ones. Figure 12(c) and (d) show the resultant 3D models of the corridors and garden walls, respectively. Note that the bottom-right of the Fig. 12(c) is the top view of the model to show the type clearly. modeling time of the above 3D models can be seen in Table 1.

The proposed simplification and LOD method can extraordinarily decrease the number of polygon while keeping the overall shape of a structure. Figure 10 shows the comparison of polygon count for the original and simplified models using our proposed LOD method. Note that the polygon count of the original model, shown in Fig. 10(a),

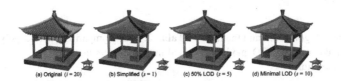

(a) Original ($i = 20$) (b) Simplified ($s = 1$) (c) 50% LOD ($s = 5$) (d) Minimal LOD ($s = 10$)

Fig. 10. The comparison between (a) the original detailed 3D model, (b) simplified model, (c) 50% LOD model, and (d) minimal LOD (critical points only).

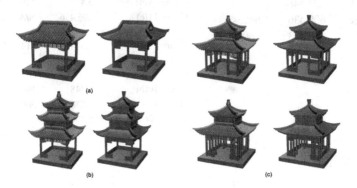

(a)

(b) (c)

Fig. 11. The resultant models of extended roof types with their simplified 3D models. (a) A ting with gable-and-hip roof (maximum LOD). (b) A three-layer pagoda (minimum LOD). (c) Top: a ting with single-rounding double-layer roof; bottom: a ting with double-rounding double-layer roof (50% LOD).

Fig. 12. The comparison of the real extended tings and the 3D models we obtained. (a) An edge-aligned hexagonal combined ting. (b) A ridge-aligned rectangular combined ting. (c) A T-type corridor. (d) Two garden (palace) wall.

is 197,284, while that of the minimal LOD model (critical points only), shown in Fig. 10(d), is down to 1,408, which means 99.3% of the polygons are reduced. Figure 10(b) and (c) are the simplified models of Fig. 10(a) with maximal and 50% LOD, respectively. The small models beside Fig. 10(a) to (d) show that the salience features are almost retained when zoom-out (80% smaller than the original size). The corresponding simplified models of Fig. 11 are shown in the right of the original models of Fig. 11 with maximum, minimum, and 50% LOD, respectively. The polygon count and the LOD parameters of the models we used in this paper are shown in Table 2, with $i = 20$ and $t = 1000$. Note that the simplified 3D models in Fig. 11 are rendered using 3D Exploration™ with smoothing parameter set to be 40, while those in Fig. 10 are not smooth rendered.

Table 1. The polygon count and the modeling time of the resultant 3D models of extended ting structures

Model	Polygons	Modeling time
Figure 12(a)	405,776	4m30s
Figure 12(b)	327,548	2m27s
Figure 12(c)	608,436	2m25s
Figure 12(d)	518,243	5m08s

Table 2. The comparison of the polygon count and the parameters used

Model	Polygons	d	s
Figure 11(a) left	188,192	N/A	N/A
Figure 11(a) right	3,296	1000	1
Figure 11(b) left	355,620	N/A	N/A
Figure 11(b) right	3,432	119	10
Figure 11(c) top-/bottom-left	296,456	N/A	N/A
Figure 11(c) top/bottom-right	2,944	514/547	5
Figure 10(a)	197,284	N/A	N/A
Figure 10(b)	3,248	100	1
Figure 10(c)	1,536	500	5
Figure 10(d)	1,408	1000	10

7 Conclusion

In this paper, we have extended the previous work [4] to modeling more kinds of featured Chinese architectures such as gable-and-hip roof, double-eave structure, pagoda structure, combined ting, corridor, and garden wall of the Chinese garden. We

combine pyramidal roof structure with gable roof to model the gable-and-hip structure, combine pyramidal and hollow roof to model the double eave structure, and stack several layers of a single ting to model the pagoda structure. Also, we combine the multiple tings in both vertical and horizontal directions to model double-layer, pagoda, and combined ting structure, and dealing with the intersection area to model the corridor and the garden wall. The experimental results show that our approach can effectively obtain similar 3D models to the real architectures in minutes.

The limitations lie on the complex structure of combined ting, such as round-ceiling-square-floor ting and the curved structured corridor. We plan to improve our approach to cover the above types of architecture to enrich our capability of modeling various featured Chinese architectures. Furthermore, we would like to improve the approach for better manipulation, capable of importing customized component models, and taking aid from image(s) for the reconstruction of the existing eastern feature architecture more precisely, intuitively, and semi-automatically.

References

1. Bai, L.-J., Wang, J.-F.: The Structure of the Official Building in Ching Dynasty (Ch'ing Tai Guan Shih Jien-ju Go-zao). Publisher of Beijing University of Technology, Beijing (2000)
2. Liang, S.-C., Heh, Z.-Y.: The Example of the Construction and Computation of the Architecture in Ching Dynasty (Ch'ing Tai Ying-tsao Tse Li). Wen Hai Foundation for Culture and Education, Taipei (1985)
3. Liu, D.-K.: The Construction Methods of Ancient Chinese Building (Chung-kuo Ku Chien-chu Wa-shih Yin-fah). Publisher of Construction Industry of China, Beijing (1993)
4. Huang, C.-Y., Tai, W.-K.: Ting tools: interactive and procedural modeling of Chinese ting. Vis. Comput. **29**, 1303–1318 (2012)
5. Ganster, B., Klein, R.: An integrated framework for procedural modeling. In: Sbert, M. (ed.) Spring Conference on Computer Graphics 2007 (SCCG 2007), pp. 150–157. Comenius University, Bratislava (2007)
6. Parish, Y., Müller, P.: Procedural modeling of cities. In: 28th Annual Conference on Computer Graphics and Interactive Techniques, pp. 301–308 (2001)
7. Prusinkiewicz, P., Hammel, H., Hanan, J., Měch, R.: Visual models of plant development. In: Rozenberg, G., Salomaa, A. (eds.) Handbook of Formal Languages, vol. 3. Springer, Heidelberg (1997)
8. Prusinkiewicz, P., Hammel, M., Měch, R., Hanan, J.: The artificial life of plants. In: SIGGRAPH 1995 Course Notes, vol. 7, pp. 1–38 (1995)
9. Prusinkiewicz, P., James, M., Měch, R.: Synthetic topiary. In: SIGGRAPH 1994, pp. 351–358 (1994)
10. Prusinkiewicz, P., Lindenmayer, A.: The Algorithmic Beauty of Plants. Springer, Heidelberg (1990)
11. Wonka, P., Wimmer, M., Sillion, F., Ribarsky, W.: Instant architecture. ACM Trans. Graph. **22**(3), 669–677 (2003)
12. Müller, P., Vereenooghe, T., Wonka, P., Paap, I., Van Gool, L.: Procedural 3d reconstruction of puuc building in xkipché, Eurographics Symposium on Virtual Reality, Archaeology and Cultural Heritage (VAST), pp. 139–146 (2006)

13. Müller, P., Wonka, P., Haegler, S., Ulmer, A., Van Gool, L.: Procedural modeling of buildings. ACM Trans. Graph. **25**(3), 614–623 (2006)
14. Bokeloh, M., Wand, M., Seidel, H.-P.: A connection between partial symmetry and inverse procedural modeling. ACM Trans. Graph. **29**(4), 104:1–104:10 (2010)
15. Chen, X., Kang, S., Xu, Y.-Q., Dorsey, J., Shum, H.-Y.: Sketching reality: realistic interpretation of architectural designs. ACM Trans. Graph. **27**(2), 11:1–11:15 (2008)
16. Tian, Y.-F.: The Construction and Design of Chinese Garden Architecture. Publisher of Construction Industry of China, China (2008)
17. Wang, S.-D., Ma, S.: Chinese Garden Architecture. Publisher of China Meteorological Press, China (2001)
18. Zong, W.-C.: Atlas of Chinese Garden Architecture. Publisher of China Book Press, China (1995)
19. Wang, S.-D., Ma, S.: The Design of Chinese Garden Architecture. Publisher of Southeast University Press, China (2004)
20. Luebke, D., Reddy, M., Cohen, J., Varshney, A., Watson, B., Huebner, R.: Level of Detail for 3D Graphics. Morgan-Kaufmann Inc., Burlington (2003)

Screen Space Hair Self Shadowing
by Translucent Hybrid Ambient Occlusion

Zhuopeng Zhang[1](✉) and Shigeo Morishima[2]

[1] Waseda University, Tokyo, Japan
zhangzp@asagi.waseda.jp
[2] Waseda Research Institute for Science and Engineering / JST CREST,
Tokyo, Japan
shigeo@waseda.jp

Abstract. Screen space ambient occlusion is a very efficient means to capture the shadows caused by adjacent objects. However it is incapable of expressing transparency of objects. We introduce an approach which behaves like the combination of ambient occlusion and translucency. This method is an extension of the traditional screen space ambient occlusion algorithm with extra density field input. It can be applied on rendering mesh objects, and moreover it is very suitable for rendering complex hair models. We use the new algorithm to approximate light attenuation though semi-transparent hairs at real-time. Our method is implemented on common GPU, and independent from pre-computation. When it is used in environment lighting, the hair shading is visually similar to however one order of magnitude faster than existing algorithm.

Keywords: Hair shadowing · Real-time rendering · Deferred shading · Computer animation

1 Introduction

According to [1], the appearance of hair is extremely important to the representation of virtual characters. Human head is usually covered by over 100,000 hair strands, and the styles of hair are always very variant, which makes illumination of hair very challenging. The term describes how incoming light hits a fiber and then scatters to viewer is called Bidirectional Curves Scattering Distribution Function (BCSDF). Two classic BCSDF scattering models for hair fibers are proposed by Kajiya-Kay [2] and Marschner et al. [3]: the former captures the basic feature of scattering from a fiber, and the latter achieves a more physically accurate expression by considering the reflection and refraction distribution when light bounces off or penetrates the hair fibers. Besides BCSDF, for hair rendering, we also have some topics as self-shadow, transparency (subsurface scattering) and global illumination to solve. To solve these problems, variant data structures and algorithms are invented, by improving the shadow map technique, or taking the idea of volume rendering. For instance, deep shadow maps [4],

© Springer International Publishing AG 2017
Y. Chen et al. (Eds.): SG 2015, LNCS 9317, pp. 29–40, 2017.
DOI: 10.1007/978-3-319-53838-9_3

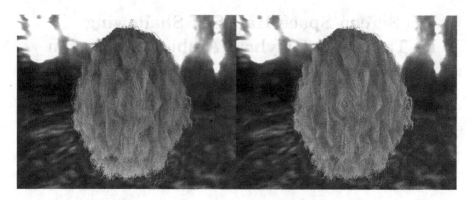

Fig. 1. Rendering hair model *wCurly* under environment lighting. Left image is rendered by ray casting runs at 3.88 fps, right is by our screen space method runs at 18.7 fps (voxelization based).

visibility function with density clustering [5], 3D light-oriented map on CPU [6], deep-opacity-maps (DOM) [7], and occupancy maps [8] are contributed to the self-shadow problem. Dual scatter [9] concludes a way to calculate internal scattering of hair volume. But these algorithms are under the assumption of a single light source. On the other hand, accessible shading [10] introduces the basic idea of ambient occlusion, effecting low frequency shadow. Screen-Space Ambient Occlusion (SSAO) [11] defers the ambient occlusion calculation to post processing, providing sizable performance improvement and plausible result. Whereas a hair model usually consists of thousands of strands, it is not easy to apply SSAO to such primitives because the depth map is discontinuous (shown in Fig. 4). Moreover, rendering hair under environment lighting is extremely expensive. The environment lighting should be appropriately compressed for real-time rendering circumstance, one practical means is by a set of Spherical Radial Basis Functions (SRBF) [12]. Based on SRBF, Ren et al. [13] achieved an interactive hair rendering model for environment lighting. Their work integrates many techniques including DOM and dual-scattering. Our paper will introduce a method that renders hair or other objects under environment lighting. It can be seen as a fast self-shadow method, filling in the gap between translucency and SSAO. By reducing calculation from object space to screen space, our method achieves much acceleration.

2 Related Works

In this paper we present a method to rapidly approximate self-shadow on hairs. It is mainly related to two topics: ambient occlusion and hair rendering under environment lighting.

Ambient Occlusion

The availability and efficiency of SSAO make it become a popular technique in recent video games. Hybrid AO (HAO) [15] combines SSAO and voxelization, allowing potential occluders located outside the field of view or behind a front object to be considered. However, their method only works for opaque object rendering. A unique AO method is introduced by Bunnell [16], in which mesh surfaces are approximated as disks. Hoberock et al. [17] improve this method by hierarchical approximation, but they put subsurface scattering in their future work. Mendez-Feliu and Sbert presented ambient occlusion with translucency, however in the context of path-tracing [18].

Hair Rendering Under Environment Lighting

Ren et al. [13] proposed an experimental hair rendering model for environment lighting. But their method includes heavy pre-computation, moreover, in order to accumulate light absorption along light direction, it renders the hair geome-try as many time as the amount of SRBFs (the number of SRBFs is between 30 and 60), making a considerable computation cost. Another environment lighting technique is spherical harmonics (SH), used by Xing et al. in [14] for hair ren-dering. In their paper, the self-shadow is efficiently computed by ray casting on voxel data. We will show that our self-shadow method is more efficient than the ray casting.

3 Translucent Hybrid Ambient Occlusion

Our main goal is screen space hair self shadowing under environmental light or pure sky light. Efficiently implementing this subject requires some innovatory work. Similar to Hybrid AO, our approach combines object space and screen space computation. However, as we aim at rendering translucent objects, we call our method as THAO. Compare to other methods, our method owns advan-tage at:

- Provide both ambient occlusion and translucency effect
- Can be used to render either hair or mesh object
- Support dynamic scene and environment lighting without precomputation
- Efficient because of mainly being a screen space method

The idea of ambient occlusion is that the amount of indirect light accesses a point p on a surface is proportional to how visible it is to incoming light over the hemisphere about p. SSAO postpones the ambient occlusion calculation for better performance, after the view-space normal vectors and depth values are rendered to a full screen render target (also called Geometry buffer or G-buffer), the ambient occlusion will be estimated at each pixel using the G-buffer as input.

Algorithm Overview

The main difference between our THAO and SSAO (or HAO) is the sample pattern. As shown in Fig. 2, we not only take samples on the hemi-sphere above the mesh surface, but also take samples beneath the surface. This sample method is helpful on estimating how much light rays are occluded from all direction. Because the mesh object itself is translucent, it will be meaningful to take account of the light transportation inside the object. When a surface point is less surrounded by other parts, there are more probability that it is a part of a prominence, thus less light is attenuated there. For example, the ear of a bunny is so thin that it looks more translucent than other parts. And we also show the feature in our result of experiment as Fig. 3. As shown in the figures, our method behaves an effect like the combination of ambient occlusion and translucency.

For mesh objects, we have to voxelize the objects to volume representation, and then render objects to G-Buffer. In the later stage we render a full screen quad, and for each pixel occupied by mesh, we get the original position and generate random sample points surrounding it. By sampling on the volume representation, the translucency and ambient occlusion is estimated. This results a value of how much light arrive the mesh surface point corresponding to the pixel. Thus we get a Translucent-AO map. Before mapping the Translucent-AO map to the scene at final shading stage, we may have to filter the map (by bilateral filter) to remove noises.

Voxelization

We previously mentioned that the voxelization is necessary for the THAO, because G-buffer only contain surface information, by which it is insufficient to know whether an arbitrary point is inside or outside an object. In the THAO algorithm, we assume that the translucency (outcome light) form a surface point is related to the density distribution of the object surround it. Voxelization provides acceleration for fast testing the presence of solid object which is originally

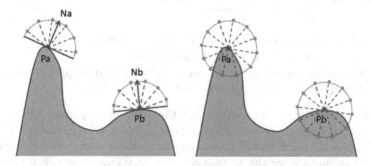

Fig. 2. Sample patterns of SSAO (left) and THAO (right). Using SSAO, we sample the positions distributed on the hemisphere directed by the surface normal. While in THAO, we sample on the whole sphere. So the two points Pa and Pb are both entirely illuminated in SSAO, while is THAO, the point Pa is more lightened than Pb because it is less occluded.

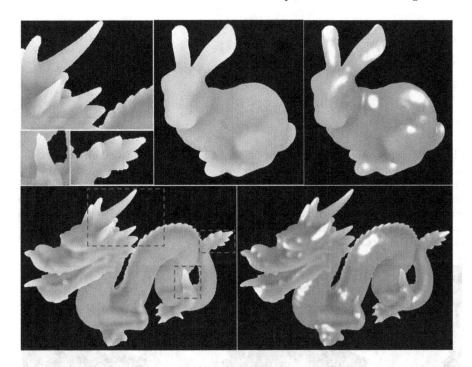

Fig. 3. Rendering translucent object using our THAO method. The Translucent-AO term is shown by left images, while right images are also include color and specular terms. Some close up images of thin parts of the dragon are shown at left-up. (Color figure online)

represented as triangle mesh. A voxelization method proposed by Eisemann and Decoret [19] can be used to voxelize the meshes on the fly.

4 Screen Space Hair Self Shadowing

The invention of SSAO makes it possible that the ambient occlusion calculation to be calculated in screen space. Different from SSAO for meshes, because complex hair models are usually represented as line segments, and the shading is calculated by tangent vectors rather than normal vectors, SSAO tends to be inappropriate for hair self-shadow. As case study, Fig. 4 shows the unideal result produced by default SSAO.

Hair is not totally opaque, according to the analysis by Marschner et al. [3], light penetrates hair and causes strong forward scattering that makes hair very bright at back-lit. SSAO is unable to handle this kind of transparency, however, our THAO can be used to handle this property. We sample the points around p on the whole sphere instead of hemisphere (see Figs. 2 and 5), and we also take the hair density around point p into account, which allows a light ray partially reach p even it is occluded by some hair fibers.

Fig. 4. We apply ordinary SSAO to the *blonde* hair model. Firstly we derive the normal map ((a) 2nd image) from the depth map ((a) 1st image), and then produce the AO map ((a) 3rd image). The AO map is too noisy, so we use Gaussian-Blur to filter it, but we still get an unideal spotty AO map ((a) 4th image). The (b) image shows the rendering of hair without/with SSAO. If you watch our appended video, you will notice that the AO map also frequently flickers caused by the unstable normal map when the view angle changes.

Fig. 5. The surface of hair volume will be rendered to G-Buffer. The point p corresponds to the current pixel we are processing. We take random points surrounding p both inside and outside the hair volume. We illustrate two sample methods here, the left is sampling on DOM, the right is on voxels.

To apply THAO to the hair rendering, we need to render hair surface position, depth, tangent and color to render targets. And during this step, the Z test is enabled and alpha blending is turned off to make sure that the hair line segments nearest to camera are finally rasterized into render targets. Then we can do the occlusion calculation in the defer shading stage. When we have generated some random points around a surface point, we also want to get the hair densities of these random points, then we calculate our self shadow term at p as:

$$A_p = \frac{1}{2\pi} \int_\Omega \rho(p, w) dw \qquad (1)$$

where the ρ is the hair density of certain surrounding point at direction w. Some result Translucent-AO maps are shown in Fig. 6. Next we will talk about two method to produce hair density map that we can use in the occlusion calculation. One is based on deep-opacity-maps and the other is by voxelization.

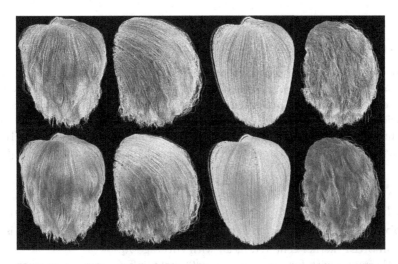

Fig. 6. Translucent-AO maps of different hair models produced by using our method. Images at up row are produced as DOM used for the density field, bottom ones are with voxelization.

Sampling on Deep-Opacity-Maps (DOM)

One DOM [7] consists of a depth map and several opacity maps. For our screen space self shadowing, we only need one DOM of hair rendered from view point, in which depth map is to store the depth value of nearest fragments from view point. Starting from this depth value, the hair volume is divided into K layers, densities of hair inside each layer are stored in corresponding opacity map. In our experiment, we construct the DOM with 7 layers. Because we have already recorded hair depth at first G-buffer pass. Only one additional pass is needed for generating the opacity maps. To correctly sample on the opacity map, we obtain the texcoord of the DOM from the view space position of the random occlusion-test sample, and then find the layer index by the z value of the sample point. Finally we get the density information from the destination pixel of an opacity map.

Sampling on Voxelized Hair Density Field

Sampling on voxelized hair volume data is more straight forward. We use a real-time voxelization method proposed by [20]. This method is a single pass GPU voxelization method using geometry shader and voxelizes hair line segments into density texture. Different from the voxelization of mesh, in which the voxel only contains a binary value, the voxelization method for hair provides full precision of storing hair density inside each voxel. So every time we get the position of a surrounding point. We lookup on the hair volume texture, fetch the density which will be used in the occlusion amount estimation.

5 Environment Lighting

5.1 SRBF and Shadow Path

Environment lighting is similar to ambient lighting that light comes from all directions, but usually environment lighting is more complex on light color and intensity, commonly presented by a skybox. Following [13], to get a low-dimensional representation of environment lighting, we approximate the environment lighting by a set of spherical radial basis functions (SRBFs) [12]. To get the $L(\omega_i)$ which gives the intensity of an incident light at direction ω_i. We have

$$L(\omega_i) \approx \sum_j LjG(\omega_i, \omega_j, \lambda_j) \tag{2}$$

where Lj is the intensity of samples of environment lighting, j is the index of each pixel on the environment map. $G(\omega_i, \omega_j, \lambda_i) = exp(-\frac{[cos^{-1}(\omega_i \cdot \omega_j)]^2}{2\lambda_i^2})$ is the Gaussian SRBF kernel centered at ω_i with coverage λ_i.

Furthermore, with forward scattering [9], light suffers from attenuation while penetrating the hair fibers. Hair fibers with darker self-shadow receive less light, it can be approximated by transmittance estimation [21]. $T(x, \omega_i)$ represents the transmittance of a point x in the incident direction generated by the hair volume, given by

$$T(x, \omega_i) \approx \prod_{k=1}^{n} exp(-\kappa\tau(x_k, \omega_i)) \tag{3}$$

where κ is an user-control absorb factor, $\tau(x_k, \omega_i)$ are the hair densities located on the light path to x. x_k are the samples taken from the volume along the path. These paths are also called *shadow paths*. To estimate the transmittance, Ren et al. [13] build Deep Opacity Depth Maps (DODM) for each light, and the DODM is nearly the same as DOM except the additional associated depth information.

We get the radiance of hair segments x along the viewing direction ω_o by

$$I(\omega_o) \approx \sum_i T(x, \omega_i)S(t, \omega_i, \omega_o)L(\omega_i) \tag{4}$$

where t is the tangent direction and S is the scattering function from Kajiya-kay or Marschner model.

5.2 Ray Casting Algorithm

We tried using multiple DOM as mentioned in [13] to estimate self shadow. However we found, voxelization based self shadow is more fast. Once we have voxelized the hair, we will fetch density data on shadow paths. A straightforward implementation is using ray casting. Amanatides and Woo [22] proposed a fast voxel traversal algorithm for ray tracing. We use this algorithm for the voxel traversal on the shadow paths. Concretely, for the calculation of Eq. (3), we start from a certain voxel and trace against a light direction. By traversing through all the cells (voxels) intersected with the light ray, we can accumulate the light absorption to get the amount of transmittance on the initial voxel.

5.3 Environment Lighting Coupled with Screen Space Self Shadow

We are going to use our THAO method to approximate the shadow path effect under environment lighting. Instead of full ray casting described in Sect. 5.2, THAO only samples the points nearly surround the hair surface. And the samples are now not randomly taken but on every shadow paths. Accordingly we change Eq. (4) to:

$$I(\omega_o) \approx \sum_i \rho(x, \omega_i) S(t, \omega_i, \omega_o) L(\omega_i) \tag{5}$$

where ρ is the hair density. This treatment is based on an assumption that light attenuates rapidly along a shadow path. Thus we apply our method by sampling only one density value on each shadow path ω_i which is located near the surface point x. And basing on the density on that point, we estimate the proportion of light accesses the surface point. From Fig. 1, we find that even sampling only one point each direction produces similar result as sampling all the voxels on the shadow path.

6 Implementation and Results

We implement our algorithm by GLSL on an AMD Radeon HD 7770. Table 1 shows how many frames can be rendered per second (fps). The shading (self-shadow and BCSDF) in THAO is performed in screen space, while the shadings in both multi-DOM and ray casting are done in object space.

If certain method is based on voxelization, we list the test result as either voxelization is executed every frame or not in brackets. The resolutions of voxelization for hair are all of 64^3, and for mesh is of 144^3. We use 36 SRBFs to approximate the environment lighting, which is calculated during pre-computation. Also, the multi-DOM are rendered from 36 SRBF directions (same as [13] mentioned, the DOMs are rendered with simplified geometry). And similarly, ray casting, THAO-DOM and THAO-voxelized also perform self-shadowing calculation on

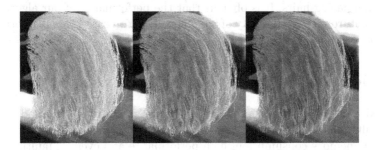

Fig. 7. Rendering hair model *natural* under environment lighting using our screen space method (voxelization based). Absorb parameter increases from left to right.

Table 1. Frames per second hair rendered under environment lighting using different techniques. If voxelization is required, we list the result in brackets that rendering hair with voxelization executed every frame, and those without brackets are by only performing voxelization at initialization and no longer repeated every frame.

Hair model/line segments	Multi-DOM	Ray casting	THAO-DOM	THAO-voxelized
Blonde/67741	2.95	9.03 (9.71)	78.9	61.2 (137.8)
Natural/151105	1.71	6.6 (7.54)	70.0	38.8 (118.3)
wCurly/339933	0.54	3.88 (4.65)	21.7	18.7 (81.85)

the 36 SRBF directions. Taking more samples makes self shadow smoother. In Fig. 6 and left image of Fig. 8, we take 14 samples, in Figs. 1, 7 and right image of Fig. 8, we take 36 samples on the SRBF directions.

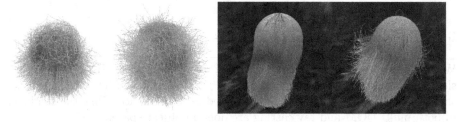

Fig. 8. Screen shots of animated hair rendered by our method under pure white sky light (left) and environment lighting (right).

Both DOM and voxel are uncomplicated GPU data structure, but the voxel is spatially more uniform. So the result by voxelization based screen space self shadowing is smoother and less twinkled than DOM based one. But they are both better than SSAO (comparing Figs. 6 to 4). Figure 8 is an example for shading animating hairs. It is obvious that the performance of our algorithm is independent from the complexity of hair geometry. You can get more information in our video.

7 Conclusion

Benefited by the simplification of the calculation domain, our method achieves a global illumination approximation that satisfies the requirements of dynamic lights, low memory consumption, high performance and even on multiplatform. Thus it can be used in high quality rendering for complex hair geometry at low cost.

Our method makes good approximation on self shadow considering translucency of hair. To approximate light attenuation though semi-transparent hairs,

our self shadowing method samples the local density field in deferred lighting stage, and the necessary density field of hair is also produced in real-time and can be done either by deep-opacity-maps or voxelization. Use the same method, we can achieve translucent object rendering on screen space (Fig. 3).

We made an assumption that light attenuates quickly inside the object, so the algorithm results only local translucency, meanwhile it can not handle highly transparent object. Another limitation is that it is actually a kind of deferred shading, some semi-transparent rendering techniques like Per-Pixel Linked Lists can not be combined with our method.

For future work, we would like to try adaptive sampling, and include treatment of light refraction in our algorithm.

Acknowledgments. We are grateful to Cem Yuksel for on his website the hair model files provided. We also thank for the Stanford 3D scanning repository for the bunny and dragon models.

References

1. Ducheneaut, N., Wen, M.-H., Yee, N., Wadley, G.: Body and mind: a study of avatar personalization in three virtual worlds. In: Proceedings of 27th International Conference on Human Factors in Computing Systems, pp. 1151–1160 (2009)
2. Kajiya, J., Kay, T.: Rendering fur with three dimensional textures. In: Proceedings of 16th Annual Conference on Computer Graphics and Interactive Techniques (SIGGRAPH 1989), vol. 23, pp. 271–280 (1989)
3. Marschner, S.R., Jensen, H.W., Cammarano, M., Worley, S., Hanrahan, P.: Light scattering from human hair fibers. ACM Trans. Graph. **22**(3), 780–791 (2003)
4. Lokovic, T., Veach, E.: Deep shadow maps. In: Proceedings of ACM SIGGRAPH, pp. 385–392 (2000)
5. Mertens, T., Kautz, J., Bekaert, P., Van Reeth, F.: A self-shadow algorithm for dynamic hair using density clustering. In: SIGGRAPH 2004 Sketches, vol. 44 (2004)
6. Bertails, F., Menier, C., Cani, M.P.: A practical self-shadowing algorithm for interactive hair animation. In: Graphics Interface, pp. 71–78, May 2005
7. Yuksel, C., Keyser, J.: Deep opacity maps. CG Forum **27**(2), 675–680 (2008)
8. Sintorn, E., Assarsson, U.: Hair self shadowing and transparency depth ordering using occupancy maps. In: Proceedings of Interactive 3D Graphics and Games (I3D), pp. 157–162 (2008)
9. Zinke, A., Yuksel, C., Weber, A., Keyser, J.: Dual scattering approximation for fast multiple scattering in hair. ACM Trans. Graph. **27**(3), 1–10 (2008)
10. Miller, G.: Efficient algorithm for local and global accessibility shading. In: SIGGRAPH 1994: Proceedings of 21st Annual Conference on Computer Graphics and Interactive Techniques, pp. 319–326, ACM, New York (1994)
11. Bavoil, L., Sainz, M.: Screen-space ambient occlusion. Technical report, Nvidia Corporation (2008)
12. Tsai, Y.-T., Shih, Z.-C.: All-frequency precomputed radiance transfer using spherical radial basis functions and clustered tensor approximation. ACM Trans. Graph. **25**(3), 967–976 (2006)
13. Ren, Z., Zhou, K., Li, T., Hua, W., Guo, B.: Interactive hair rendering under environment lighting. ACM Trans. Graph. **29**(4), 55:1–55:8 (2010)

14. Xing, X., Dobashi, T., Yamamoto, T., Katsura, Y., Anjyo, K.: Real-time rendering of animated hair under dynamic, low-frequency environmental lighting. In: Proceedings of Virtual Reality Continuum and Its Application in Industry (VRCAI 2012), pp. 43–46 (2012)
15. Reinbothe, C.K., Boubekeur, T., Alexa, M.: Hybrid ambient occlusion. In: Eurographics 2009, Annex (Areas Papers), pp. 51–57 (2009)
16. Bunnell, M.: GPU Gems 2 - Dynamic Ambient Occlusion and Indirect Lighting, pp. 223–233. Addison-Wesley, Boston (2005). Chap. 14
17. Hoberock, J., Jia, Y.: GPU Gems 3 - High-Quality Ambient Occlusion, pp. 239–274. Addison-Wesley, Boston (2007). Chap. 12
18. Mendez-Feliu, A., Sbert, M.: Obscurances in general environments. Graphicon (2006)
19. Eisemann, E., Decoret, X.: Fast scene voxelization and applications. In: Symposium on Interactive 3D Graphics and Games (I3D), pp. 71–78 (2006)
20. Zhang, Z., Morishima, S.: Application friendly voxelization on gpu by geometry splitting. In: Christie, M., Li, T.-Y. (eds.) SG 2014. LNCS, vol. 8698, pp. 112–120. Springer, Heidelberg (2014). doi:10.1007/978-3-319-11650-1_10
21. Yu, X., Yang, J.C., Yu, J.: A framework for rendering complex scattering effects on hair. In: Proceedings of Interactive 3D Graphics and Games (I3D), pp. 111–118 (2012)
22. Amanatids, J., Woo, A.: A fast voxel traversal algorithm for ray tracing. In: Proceedings of Eurographics 1987, pp. 3–10 (1987)

Optimizing Aesthetic-Based Photo Retargeting

Damon Shing-Min Liu[✉] and Chi-Cheng Huang

Department of Computer Science, National Chung Cheng University,
Chiayi, Taiwan
damon@computer.org, hccl01m@cs.ccu.edu.tw

Abstract. Photography is an art based on light. Modern cameras have auto exposure and auto focus functions, so that we can easily take photos with right exposure and focus setting. However, a nice photo depends not only on light used, its composition is also an important factor. We therefore exploit the state-of-the-art retargeting technique to automatically adjust photos for conforming the aesthetic composition. Our approach can use suitable retargeting techniques, and coordinate the composition of original photos to make photos conform the aesthetic rules. The photo types in our system particularly apply to *group photo*. To the best of our knowledge, this part has not been explored in existing literature. We analyze the common rules of composition, and propose the rules applied to suit group photos. Besides, the photos are adjusted based on the human face. We believe that using the development of our research, everyone can take an ideal photo.

Keywords: Computational aesthetics · Photography · Composition · Photo editing · Photo retargeting

1 Introduction

To take an ideal photo, we need to accumulate experience. The basic requirement is to learn the use of light. With the development of camera, using the built-in mechanisms can automatically calculate many parameters' values in the general environment, for example, we can get the correct exposure and clearly focused photos that do not need to set the parameters ourselves. However, to take an ideal photo, we must also consider the aesthetic composition of the photo that represents the sense of harmoniousness in a photo. As long as scene on the photo is harmonious then it is an ideal composition. Fortunately, there are some common rules, such as *rule of third*, can be used for photo composition. But cameras cannot automatically determine the aesthetics of composition rules, the general public would be intuitive to place object of interest in the middle. Sometimes, however, this approach is not an ideal composition.

Retargeting technique is used to change the resolution of images or video so that it can be presented in different screen size, and the position of the object is also changed in the process. Some studies use this behavior to adjust the position of subject in the photo, so that the composition changes. The difference is that traditional retargeting considers not the position of the subject but the resolution of image; however, aesthetic-based retargeting aims to perform some processing in order to change the position of the subject. Therefore, under the premise of retaining the character of the

© Springer International Publishing AG 2017
Y. Chen et al. (Eds.): SG 2015, LNCS 9317, pp. 41–60, 2017.
DOI: 10.1007/978-3-319-53838-9_4

photo, how to change the composition of a photo is a challenge. Most present studies do not focus on consumer photos consisting of many people, they usually consider the photos of nature or a single person. Nevertheless, for the consumer photos, there is usually more than one person in the photo. Moreover, some studies would change the size of photo in retargeting; sometimes it is not ideal. Therefore, how we adjust the composition of photo is a challenge when increasing the number of characters and retaining the size of original photo. We must analyze the picture framing, character location and other information in the photo to identify the most appropriate set of compound method for aesthetic-based retargeting, making the system more flexible for beautifying photos. For that purpose our research explicitly defines the use of set of rules for composition. Then, using our system, general users can easily get a perfect photo, even if they may not have a good composition concept.

2 Related Work

We introduce common image retargeting approaches that change the size of image, and the state-of-the-art aesthetic-based approaches that change the composition of photo. Subsequently we review related works and discuss advantages and disadvantages of those methods.

2.1 Image Retargeting

Image retargeting operators usually include cropping, scaling, seam carving, and warping. Seam carving [1] is a content-aware image resizing method. In it, image shrinking width by one pixel is achieved by removing one vertical seam, while shrinking height by one pixel is achieved by removing one horizontal seam. Avidan and Shamir proposed a gradient energy function to calculate the energy of each pixel, and defined the vertical and horizontal seams in the image. The optimal seam can be found using dynamic programming that calculates the minimum value of the sum of the previous phase energy. Then it goes onwards to get the status of minimum energy, and obtains the best seam. Rubinstein et al. [2] combined seam carving with cropping and scaling, which controls automatically the three operators and finds the best results. They calculated the difference between the source image and the retargeted image in similar pixels, and determined the best result of the sample. Then, using the current best results to perform different operators, they found the best path that can get the distribution between the three operators. Wolf et al. [3] proposed a retargeting approach by warping. They computed saliency score using gradient magnitude, face detection and motion detection. The approach usually has to deal with video streaming, so that they used motion detection. In recent years, the related research applies toward the development of videos.

2.2 Aesthetic-Based Retargeting

Santella et al. [4] used segmentation and eye tracking to choose a better cropping from the collection. Yan et al. [5] proposed a method of change-based cropping. They used

manually-cropped photos by three expert photographers to ascertain how to remove distracting content and enhance the composition. Cropping often can get an ideal photo quickly, but we have to remove a lot of data that are not ensured to be unimportant. Nowadays more and more studies are using compound operator to enhance photos. Liu et al. [6] proposed a crop-and-retarget approach to optimize photo composition. Jin et al. [7] proposed a crop-and-warp based approach to change image composition. Note that warping needs triangular meshes that indicate important regions. If the regions were not well defined, the result would be distorted. Guo et al. [8] proposed an approach to optimize photo composition with minimal distortions. They used seam carving approach that carves out less noticeable seams and inserted the same number of seams, thereby maintaining the image size and aspect ratio, however, using only seam carving would be limited by the space in the photo background during the adjustment process. Zhang et al. [9] proposed an approach to optimize photo composition aesthetics by rearranging subject's location. The subject is relocated to optimal positions on the complete background. It can break space constraints; nevertheless, the background line cannot be moved.

The state-of-the-art approaches often use certain combination of compound operator for retargeting, because using a single operator to adjust the photo the result would be limited in some cases. Cropping method sometimes cuts off objects that might be important. Warping needs more precise position of the subject than seam carving does. On the other hand, seam carving can retain more important regions than cropping does, and image completion can break space constraints. Consequently we choose *seam carving* as the main operator, along with *image completion* to serve as our compound operator.

3 Overview

To adjust a photo composition there are issues need to be addressed: How to get the subjects? How to modify the photo? How to evaluate the composition aesthetics? In this section we describe the proposed algorithm (see Fig. 1). First, we need to get the photo's intrinsic information. One of the most important information is the position of the faces, which always catches our eyes more than other elements do. Saliency map and segmented image help us to find the importance regions. Face line is used to represent the relationship of the crowd; we can also use this information to derive a significant line as baseline of the photo. Using rule-based composition and the aforementioned information we can derive the optimal positions and optimal operators for retargeting photo to improve its composition. Among the many candidate results in retargeting, we can obtain a good one by computing their aesthetic scores. Whenever an aesthetic score is greater than the threshold (T) in the process, we get a feasible result. If there is not anyone with a score greater than T, the one with highest score is the optimal one. The rule for composition is the rule of use before retargeting. After a series of judgments (see Fig. 2), we know how to perform the retargeting. In Sect. 4, we describe composition guidelines, pre-processing, and aesthetic computation. In Sect. 5, we discuss aesthetics-based photo editing, and show rule-based compositions in Sect. 6.

Fig. 1. Flowchart.

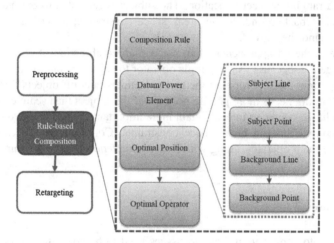

Fig. 2. Rule-based compositions.

4 Aesthetic Measurement

Our approach is based on compound operator, using different retargeting operation with different contexts of composition rules, and chooses the best aesthetic composition, allowing the system to get maximal flexibility.

4.1 Aesthetic Composition Guidelines

Before conducting this study, photo composition knowledge is indispensable. We reviewed the photography books [10] on composition. Composition usually can balance the screen, causing the viewer feel harmony. Even if there is no particularly compelling subject on the frame, a photographer taking a photo using different composition could yield considerably different results. The basic composition rules can be divided into point rules, line rules, and shape rules. We describe the representative of

composition rule such as Rule-of-thirds and Diagonal dominance. *Rule-of-thirds* is commonly used in photo. It simply affects highlight of subject of shooting. As long as there is a sense of weight on the bottom of the screen, it makes photos stabile and balanced. This rule belongs to a point and line rule. *Diagonal dominance*, on the other hand, allows viewer to experience a sense of tension, and imparts a dynamic sense. Whenever letting the subject place on the diagonal line, we can get the aforementioned effects. This rule belongs to a line rule. Shape composition does not belong to a rule of location, so that we do not consider it here. Currently we only use two compositions, i.e., Rule-of-thirds and Diagonal dominance, in our research. However, those two composition rules already include all the factors in line and point rules; in a similar way, we can easily add other new rules into our system if needed.

4.2 Pre-processing

Before improving the composition of photo, we need to acquire composition knowledge and the position of visual elements (e.g., people, line, or others). We use [11] to find the location of the faces, obtaining a saliency map by [12], and segmenting the image [13]. Combining these information we can calculate more accurate salient region using the saliency map as a mask to compute with segmented image, as shown in Fig. 3. Then, we use Hough Transform to find out prominent lines of the background. There are two kinds of prominent lines we consider here: (1) a diagonal of the subject: We use the saliency map to get the shape of the region, and use the elliptic approximation to calculate the longer axis and angle of the ellipse of the region. After obtaining the angle, we can determine whether the salient region is presented as a diagonal line (see Fig. 4); (2) a line with faces: It happens frequently in group photos if we assign the center of each face as a reference point, we can cluster those points using hierarchical clustering method, at the same time we set the height of face as a maximum range. Therefore people are considered as standing in the same row if area of their face lies within the range. Finally, by calculating the approximation line with clustered points, we can compute the number of row of people appearing in the photo (see Fig. 5).

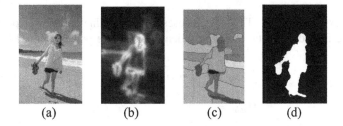

(a) (b) (c) (d)

Fig. 3. Salient region. (a) Original photo [14]. (b) Saliency map. (c) Segment map. (d) Subject mask.

Fig. 4. Long axis of ellipse [15]. **Fig. 5.** Face lines [15].

4.3 Aesthetic Score Computation

There may be several ways for performing retargeting. We need to choose the one resulting from optimal retargeting using aesthetic score. In this section, we present an approach to evaluate aesthetic quality based on photo composition rules, with reference from [6, 15].

Aesthetic score: The aesthetic score function is defined as a combination of three individual scores:

$$Score = \omega_C Composition + \omega_R Retarget + \omega_Q Quality \qquad (1)$$

where $\omega_C = 0.75$, $\omega_R = 0.05$ and $\omega_Q = 0.2$. "Composition" is composition score; "Retarget" is cost for retargeting; "Quality" is quality of retargeted photo. We combine these three scores so that scores are more consistent with our needs.

Composition score (C): According to the rules of composition used to develop individual formulas. The score has three parts, including Rule-of-thirds (C_{RT}), Diagonal dominance (C_{DL}) and Salient size (C_{SZ}):

$$C = (1 - \omega_{SZ}) \frac{\omega_{RT} C_{RT} + \omega_{DL} C_{DL}}{\omega_{RT} + \omega_{DL}} + \omega_{SZ} C_{SZ} \qquad (2)$$

where $\omega_{RT} = 1$, $\omega_{DL} = 1$ and $\omega_{SZ} = 0.08$. If there is not any diagonal in the photo, the $\omega_{DL} = 0$.

Rule-of-thirds score (C_{RT}): This rule focuses on power line and power point, so we calculate the Euclidean distance of the salient point to the power point ($P_1 \sim P_4$):

$$D_{point} = e^{-\left(\frac{\min_{i=1,2,3,4}\{|P'_{face} - P_i|\}}{\min_{i=1,2,3,4}\{|P_{face} - P_i|\}} \right)} \qquad (3)$$

where P_i is power point of Rule-of-thirds, and P_{face} is the location of face. We calculate the Euclidean distance of P_{face} to P_i, and find the shortest distance, then, calculating the Euclidean distance of P'_{face} to P_i. If distance of P'_{face} to P_i is zero, the score is 1 (max).

The *line score* is calculated as:

$$D_{line} = e^{-\left(\frac{\min_{i=1,2,3,4}\{|L'_{saliency}-L_i|\}}{\min_{i=1,2,3,4}\{|L_{saliency}-L_i|\}}\right)} \tag{4}$$

where $L_{saliency}$ is the prominent line, L_i is the power line. Line score and point score have the same concept. Then, we combine line and point, the Rule-of-thirds score can be defined as:

$$C_{RT} = \omega_p D_{point} + \omega_l D_{line} \tag{5}$$

where $\omega_p = 0.5$ and $\omega_l = 0.5$.

Diagonal dominance score (C_{DL}): The calculating approach is similarly to D_{line} of Rule-of-thirds which is defined as:

$$C_{DL} = e^{-\left(\frac{\min_{i=1,2,3,4}\{|L'_{subject}-L_i|\}}{\min_{i=1,2,3,4}\{|L_{subject}-L_i|\}}\right)} \tag{6}$$

Salient-region size score (C_{SZ}): Different subject size would affect the quality of a photo. Liu et al. [6] counted more than 200 professional photos, and there are three peak values in 10%, 56% and 82% of the photo area. The salient-region size score is defined as:

$$C_{SZ} = \frac{1}{i}\sum_i \max_{j=1,2,3} e^{-\frac{(r(S_i)-r_j)^2}{2\tau_j}} \tag{7}$$

where r_j is three peak values (0.1, 0.56, and 0.82). τ_j is regulatory parameters (0.07, 0.2, and 0.16) for Gaussian function.

Retarget score (R): We compute the cost for retargeting which is defined as:

$$R = 1 - \sum \omega_T \frac{D_{lose}}{D_{total}} \tag{8}$$

where D_{lose} is number of removed data, D_{total} is number of total. ω_T is weight for different technologies. All the ω_T is shown in Table 1. No data is really lost in increased seams. The seam is calculated using the interpolation method so the weight is 0.5. Scaling is using interpolation so we set the weight to 0.5. Because Completion fills the mask of subject and Matting separates foreground and background, we assume the weight as 0.5.

Table 1. Weight of retarget.

Technologies	Weight
Remove seams	1
Insert seams	0.5
Scaling	0.5
Completion	0.5
Matting	0.5

Quality score (Q): Evaluate the difference between retargeted photo and original photo. The purpose is to get the balance between the photo composition and quality. The score has two parts:

$$Q = \omega_{ss} CWSSIM + \omega_{cls} Closeness \tag{9}$$

where $\omega_{ss} = 0.5$ and $\omega_{cls} = 0.5$.

CWSSIM score: Structural Similarity Index for measuring image quality is a common method. It is based on luminance, contrast and structure. Concept of CW-SSIM [16] is that image distortions making the change of consistent phase in the local wavelet coefficients, and the image's structure is not changed in consistent phase shift of the coefficients. It fits rotations and translations:

$$\tilde{s}(c_x, c_y) = \frac{2\left|\sum_{i=1}^{N} c_{x,i} c_{y,i}^{*}\right| + K}{\sum_{i=1}^{N} \left|c_{x,i}\right|^2 + \sum_{i=1}^{N} \left|c_{y,i}\right|^2 + K} \tag{10}$$

where c_x and c_y are the two sets of coefficients extracted in the same wavelet sub-bands of the two images. The c^* is the complex conjugate of and K is a small positive constant. If c_x and c_y are the same image, the score is 1 (max).

Closeness score: It is a social relationship [15] that tells the relationship of people in the photo. We use the average face distance with minimum spanning tree to represent closeness score, and the connected weighted graph is found by Kruskal's algorithm. The score is:

$$Closeness = e^{-\frac{|aw' - aw|}{aw}} \tag{11}$$

where aw is the average distance for original photo, and aw' is the average distance for retargeted photo.

5 Aesthetic-Based Photo Editing

In the section, we start to present our approaches for photo editing. There are four combinations of retarget operators.

Operator 1, Seam Carving: We use insertion and removal of seams [1, 8], and the procedure is shown in Fig. 6. We aim to move the person right. In Fig. 6(a), the photo can be edited except the intermediate region which has been protected, and the arrow is the direction that we want to move. In (b) and (e), the region uses insertion seams, and the region uses removal seams in (c) and (d). After four steps, the subject moves to the power point (P_2) in rule-of-thirds shown in Fig. 6(e). If the aesthetic scores are greater than 0.8, we do not use other operator.

 Operator 2, Seam Carving and Scaling: If there are not enough space for retargeting, we can use Seam carving and Scaling. In Fig. 7(a), there are no space

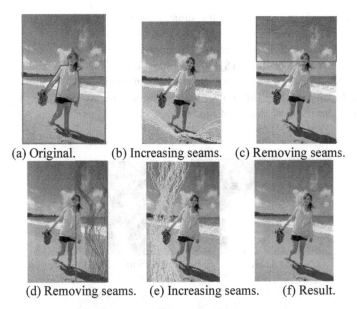

(a) Original. (b) Increasing seams. (c) Removing seams.

(d) Removing seams. (e) Increasing seams. (f) Result.

Fig. 6. Operator 1: Seam carving.

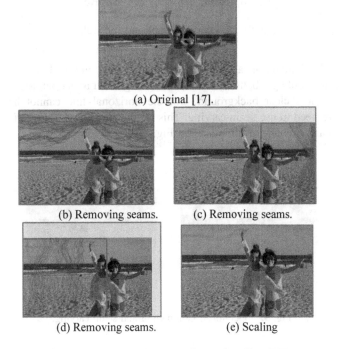

(a) Original [17].

(b) Removing seams. (c) Removing seams.

(d) Removing seams. (e) Scaling

Fig. 7. Operator 2: Seam carving and scaling [17].

(background region) to move below the subject for operator 1. Using removing seams ((b), (c), and (d)), we can get the retargeted result (e).

Operator 3, Completion and Scaling: This operator is also used when there are not enough space. We use matting [18] to get subject mask (Fig. 8(b)), and the trimap is necessary data for matting. Then, we use completion technique [19, 20] to fill the void (Fig. 8(c)). Finally, scaling the subject with required size, we compose the subject to background. The result is shown in Fig. 8(d).

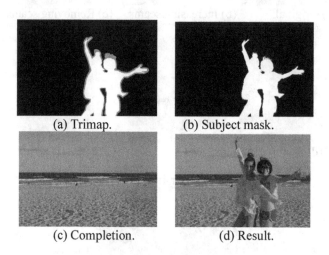

(a) Trimap. (b) Subject mask.

(c) Completion. (d) Result.

Fig. 8. Operator 3: Completion and scaling.

Operator 4, Completion and Seam Carving: If we combined Seam carving and Completion, we could get better results on the background than operator 3. After using Matting, we got a clear background. But the horizontal line cannot be moved by operator 3, we need to use seam carving. This results are shown in Fig. 9(a). Then, the background can be changed differently in Fig. 9(b).

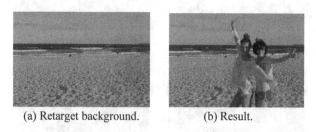

(a) Retarget background. (b) Result.

Fig. 9. Operator 4: Completion and seam carving.

6 Rule-Based Compositions

This section describes how to use the pre-processed data to compute the optimal position and operator. First, we need to decide which composition rules to be used, and choose a prominent element (i.e., line or point) as the datum element. If there are more than one prominent element, we use the following order of vision elements to decide the optimal position: (1) Subject line; (2) Subject point; (3) Background line; (4) Background point. Finally, calculating the distance between datum element and power element, we can know the optimal operation for retargeting, as shown in Fig. 2.

6.1 Determine Composition Rule

There are just a few simple steps to determine. Because there are clear characteristics with composition rule, they are not confused with each other. Sometimes, rule-of-thirds and diagonal dominance can be used together in a photo. If there is a diagonal line on subject or background (considering line of subject first), we use diagonal dominance and rule-of-thirds. If those rules cannot be applied concurrently, we consider diagonal rule first.

6.2 Determine Datum Element and Power Element

If there are more than one prominent element (line or point), we need to define an order to apply the rules. The order of element: (1) Subject line. Diagonal line first, and then straight lines (i.e., horizontal or vertical); (2) Subject point; (3) Background line. Diagonal line first, and then straight lines; (4) Background point. Then, we describe four cases of photo: (a) Dispersed subjects and different power elements; (b) Dispersed subjects and the same power element; (c) Indivisible subject and the same power element; (d) Indivisible subject and different power elements.

(a) *Dispersed subjects and different power elements*: This is the simplest case, and we do not need to choose datum element additionally. By aforementioned order, we can get the datum element. For example, there are three elements (two diagonal line and one point) in Fig. 10. First, we chose the subject line of two diagonal lines. Second, we chose face point (subject point). Finally, we chose the background line of two diagonal lines. In Fig. 11 [21], there are two people and no diagonal lines. Their face points correspond to different power points so we use face points as the datum points. There is a dependence relationship between objects in Fig. 11. If the distance between soccer and characters is changed, the relationship between them would be affected. We use the mask by preprocessing and manual line to ensure the dependence relationship. Therefore, the soccer and people could move together.

(b) *Dispersed subjects and the same power element*: In Fig. 12 [15], the two face points correspond to the same power point, but we cannot place the two points on the same location of power point. We need to decide the only datum point so we use the centroid of two face points as the datum point in this case.

(c) *Indivisible subject and the same power element*: We illustrate the case using Fig. 7(a). There are two people in the photo, and we get the face line by pre-processing. If the length of face line is less than one-third of width (for whole photo), we use the center of the line as datum point, instead of using face line as the datum line. If we place the people, whose length of face line is more than one-third of photo's width, on the power point, the frame of photo would not be balanced. In Fig. 13, the approximation line of all face points is diagonal. By the previous order, line of subject has the highest priority so that we use the diagonal line as the datum line. In Fig. 14, we find the row with the most people (1st row, seven people). If the row in front of 1st row occludes the 1st row, we will re-compute an approximation line across all face points in two rows, and take this line as a datum line.

(d) *Indivisible subject and the different power elements*: Sometimes, we cannot suffice all power elements in some photos. In Fig. 15, two face lines correspond to the different power line, and the numbers of people in two rows are the same. We cannot use the two lines together because the six people cannot be separated. In this case, we only choose the datum line that is closest to the power line. In Fig. 16, face lines correspond to the different power lines. The top row is the closest to the power line so we use the line as a datum line. In the photo, we also choose a datum point that is the centroid of subject because we want the photo to suffice the composition of visual balance [6].

Fig. 10. Order of vision elements [14].

Fig. 11. Dependence relationship [21].

Fig. 12. Two face points and one power point [15].

Fig. 13. Diagonal line [15].

Fig. 14. Datum line.

Fig. 15. Two face lines [15].

Fig. 16. Retargeted photo [15].

6.3 Optimal Operation

The last step, we must know how to use retargeting techniques. In operator 1, if we know the distance between datum element and power element, we can know how to operate. In operator 2, operator 3, and operator 4, we need an additional calculation. In Fig. 7, we want the datum point move to power point. Because of no enough space, the operator 1 cannot suffice the purpose and we use operator 2. Then, we compute the distance which is the shortest between datum element and power element for operator 2. Finally, we use the top space to calculate how many seams must be removed or inserted on the left or right space.

To retain the size of original photo, we remove N ($-$height/3 < N < height/3) seams on top space and remove the corresponding proportion of seams on the right and left space. First, we can get the shortest distance by removing top (76) seams and right (114) seams. But there is not enough space on the right space (47 seams). After removing (47) seams on the right, we calculated once again. We need to remove top (91) seams and left (137) seams to get the minimum distance. Deducting 47 seams previously removed, we get the optimal operation: First, we remove 91 seams on top space, then, remove 47 seams on right space, last, remove 90 seams on left space. This method that calculates the distance which is the shortest between datum element and power element can be applied to operator 3, and 4.

7 Validation and Results

We first discuss the user studies. After that, we evaluate the results by aesthetic score. At last, we show more results from our system.

7.1 User Study

We used two user studies to evaluate the performance of our approach. We prepare 30 pairs of photos each pair includes one original photo and one our result. The photo sets are composed of personal photos and photos with more than two people. We invite 13 participants, most of them have no expertise in photography, and their ages are from 20 to 30.

Part 1: They are asked to select the more appealing composition in each pair of photos. We randomly order the pair of photos, and we also randomly place our result on right or left. Besides, we do not tell them what composition rules we use in the photos. There are average 80.1% of our results which is chosen by the people (see Table 2). This means that 80.1% of photos are judged to be improved on aesthetic quality by our approach.

Table 2. Preference shown in user study, Part 1.

Original	Our result
19.9%	80.1%

Part 2: We reference [22] and design a questionnaire. We want to explore the reasons why our results were not chosen. We showed the pairs of photos that participants did not choose our result in Part 1, and told them that which are original photos and which are our results. Then, we also asked them to choose which of the following factors concern you in the result. The factors include: (1) People or foreground objects are deformed; (2) Prominent lines (e.g., horizontal, vertical, or diagonal line) are distorted; (3) Contents are removed or cut-off; (4) I dislike the change of proportions of objects; (5) The idea or topic is not clear in photo; (6) Nonspecific reasons. The original photo is more appealing; (7) Similar; (8) Others.

There are three purposes in the questionnaire. (1) The defect that can be seen by eyes, e.g., object is deformed. (2) Aesthetics theme, e.g., proportions of objects. (3) Intuition factors, e.g., similar. The result of survey shows in Fig. 17. The y-axis represents the times of that factor was chosen. The factor 3, factor 4, and factor 7 of the questionnaire were chosen by most people. The state-of-the-art saliency detection is unable to find all the important areas so that we might remove some contents that need be retained (see Fig. 18). Due to this reason, people chose factor 3. Although we use salient-region size score [6] to evaluate the aesthetic quality of subject with different size, we cannot get the precise size of saliency region so that we get a deviation in the score (see Fig. 19). Consequently, they chose factor 4. There are two reasons why they chose factor 7. Some original photos have conformed composition rules, and some original photos are mainly composed of people so that we cannot recompose the photo casually (see Fig. 20).

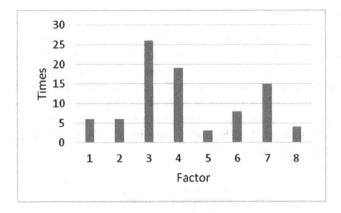

Fig. 17. Distribution of result of user study, Part 2.

Fig. 18. Factor 3. Left: Original [15]. Right: Ours.

Fig. 19. Factor 4. Left: Original [15]. Right: Ours.

Fig. 20. Factor 7. Left: Original [15]. Right: Ours.

7.2 Results

We evaluate the results by aesthetic score. In Fig. 21, there are two people in the photo. First, we use operator 1 to modify the photo resulting in Fig. 21(b), and getting the aesthetic score 0.60 (Table 3). Then, we use operator 2 to modify the photo (Fig. 21(c)) and get the aesthetic score 0.84 (Table 3). The score is greater than the threshold (we set 0.8 in experiments) so we get a feasible result (Fig. 21(c)). The most difference between (b) and (c) is composition score which means that (c) is more consistent with composition rules than (b). And the aesthetic quality of (c) is judged to be improved by most people in previous user study.

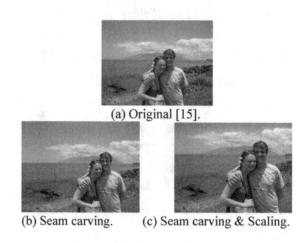

(a) Original [15].

(b) Seam carving. (c) Seam carving & Scaling.

Fig. 21. Operator 1 & Operator 2.

Table 3. Aesthetic score. (Corresponding to Fig. 21)

	Composition	Retarget	Quality	Total
(b)	0.56	0.84	0.72	0.60
(c)	0.92	0.54	0.65	0.84

There are two people in the photo (Fig. 22(a)). We use operator 1 to 4 to modify the photo (shown in Fig. 22(b) to (e)), and select the highest aesthetic score (Table 4). The composition score of (c) and (e) are higher than (b) and (d), but the retargeting and quality score are slightly lower than (b) and (d). The (b) and (d) are limited to the lower half of the space so that they cannot move to the specified location. The aesthetic score of (e) is higher than (c) so the (e) is the optimal result. In fact, the aesthetic quality of (e) is judged to be improved by most people in previous user study so this result explains that our system can help users to get an optimal composition photo.

Finally, we compare some results with Liu et al. [6]. In Fig. 23(c), Liu's result is limited by space, but we use completion technique to break space constraints (see Fig. 23(e)). If we want the tree to be foreground, we can use dependence relationship

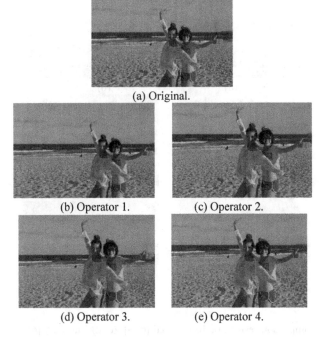

(a) Original.

(b) Operator 1. (c) Operator 2.

(d) Operator 3. (e) Operator 4.

Fig. 22. Retargeted photo.

Table 4. Aesthetic score. (Corresponding to Fig. 22)

	Composition	Retarget	Quality	Total
(b)	0.46	0.93	0.92	0.57
(c)	0.78	0.58	0.76	0.77
(d)	0.51	0.80	0.77	0.58
(e)	0.80	0.71	0.77	0.79

(in Sect. 6.2) to achieve the goal. In Fig. 23(d) and (f), our result shows better composition than Liu et al. [6].

7.3 Limitations

Our system still has some limitations. Sometimes, professional photographers may disobey our rules. They might apply other rules or skills, e.g., *vanishing point* or *Depth-of-Field* (see Figs. 24 and 25). We might destroy the effect professional photographers produced after retargeting. If the photo is with too complicated background, there might be some defects in the result. Too complicated background cannot make salient algorithm find all important regions so that we might get a flawed result in retargeting. And the mutually occluded objects cannot make completion perfectly repair the mask.

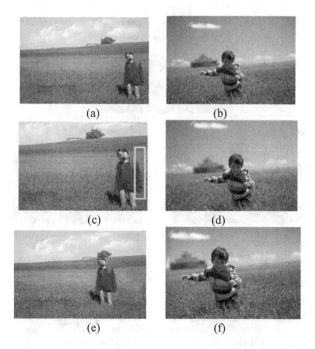

Fig. 23. Comparison results. (a, b) Original [6, 9]. (c, d) Liu et al. [6] (e, f) Ours.

Fig. 24. Depth-of-Field [14]. **Fig. 25.** Vanishing point [14].

8 Conclusion and Future Work

Many people may wonder why professional photographers can shoot beautiful photos. In addition to differences in the camera, the *composition* also plays a very important role. Therefore, in recent years there have been numerous researches that improve photo composition, but most of them do not focus on consumer photos with people. Our research here uses the theme as the core, with compound operator for aesthetic-based retargeting (seam carving, scaling, and completion), and identifies a set of rule-based compositions. We therefore can use a series of mechanism to allow group photographs or personal photographs to conform the aesthetic composition.

In the future, we will improve our rule-based composition system by making the process more flexible, for example, using machine learning mechanism, and reshaping

rules to be more close to professional photographer. Ultimately we like to improve performance, and enable the system to migrate to smart phones and embedded cameras.

References

1. Avidan, S., Shamir, A.: Seam carving for content-aware image resizing. ACM Trans. Graph. (TOG) **26**, 10 (2007)
2. Rubinstein, M., Shamir, A., Avidan, S.: Multi-operator media retargeting. ACM Trans. Graph. (TOG) **28**, 23 (2009)
3. Wolf, L., Guttmann, M., Cohen-Or, D.: Non-homogeneous content-driven video-retargeting. In: IEEE Conference on Computer Vision, pp. 1–6 (2007)
4. Santella, A., Agrawala, M., DeCarlo, D., Salesin, D., Cohen, M.: Gaze-based interaction for semi-automatic photo cropping. In: Proceedings of the ACM SIGCHI Conference on Human Factors in Computing Systems, pp. 771–780 (2006)
5. Yan, J., Lin, S., Bing Kang, S., Tang, X.: Learning the change for automatic image cropping. In: IEEE Conference on Computer Vision and Pattern Recognition (CVPR), pp. 971–978 (2013)
6. Liu, L., Chen, R., Wolf, L., Cohen-Or, D.: Optimizing photo composition. Comput. Graph. Forum **29**, 469–478 (2010)
7. Jin, Y., Qingbiao, W., Liu, L.: Aesthetic photo composition by optimal crop-and-warp. Comput. Graph. **36**(8), 955–965 (2012)
8. Guo, Y.W., Liu, M., Gu, T.T., Wang, W.P.: Improving photo composition elegantly: considering image similarity during composition optimization. Comput. Graph. Forum **31**, 2193–2202 (2012)
9. Zhang, F.-L., Wang, M., Hu, S.-M.: Aesthetic image enhancement by dependence-aware object re-composition. IEEE Trans. Multimedia **15**(7), 1480–1490 (2013)
10. Freeman, M.: The Photographer's Eye: Composition and Design for Better Digital Photos, vol. 1. Focal Press, Waltham (2007)
11. Viola, P., Jones, M.J.: Robust real-time face detection. Int. J. Comput. Vis. **57**(2), 137–154 (2004)
12. Goferman, S., Zelnik-Manor, L., Tal, A.: Context-aware saliency detection. IEEE Trans. Pattern Anal. Mach. Intell. **34**(10), 1915–1926 (2012)
13. Yang, A.Y., Wright, J., Ma, Y., Sastry, S.S.: Unsupervised segmentation of natural images via lossy data compression. Comput. Vis. Image Underst. **110**(2), 121–225 (2008)
14. Wing-man. Flickr wing-man kenting (2014). https://www.flickr.com/photos/wingmanzero/sets/
15. Li, C., Gallagher, A., Loui, A.C., Chen, T.: Aesthetic quality assessment of consumer photos with faces. In: IEEE International Conference on Image Processing (ICIP), pp. 3221–3224 (2010)
16. Sampat, M.P., Wang, Z., Gupta, S., Bovik, A.C., Markey, M.K.: Complex wavelet structural similarity: a new image similarity index. IEEE Trans. Image Process. **18**(11), 2385–2401 (2009)
17. Cai, S.-Y.: Ctitv.com (2013). http://tw.photo.chinayes.com/img2/2013/06/28/201402131016356261528.jpg
18. Zheng, Y., Kambhamettu, C.: Learning based digital matting. In: IEEE International Conference on Computer Vision, pp. 889–896 (2009)

19. Korman, S., Avidan, S.: Coherency sensitive hashing. In: IEEE International Conference on Computer Vision (ICCV), pp. 1607–1614 (2011)
20. Criminisi, A., Perez, P., Toyama, K.: Object removal by exemplar-based inpainting. In: Proceedings of the IEEE Computer Vision and Pattern Recognition (CVPR) (2003)
21. icpress.cn. china.com (2014). http://sports.china.com/2014/pics/11155328/20140702/1860 2494.html
22. Rubinstein, M., Gutierrez, D., Sorkine, O., Shamir, A.: A comparative study of image retargeting. ACM Trans. Graph. (TOG) **29**, 160 (2010)

Sketching and Visualization

InvisiShapes: A Recognition System for Sketched 3D Primitives in Continuous Interaction Spaces

Paul Taele(✉) and Tracy Hammond

Sketch Recognition Lab, Texas A&M University, College Station, TX 77840, USA
{ptaele,hammond}@cse.tamu.edu
http://srl.tamu.edu

Abstract. Continued improvements and rising ubiquity in touchscreen and motion-sensing technologies enable users to leverage mid-air input modalities for intelligent surface sketching into the third dimension. However, existing approaches largely either focus on constrained 3D gesture sets, require specialized hardware setups, or do not deviate beyond surface sketching assumptions. We present InvisiShapes, a recognition system for users to sketch 3D geometric primitives in continuous interaction spaces that explore surfaces and mid-air environments. Our system leverages a collection of sketch and gesture recognition techniques and heuristics and takes advantage of easily accessible computing hardware for users to incorporate depth to their sketches. From our interaction study and user evaluations, we observed that our system successfully accomplishes strong recognition and intuitive interaction capabilities on collected sketch+motion data and interactive sketching scenarios, respectively.

Keywords: Sketch recognition · Gesture recognition · Continuous interaction spaces · 3d drawing · Mid-air interaction

1 Introduction

Designing intelligent user interfaces for automatically recognizing digital sketches have conventionally focused on sketches made on physical surfaces, and we can see this ranging from the traditional interactions of a stylus contacting pen-enabled monitors, to the ubiquitous interactions of a finger contacting a smartphone screen, and even to the emerging interactions of several fingers contacting the surface of large tabletop displays. However, the relatively recent trend of commercially-available motion-sensing hardware devices continues to shift the landscape of how people interact with computing devices. These trends can be seen from previous mainstream commercial hardware devices such as the wand-based controls of the Nintendo's Wii or the far-field motion-sensing controls of Microsoft's Kinect, to more recent releases of near-field motion-sensing devices such as Leap Motion's namesake sensor or Creative's Senz3D. Therefore, users are no longer restricted to interactions such as sketching made on physical computing surfaces, but can further broaden these interactions either continuously or disjointly into mid-air using motion-sensing hardware devices.

© Springer International Publishing AG 2017
Y. Chen et al. (Eds.): SG 2015, LNCS 9317, pp. 63–74, 2017.
DOI: 10.1007/978-3-319-53838-9_5

As these motion-sensing hardware devices are experiencing growing reliability, shrinking form factors, and wider ubiquity, researchers and developers can tap into these resources and explore the design of intelligent spatial sketch user interfaces to recognize sketches other than solely from the established settings of familiar touchscreens. These interfaces can take advantage of expanding sketching interactions beyond current surface interaction spaces for a variety of applications, and into novel interaction spaces that continuously extend from surfaces (i.e., continuous interaction spaces [9]). Sketching scenarios in continuous interaction spaces can therefore motivate both realized and potential applications, whether it is rapidly prototyping or representing entities in design and planning, quickly creating artifacts for gaming or immersive environments, more intuitively drawing three-dimensional concepts, or so on.

However, adapting intelligent user interfaces for spatial sketching interactions first involves seriously considering the challenges inherent with motion-sensing technologies distinct from conventional pen- and touch-enabled computing devices. These challenges include but are not limited to: determining appropriate non-surface sketching analogs to surface sketching, addressing imprecise motion-sensing sensors compared to touch display sensors, discovering optimal domain contexts that naturally benefit from the use of a third spatial dimension, and accommodating non-surface sketching factors that are unique to working in continuous interaction spaces [15]. Furthermore, prior research have little explored intelligent user interfaces specific to spatial sketches. Previous works for surface interaction spaces are constrained by solely surface sketching assumptions [14], existing works for mid-air interaction spaces focus on command gestures that have limited gesture vocabularies [12], and current works for continuous interaction spaces focus instead on other forms of interactions such as selection (e.g., [11]) and modeling (e.g., [3]).

In this paper, we therefore describe our approach that adapts existing recognition approaches from the sketch and gesture recognition research field, and leverages existing technologies with commercial motion-sensing hardware for recognizing freehand sketched 3D geometric primitives in continuous interaction spaces, with the hope that such an approach allows people to intuitively extend the expressiveness of their surface sketches and without resorting to mode switching (e.g., selectable menu options). We developed this approach by taking advantage of corner-finding and primitive geometric shape recognition techniques from the sketch recognition field, and then adapting them to continuous interaction spaces that utilizes a conventional touch-enabled surface display (e.g., notebook computer screen) and a lightweight motion-sensing hardware device (e.g., Leap Motion sensor). From evaluating our approach for a set of 3D geometric primitives, we discovered that users were able to intuitively draw automatically-recognized primitives with reasonable accuracy.

2 Related Work

2.1 Surface Interaction Spaces

Various directions for automatically recognizing sketches from the surface sketch recognition community have focused on addressing the challenges of recognizing raw digital surface ink strokes at different levels. At the low-level stage, techniques such as IStraw [18] proposed processing the raw strokes and segmenting out candidate corners within these strokes. The corner information is then used for the next recognition stage, where techniques such as PaleoSketch [10] and QuickDraw [2] rely on the segmented surface stroke information from corner-finding techniques in order to classify the original raw strokes into various simple and complex geometric shapes. Furthermore, top-level sketch recognition systems such as LADDER [4] can then take advantage of this combined information such as from primitive geometric shape classifiers to recognize fuller sketches. While these techniques perform very well for sketches made on surfaces interaction spaces, they are also constrained to surface sketching assumptions and do not account for the diverse challenges of recognizing noisier sketches with different sketching behaviors beyond surface interaction spaces [14].

2.2 Continuous Interaction Spaces

Research work for designing interfaces that explored continuous interaction spaces – or interaction spaces that occur both on and above surfaces [9] – have taken advantage of different types of computing input devices at both the on-surface and above-surface level. Work by [13] introduced the idea early on for mid-air selection and movement operations using a tabletop display augmented by a digital pen recording mid-air spatial positions. As tabletop display systems became more sophisticated, researchers began exploring continuous interaction spaces that adopted more diverse forms of interaction. For example, work by [9] described broadening the possible input modalities to include multi-touch and tangible objects, work by [11] provided more refined guidelines for previous explored interaction tasks, and work by [3] expanded interaction tasks using a system called Mockup Builder to include sketch-based modeling of three-dimensional objects. While Mockup Builder enables users in continuous interaction spaces to model three-dimensional objects with a combination of gestures and motions in a spatial sketch user interface, our work differs by focusing on a recognition approach for automatically recognizing users' sketched 3D geometric primitives within an intelligent spatial sketch user interface.

2.3 Mid-Air Interaction Spaces

With continuing improvements made to commercial motion-sensing technologies and growing shifts of natural user interfaces, researchers have strongly capitalized on existing surface gesture recognition techniques, and then adapting

them to automatically understand motion gestures performed in mid-air inter-action spaces. For example, $3 [6, 7] provide mid-air analogs to Dollar recognizers (e.g., [1]), while [5, 8] further improve upon the lessons from prior mid-air motion gesture recognition techniques. However, due to the limited vocabularies of mid-air motion gesture recognition techniques [12], and since the gesture sets are generally minor 3D variants of flat 2D gestures, they are not optimal approaches for recognizing the greater complexity of 3D geometric primitives.

3 Interaction Methodology

In order to develop a system that is able to classify users' interactions of sketched 3D primitives, it is important to better understand how users would produce them in continuous interaction spaces with accessible commercial hardware devices such as touch-enabled screens and inexpensive motion-sensors. There-fore, we first conducted a short-term interaction study that involved observing users informally demonstrating such interactions offline, and then taking insights from their interactions to produce a representative list of both 3D geometric primitives to classify and also corresponding interactive cues to draw them in a continuous interaction space.

Table 1. A representative list of the 3D geometric primitives that InvisiShapes can classify that were derived from the interaction study. The shape name is the real-world label presented to users, the formal term is its geometric label, and the surface, transition, and mid-air classes refer to the components that the geometric primitive is composed of.

Shape name	Formal term	Surface	Transition	Mid-air
Path	Horizontal line	Path	Click	Empty
Pole	Vertical line	Dot	Tip	Empty
Wall	Vertical plane	Path	Flat	Equal
Cone	Cone	Ellipse	Tip	Empty
HalfCone	Ellipse frustum	Ellipse	Flat	Greater
Cylinder	Cylinder	Ellipse	Flat	Equal
Bowl	Reverse ellipse frustum	Ellipse	Flat	Lesser
Pyramid	Pyramid	Quadrilateral	Tip	Empty
HalfPyramid	Rectangle frustum	Quadrilateral	Flat	Greater
Box	Cuboid	Quadrilateral	Flat	Equal
Pan	Reverse rectangle frustum	Quadrilateral	Flat	Lesser

3.1 Interaction Study

We initially recruited a group of nine participants – two females – from ages 18 to 33 years, all of whom self-reported strong experience using touch-enabled devices, and ranged from average to strong familiarity with motion-sensing devices. The study participants were told that they would be individually taking part in an interaction study that involved demonstrating how to create various 3D geometric shapes on a surface space. We further expanded our explanation by having the participants assume that their demonstrated interactions of these shapes would later be understood by a touchscreen and external camera.

After introducing the scenario to the participants, we then sat them at a table and provided the participants with both a pen to draw on paper and a touch-enabled notebook computer to draw on a basic drawing application, in order to act out their roles in the described scenario. Once the participants communicated to us that they understood their scenario, we verbally prompted the users to demonstrate a list of different geometric primitive shapes conventionally found in geometry math textbooks and computer graphic applications.

Summarizing our general observations of the user participants, we discovered that the participants came to a consensus on how they demonstrated drawing the 3D geometric primitives. The participants first drew the intended shape base of the verbally-prompted shape on the flat surface (e.g., on paper or touch-screen display), then extended away from the completed sketched base, and lastly expressed the depth of the shape in mid-air before connecting their pen and finger on paper and screen, respectively, on the edge of the shape's sketched base. We observed that the participants' demonstrated motions align with similar interactions from prior systems based in continuous interaction spaces (e.g., [3]) and is supported by generalized drawing behaviors of shapes in other domains from the cognitive psychology (e.g., [16]).

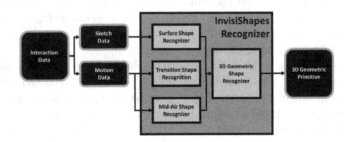

Fig. 1. A generalized system overview of the InvisiShapes recognition system.

3.2 Interaction Process

From the insights of our interaction study, as well as the lessons from the interaction cues of related interactive systems and the observational findings of related

cognitive psychology works, we first derived a representative list of eleven geo-metric shape primitives (Table 1) that also happen to be analogs in 3D to most of the eight geometric shape primitives found in surface geometric shape primitive recognizer PaleoSketch [10].

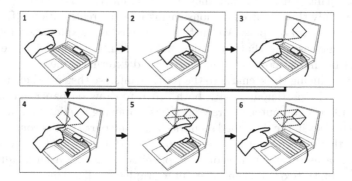

Fig. 2. A visual representation of the user's interactive steps with their finger to draw a tall cuboid using a touch-enabled notebook computer screen and an accompanying Leap Motion sensor device: the user is (1) about to draw the primitive, (2) drawing the primitive's surface base, (3) extends out from the surface base, (4) draws the corresponding mid-air base, (5) motions towards to tap screen to complete the sketch, and (6) hovers away from the completed drawing.

We additionally derived a series of interactive steps for users to draw these primitives in continuous interaction spaces (Fig. 2). Our particular interaction setup combines stylus or touch strokes that are visualized on a display monitor, and then viewed as a visualized cursor during mid-air interactions. We also normalized the motion-sensed coordinates to the display screen coordinates by offsetting them relative to the most recent position recorded from the surface sketch point, so that the user can see a cursor indicating where their mid-air stylus or finger relative to the display.

In regards to the primitives list, we briefly elaborate on three notable omis-sions: freeform shapes, non-quadrilateral polygons, and sphere-based primitives. For the first group of freeform shapes, our recognition system can trivially label these shapes as non-geometric primitives. For the second group of non-quadrilateral polygons, our system can trivially recognize them in the same process that is used to recognize quadrilaterals, but we chose to not list them in the paper for brevity. For the third group of sphere-based primitives, we dis-covered from our interaction study that participants had difficulty in coming to a consensus on how to demonstrate sketching them, so we omit these primitives from our initial list and discuss potential directions near the end of the paper.

4 Recognition Methodology

The InvisiShapes recognition system builds upon a variety of sketch and gesture recognition techniques and heuristics to classify the diverse types of components that construct the 3D geometric primitives (Fig. 1). The system takes in the user's interaction data that is composed of both the sketch data performed on a touchscreen made by either stylus or finger, and also the motion data performed in the air on a motion-sensing device that extends from the sketch. The sketch and motion data are subsequently sent to their respective recognizers before combining their results to a final recognizer that outputs the most likely 3D geometric primitive.

4.1 Surface Sketch Recognition

The surface sketch recognizer was designed for data produced from touch or stylus input, and relies on corner segmentation information from IStraw [18] and individual surface sketch shape tests and closed shapedness derived from various sketch recognition techniques such as PaleoSketch [10] and ShortStraw [17] to classify the surface sketch (Fig. 3).

Elliptical Base **Rectangular Base** **Path Base**

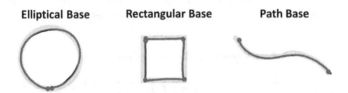

Fig. 3. Examples of surface bases that users sketched of different geometric primitives that were segmented with IStraw and classified with various surface sketch recognition techniques (L-R): the elliptical base of a sketched square with two detected corners, the rectangular base of a sketched square with five detected corners, and the path base of a sketched curve with two detected corners.

Path sketches consist of either polylines or curvilinear lines that form either path or wall shapes, and these sketches rely solely on identified endpoints not demonstrating closed shapedness.

Dot sketches consist of pole shapes and require merely a tap on the screen. These sketches are defined by their bounding box not exceeding a small area threshold (i.e., 100 pixels squared).

Ellipse sketches follow the ellipse test from PaleoSketch in that they must contain at most three corners and closed shapedness. Then, the two furthest points are first located from the stroke, and then rotated by the opposite of the angle that is formed from the line between these endpoints. Afterwards, the smaller value between the ellipse stroke's path length and the Ramanujan approximation of the ideal circumference length is divided from the larger value to form a ratio that must exceed a certain threshold (i.e., 0.9).

Polygon sketches similar follow polygon tests from PaleoSketch in that they must contain $n+1$ corners, where n is the number of vertices in the polygon, and closed shapeness. Then, a line test is performed between each segmented corner, where the ratio of the line's path length and ideal line length is calculated and must exceed a certain threshold (i.e., 0.9).

4.2 Transition Motion Recognition

Identifying the shape of both bases of the user's interaction data is crucial to determine the type of 3D geometric primitive it forms. However, due to the noisy nature of current commercially available motion-sensing devices, it is challenging to separate what part of the motion data is the base itself and what part is the transition to the base. As a result, the motion data is classified from two different recognizers. The first is the transition motion recognizer, which identifies whether the base potentially exists initially, and then determines whether it is tipped (e.g., pyramids or cones) or flat (e.g., cylinders, cuboids, frustums).

A useful feature of the motion data to help identify the type of transition of the motion data is from how the z-axis motion is graphed with respective to the number of points (Fig. 4). We empirically observed that the smaller the mid-air base, the more steep the curve is formed from the z-axis motion. As a result, we first calculate the angle of the left and right lines formed from the endpoints to the peak of the graph, and then average the two angles.

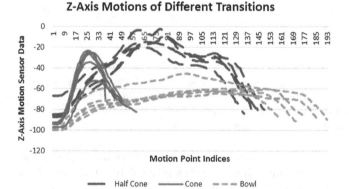

Fig. 4. A plot of z-axis motions from the Leap Motion sensor device for a subset of motioned 3D geometric primitives, where shapes with smaller mid-air bases contain fewer collected points and steeper overall slopes.

For tip motions, we classify them if their averaged angles exceed a certain threshold (i.e., $60°$). Contrary to tip motions, flat motions are classified as such if their averaged angles do not exceed the tip motion's angle threshold requirement.

A special case of the bases involve clicks, which are rapid clicks that form for shapes that are not 3D such as paths in order to denote the lack of depth. If

the area of the motion does not exceed a certain area threshold (i.e., 1000 stroke pixels squared from a Leap Motion sensor), then it is classified as a click motion.

4.3 Mid-Air Motion Recognition

In conjunction with the information received from the transition motion recognizer, we can finally classify the mid-air base of the demonstrated 3D geometric primitive. We first trim the tails that form from the motion data due to the unintentional surface sketch noise produced as the user transitions from the surface sketch base to the intended mid-air base. We empirically set the trimming of the tails to the first and last 10% of the motion stroke, since we empirically observed that this adequately approximates the users' intended motioned mid-air base. Due to the noisiness of the motion data, we also define the mid-air base by first resampling both the sketch and motion strokes so that they have the same number of points, and then compare the ratio of points within each stroke's bounding box (Fig. 5).

Fig. 5. Examples of sketched and motioned data strokes of shapes with varying mid-air bases, where the dotted gray lines represents the surface stroke and the solid black lines represent their corresponding mid-air stroke. The two frustums visually demonstrate surface stroke points that lie either completely or dominantly inside or outside the bounding box of their corresponding mid-air stroke. For geometric primitives with congruent bases, points from their surface and mid-air strokes more frequently overlap each others' bounding boxes.

With geometric primitives that consist of congruent sketched and motioned bases, we take the bounding boxes of both bases and compare the ratio of number of points of the sketched base to the motioned base and vice versa. If the greater and lesser ratios do not exceed certain thresholds (i.e., 0.9 and 0.1, respectively), we then classify the mid-air motion as equal to the surface base.

For the larger mid-air base, we classify the motion as greater if the ratio of sketched points within the motioned point's bounding box exceeds 0.9. On the other hand, we perform the opposite ratio test for lesser motions representing a larger surface base, where the motioned points contained within the sketched points' bounding box must exceed 0.9. However, for shapes that do not have bases, such as those that are tipped or clicked, we rely on the transition shape information to automatically classify their motions as empty.

4.4 3D Geometric Shape Recognition

Once the sketch and motion data are processed through their respective classifiers, the three labels of surface, transition, and mid-air that are generated from the classifiers are then sent to the final 3D geometric shape recognizer. We rely on the labels produced from Table 1 to then determine the interaction data's associated primitive type. If the interaction data's three labels do not fit appropriately to the list of surface, transition, and mid-air labels, we instead classify the primitive as a freeform shape.

5 Evaluation and Discussion

To evaluate our approach, we utilized a touch-enabled Wacom tablet and a Leap Motion sensor to record users' surface and mid-air sketching, respectively. Prior to performing our data collection, we performed a one-time calibration of the Leap Motion's motions to that of the screen dimensions of the tablet screen, and placed the Leap Motion in front of the screen lying within several inches directly from the tablet screen's center. We also ran these commercially-available hardware devices within their optimal interaction settings of a table setting in a normally-lit room.

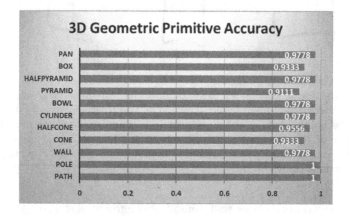

Fig. 6. Recognition accuracy of the different 3D geometric primitives using all-or-nothing classification.

For the data collection study, we recruited nine individuals – two females – between the ages of 25–35 years, all of whom self-reported some experience with motion-tracking controls from commercial video game systems but not from research-driven motion-tracking applications. Each user was provided instructions on the type of interactions that they were performing and the shapes that they were about to draw, but were not given specific instructions on how to draw the shapes. After allowing the users to spend at most five minutes to freely draw

in this continuous interaction space setup, they were then prompted to sketch five consecutive iterations of each shape listed in Fig. 1 for a total of 495 shapes. We then classified their sketched shapes with our approach using all-or-nothing accuracy Fig. 6, where shapes were considered as correctly classified if the user's actual input completely matched the expected label without exception.

From our approach, we demonstrate that users were able to successfully perform three-dimensional drawing of representative geometric primitives with reasonable accuracies, where accuracies for each shape did not fall below 90%. The most common types of mis-classifications came from users drawing bases that were either congruent for expected frustum shapes or not congruent for expected prisms or cylinders, or drawing mid-air bases that were not accurately detected from the motion sensor.

6 Conclusion and Future Work

In this paper, we describe our work on InvisiShapes, a 3D geometric primitive shape recognizer for continuous interaction spaces. From our evaluation, we demonstrate that not only were users able to intuitively sketch geometric primitives using commercially-available touchscreen and motion-sensing hardware, but also with their interaction data classified to their 3D geometric primitives from our recognition system with reasonable accuracy. From our current work's progress, we propose several potential future directions such as expanding our recognition system to incorporate more challenging 3D geometric primitives, developing appropriate spatial sketch user interfaces that take advantage of our recognition system for various domains, observing how users draw in more varied interaction scenarios, and expanding the recognizer to other motion-sensing hardware.

References

1. Anthony, L., Wobbrock, J.O.: $N-protractor: a fast and accurate multistroke recognizer. In: Proceedings of Graphics Interface 2012. Canadian Information Processing Society, Toronto (2012)
2. Cheema, S., Gulwani, S., LaViola, J.: QuickDraw: improving drawing experience for geometric diagrams. In: 2012 Proceedings of the SIGCHI Conference on Human Factors in Computing Systems. ACM, New York (2012)
3. De Araùjo, B.R., Casiez, G., Jorge, J.A.: Mockup builder: direct 3d modeling on and above the surface in a continuous interaction space. In: Proceedings of Graphics Interface 2012, pp. 173–180. Canadian Information Processing Society, Toronto (2012)
4. Hammond, T., Davis, R.: LADDER, a sketching language for user interface developers. Comput. Graph. **29**, 518–532 (2005)
5. Hoffman, M., Varcholik, P., LaViola Jr., J.J.: Breaking the status quo: improving 3D gesture recognition with spatially convenient input devices. In: Proceedings of the 2010 IEEE Virtual Reality Conference. IEEE Computer Society, Washington (2010)

6. Kratz, S., Rohs, M.: A $3 gesture recognizer: simple gesture recognition for devices equipped with 3D acceleration sensors In: Proceedings of the 15th International Conference on Intelligent User Interfaces. ACM, New York (2010)

7. Kratz, S., Rohs, M.: Protractor3D: a closed-form solution to rotation-invariant 3D gestures In: Proceedings of the 16th International Conference on Intelligent User Interfaces. ACM, New York (2011)

8. Kratz, S., Rohs, M., Essl, G.: Combining acceleration and gyroscope data for motion gesture recognition using classifiers with dimensionality constraints. In: Proceedings of the 18th International Conference on Intelligent User Interfaces. ACM, New York (2013)

9. Marquardt, N., Jota, R., Greenberg, S., Jorge, J.A.: The continuous interaction space: interaction techniques unifying touch and gesture on and above a digital surface. In: Campos, P., Graham, N., Jorge, J., Nunes, N., Palanque, P., Winckler, M. (eds.) INTERACT 2011. LNCS, vol. 6948, pp. 461–476. Springer, Heidelberg (2011). doi:10.1007/978-3-642-23765-2_32

10. Paulson, B., Hammond, T.: PaleoSketch: accurate primitive sketch recognition and beautification. In: Proceedings of the 13th International Conference on Intelligent User Interfaces, pp. 1–10. ACM, New York (2008)

11. Spindler, M., Martsch, M., Dachselt, R.: Going beyond the surface: studying multi-layer interaction above the tabletop. In: 2012 Proceedings of the SIGCHI Conference on Human Factors in Computing Systems, pp. 1277–1286. ACM, New York (2012)

12. Steins, C., Gustafson, S., Holz, C., Baudisch, P.: Imaginary devices: gesture-based interaction mimicking traditional input devices. In: Proceedings of the 15th International Conference on Human-Computer Interaction with Mobile Devices and Services, pp. 123–126. ACM, New York (2013)

13. Subramanian, S., Aliakseyeu, D., Lucero, A.: Multi-layer interaction for digital tables. In: Proceedings of the 19th Annual ACM Symposium on User Interface Software and Technology. ACM, New York (2006)

14. Taele, P., Hammond, T.: Initial approaches for extending sketch recognition to beyond-surface environments. In: Proceedings of the 2012 ACM Annual Conference Extended Abstracts on Human Factors in Computing Systems Extended Abstracts, pp. 2039–2044. ACM, New York (2012)

15. Taele, P., Hammond, T.: Developing sketch recognition and interaction techniques for intelligent surfaceless sketching user interfaces. In: Proceedings of the Companion Publication of the 19th International Conference on Intelligent User Interfaces, pp. 53–56. ACM, New York (2014)

16. van Sommers, P.: Drawing and Cognition: Descriptive and Experimental Studies of Graphic Production Processes. Cambridge University Press, Cambridge (1984)

17. Wolin, A., Eoff, B., Hammond, T.: ShortStraw: a simple and eective corner finder for polylines. In: Proceedings of the Fifth Eurographics Conference on Sketch-Based Interfaces and Modeling, pp. 33–40. ACM, New York (2008)

18. Xiong, Y., LaViola Jr., J.J.: A ShortStraw-based algorithm for corner finding in sketch-based interfaces. Comput. Graph. **34**(5), 513–527 (2010)

FloodSight: A Visual-Aided Floodlight Controller Extension for SDN Networks

Xi Chen$^{(\boxtimes)}$, Dongqi Guo, Wufangjie Ma, and Longhui He

School of Computer Science and Technology,
Southwest University for Nationalities, Chengdu 610041, China
cx@swun.edu.cn

Abstract. The Software Defined Networking (SDN) is considered as a primary evolutionary direction for the next generation networks. The OpenFlow protocol enabling SDN decouples the control plane from the data plane, thus complex controlling and management functions are able to be eliminated from switches, resulting in dumb switches with fewer layers and higher forwarding efficiency. Sophisticated controlling and management functions seen in traditional switches are moved to dedicated controllers in an SDN environment. Therefore, controllers play an important role in SDN. Floodlight is a widely used and most accepted controller, which offers a variety of useful functions. However, Floodlight lacks several key features needed in a simulation-oriented SDN environment, especially the GUI-aided configurations. To tackle there problems, we propose FloodSight (Floodlight with Sight) in this paper to assist network administrators and researchers to efficiently prototype and test an SDN network with visual support. FloodSight is a visual-aided Floodlight extension based on Floodlight's REST APIs. The current version of FloodSight consists of 3 major components: the QoS-aware Topology Viewer, the Topology Maker and the Flow Manager, which offer visual support for QoS-aware topology viewing, topology making and flow manipulation not seen in the original Floodlight controller. The experiments on the FloodSight show that it offers desirable features and feasible performance.

Keywords: SDN · OpenFlow · Floodlight · QoS · LLDP

1 Introduction

SDN (Software Defined Networking) [6] is nowadays a research hot spot in computer networks. It is commonly foreseen as an evolutionary direction for the next generation networks. An SDN empowered network controls and manages

This paper is supported by the Fundamental Research Funds for the Central Universities (Grant No. 2014NZYQN24), the Key Projects of the Education Department of Sichuan Province (Grant No. 15ZA0396) and the Undergraduate Training Programs for Innovation and Entrepreneurship (Grant No. X201510656115 and X201510656117).

© Springer International Publishing AG 2017
Y. Chen et al. (Eds.): SG 2015, LNCS 9317, pp. 75–86, 2017.
DOI: 10.1007/978-3-319-53838-9_6

switching devices in a centralized fashion with the southbound interface of the OpenFlow protocol through controllers, so that upper layer network services can be easily decoupled from the lower layer network devices. Due to the centralized control, the consistency of the configuration and the flexibility of the services can both be enhanced, compared with the traditional per-device configuration that is still dominantly used in the network arena. With the advantages offered by controllers mentioned above, controllers are a key factor for an SDN-enabled network.

Among others, Floodlight [1] is one of the most adopted SDN controllers seen in the SDN field. Although Floodlight provides powerful management and controlling functions for SDN, it lacks some key features needed in a simulation-oriented SDN environment, especially the GUI-aided configurations. For example, at present, the network topology designing in Floodlight is heavily relying on hand-written Python scripts, which is inconvenient and error-prone, requiring researchers and network administrators with the basic Python knowledge. It also lacks a convenient and intuitive method for flow table entry pushing from controllers to switches. The researchers and network administrators must be equipped with cURL and CLI (Command Line Interface, as opposed to GUI) knowledge to have flow table entry pushed down to switches. The last but not the least is the lack of QoS (Quality of Service) information gathering and rendering mechanisms in the Floodlight controller, therefore network administrators and researchers are not capable of making QoS-aware decisions due to the lack of QoS information. The aforementioned shortcomings at large reduce the usability of the Floodlight controller. These shortcomings remaining to be solved have made Floodlight less useful than expected in SDN configuration, managements and researches. To tackle these problems, in this paper, we propose FloodSight, aiming at providing various applicable extensions to enlarge and enhance Floodlights management and controlling functions for both administrative and research purposes.

The organization of this paper is as follows. Section 2 describes the motivations of our FloodSight extension; Sect. 3 specifies in details the 3 major components offered by FloodSight and their backend working principles; In Sect. 4 we carry out necessary experiments to demonstrate the features and performance offered by FloodSight. Section 5 gives the summary and next steps of our future research plan.

2 Motivations

Switches in SDN are all dumb devices [7], meaning that controlling and management functions such as routing, decision-making, etc., are all eliminated from switches (in the SDN terminology, the term "switch" means various forwarding devices including switches, routers, etc.). Switches now become pure forwarding devices. Therefore more efficient forwarding can be achieved in switching devices. In an SDN environment, complex controlling is implemented by software contained in controllers which requires higher intelligence (i.e. the control-plane),

and repeated forwarding is implemented by hardware contained in switches which requires higher efficiency (i.e. the data-plane). The interaction between controllers and switches are conducted through the secure OpenFlow [6] protocol.

Unlike traditional networks, an SDN controller can now flexibly design a network in a programmatic way by manipulating and combining various data-plane devices as basic building blocks, quite like invoking various modules and functions in software programming (and this is why it is named Software Defined Networking).

According to a survey conducted by the sdnap community [8], the adoption of Floodlight comprises over 40% of all controller usages. The popularity of Floodlight is originated from features such as follows:

- Cross-platform: Floodlight is designed and implemented using Java, which offers cross-platform feature and excellent portability.
- Powerful APIs: Floodlight offers APIs in two flavors: REST (REpresentational State Transfer) API [10] and Module API. REST APIs can be conveniently invoked through HTTP protocol whereas Module APIs are Java-encoded classes and interfaces conforming Floodlights underlying module framework.
- Extensible framework: Floodlights comes with various extensible classes and interfaces that developers can extend/implement to fulfill custom functionalities. The customized functionalities can be painlessly deployed to Floodlight and co-exist peacefully with pre-installed Floodlight modules, thanks to Floodlights module-loading system.

However, as we mentioned above, several key features are missing in Floodlight, especially in a simulation-based SDN environment.

- Verbose flow table manipulation: Floodlight does not offer GUI frontend to invoke its powerful REST APIs. One must be familiar with cURL for the invocation.
- Lack of "Drag and Drop" topology creation: In a simulation-oriented SDN environment, Floodlight usually works with the well-known Mininet [3,9] SDN simulator. Mininet relies on Python to describe the topology. One must be familiar with Python to deploy a topology to Mininet. However, Floodlight does not offer a GUI frontend for "Drag and Drop" topology creation.
- Lack of QoS gathering and rendering: Floodlight has a basic feature for topology rendering, merely displaying the network structure without rich auxiliary information. For some research-oriented SDN environment, researchers would need the feature for QoS gathering and rendering in the topology interface to assist QoS provisioning research. Unfortunately Floodlight lacks both.

3 System Designs and Architecture

To tackle problems faced with current version of Floodlight, we propose Flood-Sight (**Flood**light with **Sight**), to offer key missing features mentioned above. The FloodSight is a Floodlight extension, and its current version consists of several components:

3.1 The QoS-Aware Topology Viewer

The QoS-aware Topology Viewer, together with its backend supporting modules, is capable of QoS information gathering and QoS-aware topology rendering to assist QoS-related research. We first explain how the QoS information is collected by The QoS-aware Topology Viewer – the novel QoS over LLDP scheme.

QoS over LLDP. In standard SDN networks, controllers are aware of switches directly connected to them through bidirectional Hello messages in the standard OpenFlow protocol. However the underlying link states between switches (i.e., how switches are mutually connected) are not visible to controllers in the first place. That is to say in the initial stage of an SDN network, controllers do not have the topology knowledge of the whole SDN network. In order to perform centralized control over an SDN network, controllers must carry out topology discovery. Controllers usually use LLDP [5] (Link Layer Discovery Protocol) to fulfill such a task. LLDP is an IEEE proposed protocol widely used in network arena for topology discovery.

The controller instructs a switch to multicast the LLDP packet to all of its ports through a PacketOut (instructive packets from controllers to switches) [4]. In this PacketOut, topological information of the switch such as chassis information, port information, etc. is all contained. All other switches connected to this sender switch receive the LLDP packet, and then match this packet against the flow table entries of their own, only to find no matches for LLDP packets. Thus switches will send a PacketIn (packets from switches to controllers) containing this LLDP to the controller asking how to process this packet. Since the PacketIn contains topology information about both the sender switch and the receiver switch, the controller can now assert that there exist a link between the two switches based on the received PacketIn. By means of this iterative PacketIn/Out interaction, topology of the whole SDN network can be discovered by the centralized controller. This centralized topology discovery in SDN is quite different from how LLDP works in traditional networks where topology discovery is done by individual switches independently, although LLDP is used in both cases.

Standard LLDP packets usually contain basic information such as MAC address, chassis information, port information, etc. We can see from the above topology discovery phase, no QoS information is contained in LLDP packets. Should QoS information be incorporated, the QoS-aware topology discovery can be done to enable further QoS-aware decisions and policies, thus QoS provisioning becomes possible.

LLDP is a TLV (Type/Length/Value, i.e. key-value pair with length information) based protocol where TLVs are used for property descriptions. We can include QoS information as custom TLVs in LLDP packets. In this way, LLDP can be seen as the "ferry" containing QoS information (i.e. QoS over LLDP) and other useful properties as its payload. We define QoS TLV as follows.

In the TLV Type field, it must be designated as 127 to indicate this is a custom TLV. The Length field specifies the variable-length value contained in

TLV Type=127 (7 bits)	TLV Length (9 bits)	Organization Code (3 bytes)	Subtype (1 byte)	Value String (x bytes)

contains

Bandwidth (1 byte)	Availability (1 byte)	Drop Rate (1 byte)	Delay (1 byte)	Jitter (1 byte)

Fig. 1. QoS over LLDP

the TLV. The Organization Code field indicates the designer of this customized TLV. We use the Organization Code as 0x121212 for the time being. The Subtype field specifies the detailed type of the contained value. Value String field gives the real value. We contain various QoS properties in the Value String. In order for the receiver to conveniently parse the different QoS properties, we use the predefined property order and length. We can see from Fig. 1 several properties are included in fixed length in our current settings. Note that more properties can be included in the future work. The advantages from QoS over LLDP are obvious:

– Minor network traffic overhead: Since LLDP packets are spread around in the SDN network no matter whether the QoS information is included, QoS over LLDP will not cause much extra traffic to be sent in an SDN network. It merely adds several bytes for QoS description to the original LLDP packet. Compared with solutions sending self-contained custom packets containing QoS information, QoS over LLDP is quite cost-effective with regard to traffic overhead.
– Good suitability and minor source code modification: Any implementation of OpenFlow protocol includes modules for LLDP packets processing, thus QoS over LLDP can be conveniently accommodated in and ported to various controller environments not limited to Floodlight, although discussions in this paper are based on Floodlight. If there is no module found in the controller for QoS TLV processing, the worst case is merely the lack of QoS TLVs processing, but it will not cause any conflict with the controller's basic workflows since all controllers support LLDP processing. To support QoS over LLDP, we only need to add a module for QoS TLV processing so that the controller can fetch QoS information from custom TLVs. In this way, no fundamental source code modification is needed, thus no major processing overhead is caused.

With the QoS information of every switch at disposal, the controller is capable of adding visual-aided and QoS-aware extensions to the original Floodlight. Figure 2 (explained later) shows the interface of the implemented QoS-aware Topology Viewer component. The gains from the component includes:

– QoS status overview: FloodSight is capable of the depiction of the global and individual QoS status overview since it centralizes the scattered QoS information. When selecting individual devices, detailed QoS information is popped

up for deeper inspection. Meanwhile, overall QoS status can be leveraged for QoS-aware decision-making. It is also possible that different views with regard to different QoS properties (such as bandwidth, delay, jitter, etc.) can be shown for the current topology.

– QoS coloring: Different QoS levels for different QoS properties can be defined at the controller side. According to these QoS levels, various parts of the topology can be colored to indicate QoS status. In this way, the network administrator can carry out decision-making accordingly with regard to overall or individual QoS situations. Take the delay property for instance, we can conduct link coloring based on delays. For those links with low latency, green is designated; for links with fair latency, yellow is assigned; for high latency, red is used, quite like the traffic congestion indicator in the transportation system. Therefore for those delay-critical applications such as video streaming, intuitively, the network administrator can fine-tune the flow table to form a path with the minimal delay all the way along. Also, he can remove those flow table entries with high latency. Other QoS properties such as bandwidth etc. can also be used for link coloring in different application scenarios. Besides, not only links can be colored, but also the switches and their various ports. In this way, the network administrator can manage and control the SDN network in an intuitive manner by manipulating flow table entries manually, automatically or programmatically.

– Poor QoS alarming: QoS information can also be used for poor QoS situation alarming. If poor QoS situation beyond the threshold sustains for a predefined period, various alarming means can be made the most of as alerts. For example, if the drop rate of packets of a switch continues to be at a high level for several minutes, a sound can be played to inform the network administrator of this event. It is also possible this event can be pushed to his mobile device on the fly.

An example of QoS coloring is shown in Fig. 2. We first collect the QoS information by modifying LLDP processor source code to enable QoS gathering. Then in Fig. 2, we enable the link state coloring for delay property. As we can see in Fig. 2, among all the paths from h1 to h6, the path through s1-s2-s4 is comparatively better than s1-s3-s4 with regard to delay of links. The network administrator can accordingly carry out proactive pushes to switches that best fits users QoS criteria.

3.2 The Topology Maker

Mininet is the primary SDN simulation environment. Floodlight can play as a remote controller on the basis of a Mininet topology. Mininet topology relies on Python scripts for topology description, which is a barrier for researchers with little Python backgrounds. Floodlight also lacks a "Drag and Drop" style topology creation feature. Efficient prototyping of topology plays a key role in SDN research. Therefore we implement the "Drag and Drop" topology creation in our FloodSight as the Topology Maker, to accelerate the topology creation

Fig. 2. The QoS-aware Topology Viewer

and bridge the gap between Floodlight controller and Mininet simulation environment for topology deployment. Figure 3 reveals key features offered by the Topology Maker, including as follows.

- Drag and Drop topology editing: One can select different node type (i.e., switch, host, controller) to add an instance of it. Links can be easily created by dragging a line from a node to another. Illegal links are prevented at the GUI level, e.g., links between hosts are not allowed. Double-click on a node or a link removes the object being clicked. This feature relieves the need for Python backgrounds.
- One-Click topology generation: By pressing "Generate Topology" button, the Mininet-compatible topology script is generated for later use or direct deployment to Mininet (Fig. 3 left-bottom corner). Several versions of the topology can be saved without conflict with each other, which is especially useful for frequent topology modification and reuse.
- Customized topology deployment: By pressing "Deploy" button, the generated topology can be painlessly deployed to Mininet simulation environment without the user knowing Mininet commands. One can also specify various Mininet options before topology deployment (Fig. 3 left-top corner), for example to designate the switch type, MAC address specification, OpenFlow version, etc. This feature relieves the need for Mininet CLI backgrounds.
- QoS property assigning: Besides, QoS properties can be defined manually when selecting one node (Fig. 3 left-middle).

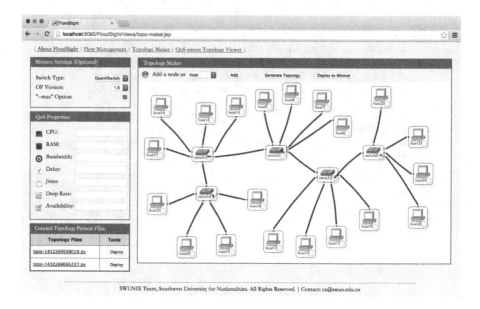

Fig. 3. The Topology Maker

– Parameterized topology template: A feature yet to be implemented is the parameterized topology template. For those frequently used topologies such as tree-like or hub topologies, we are planning to implement respective template which is able to consume user-fed parameters and then automatically generate topologies accordingly.

The topology Maker is able to create and generate topologies with hundreds of nodes as we can see from Fig. 3. The Topology Maker also reduces the verbosity of manual writing and topology deployment and let the researchers focus on their core researches rather than peripheral utilities.

3.3 The Flow Manager

The flow table is one of the main means for a controller to manage the whole SDN network since it indicates how traffic is directed from one node to another by means of flow matching. Floodlight offers the REST APIs for researchers to invoke for flow table manipulation such as adding, removing, modifying, listing, etc. But it lacks a convenient frontend for these APIs. One must use the cURL utility to make the most use of REST APIs. cURL is a command line based tool. When writing a flow table entry using command line, it is error-prone and tedious. We implement an intuitive flow table management in our FloodSight as the Flow Manager. It offers CRUD operations for flow table entry management. At the top (Fig. 4), there is an HTML form-based flow adding/modifying tool to reduce the complexity. In the middle, in case the offered flow form cannot fully

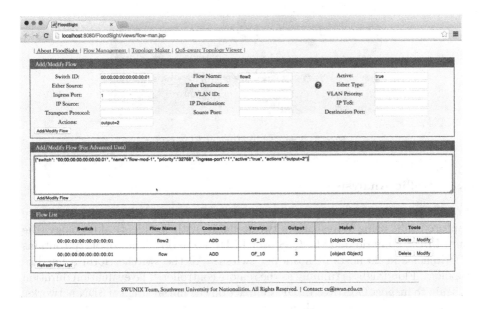

Fig. 4. The Flow Manager

meet the need when adding/modifying a flow, we maintain an editor-based flow adding/modifying tool. One can still use the editor to write extensive flow table entries to fulfill his/her specific need as he/she do with the traditional cURL. In the bottom, all flow table entries from various switches are shown in the list. One can also delete those entries not in need anymore from this list.

3.4 Architecture

The whole FloodSight system is implemented using Java Servlet as the backend core based on the Floodlight REST APIs, and jQuery and jsPlumb [2] as the frontend presentation layer, as a proof-of-concept in the simulation-based SDN environment. The overall architecture of FloodSight is shown in Fig. 5. At present, QoS Module in the architecture merely supports QoS information gathering through QoS over LLDP. More QoS related functions and algorithms will be added in the future.

4 Experiments

Experiments on traffic overhead of the QoS over LLDP scheme and QoS-aware topology rendering are carried out in the following experiment environment: MacBook Pro (Retina, 13-inch, Mid 2014), 2.6 GHz Intel Core i5, 8 GB 1600 MHz DDR3, Intel Iris 1536 MB and 256 GB SSD with OS X 10.10.3.

Fig. 5. The architecture of FloodSight

4.1 Traffic Analysis

In order to evaluate the impact on network traffic caused by QoS over LLDP, we capture traffic using Wireshark in two scenarios with the identical topology (the pure LLDP scenario and the QoS over LLDP scenario). The topology contains 5 switches and 20 hosts (4 hosts per switch). All the switches form a line-like topology. FloodSight is running as the remote controller. The evaluation duration is 3 min to inspect QoS over LLDP's impact on the initial stage of SDN networks. The evaluation results are shown in Table 1. In the QoS over LLDP scenario, LLDP packets contain the QoS TLV, thus the packet length (81 bytes) is longer than pure LLDP packets (63 bytes). We can see from the Organization Code (see Sect. 3.1) in the red square in Fig. 6, the QoS TLV is successfully contained in LLDP packets according to the Wireshark capture. It causes extra network overhead. However the percentages of LLDP bytes in both scenarios are almost the same (0.02%), meaning that QoS over LLDP does not deteriorate the network traffic performance. The experiment results indicate that QoS over LLDP is an applicable approach for QoS delivering in an SDN environment.

```
● ● ●                           Wireshark · Packet 2300 · paper-sg-qos-t

▶ Frame 2300: 81 bytes on wire (648 bits), 81 bytes captured (648 bits)
▶ Linux cooked capture
▼ Link Layer Discovery Protocol
  ▶ Chassis Subtype = MAC address, Id: 00:00:00:00:00:01
  ▶ Port Subtype = Port component, Id: 0003
  ▶ Time To Live = 120 sec
  ▶ Unknown – Unknown (0)
  ▼ Unknown – Unknown (1)
       1111 111. .... .... = TLV Type: Organization Specific (127)
       .... ...0 0001 0000 = TLV Length: 16
       Organization Unique Code: Unknown (0x121212)
       Unknown Subtype: 1
       Unknown Subtype Content: 00000000000000087868584
  ▶ Unknown TLV
  ▶ Unknown TLV
  ▶ End of LLDPDU
```

Fig. 6. Wireshark captures of QoS over LLDP

Table 1. QoS over LLDP performance

Scenario	Duration	Total packets	LLDP packets	Total bytes	LLDP bytes
Pure LLDP	180s	67279	476 (0.71%)	183633341	29988 (0.02%)
QoS over LLDP	180s	46208	476 (1.03%)	184223552	38556 (0.02%)

4.2 Topology Rendering Time

As aforementioned, the QoS-aware Topology reads the topology created in Mininet simulation environment and extra QoS information, then renders it in the browser. The topology rendering time varies accordingly with different topologies and QoS information. We generate random topologies with different sizes and link states to evaluate the topology rendering time, including transferring time between server side and browser side and the rendering time in the browser. The results are shown in Fig. 7. The x-axis represents the topology size indicated as switches/hosts pair, and the y-axis represents the rendering time in millisecond (including all the overhead time). We can see from Fig. 7 that the rendering of fairly complex topology (with over 30 switches and 180 hosts, and the out degree of every switch is 8) is still efficient, with approximately 4650 ms. The experiment demonstrates FloodSight's applicability in complex topology and QoS status rendering.

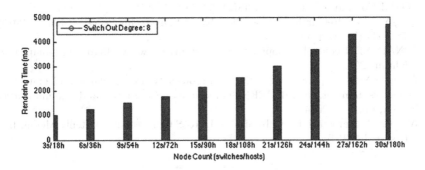

Fig. 7. Topology rendering time

5 Summary and Future Work

In this paper, we proposed and implemented a visual-aided Floodlight extension – the FloodSight – to tackle problems faced with the current Floodlight features, for simulation-oriented SDN environments. FloodSight consists of 3 major components (namely the Topology Maker, the QoS-aware Topology Viewer and the Flow Manager) for the time being. The experiment results show that Flood-Sight provides the missing features needed in the simulation-oriented SDN environment. It is capable of accelerating the research process, especially in quick

topology prototyping, QoS gathering, QoS-aware topology rendering, etc. In our future research plan, we are planning on backend algorithms, especially those for QoS provisioning. Since in this paper we have implemented applicable approaches for QoS collection from different switches, we envision an adapted K-Shortest Path algorithm with regard to various QoS properties in the backend to support QoS provisioning for some specific property or the aggregated QoS status.

Acknowledgement. The authors thank the members of SWUNIX (**S**outh**W**est **U**niversity for **N**ationalities **N**etwork **I**nnovation e**X**ercises) team for their efforts and devotion in system development of FloodSight.

References

1. Floodlight. http://www.projectfloodlight.org
2. jsplumb. https://jsplumbtoolkit.com
3. Mininet. http://mininet.org
4. Chao-Kun, Z., Yong, C., He-Yi, T., Jian-Ping, W.: State-of-the-art survey on software-defined networking (SDN). J. Softw. **26**(1), 62–81 (2015). (in Chinese)
5. Cisco: LLDP-MED and cisco discovery protocol. Cisco White Papers, pp. 1–12 (2006)
6. Mckeown, N., Anderson, T., Balakrishnan, H., Parulkar, G., Peterson, L., Rexford, J., Shenker, S., Turner, J.: OpenFlow: enabling innovation in campus networks. SIG-COMM Comput. commun. rev. **38**(2), 69–74 (2008)
7. Qing-Yun, Z.: Research on OpenFlow-based SDN technologies. J. Softw. **24**(5), 1078–1097 (2013). (in Chinese)
8. SDNAP: SDN controller popularity survey. http://www.sdnap.com/sdnap-post/485.html (2015)
9. Wang, S.Y.: Comparison of SDN OpenFlow network simulator and emulators: Estinet vs. mininet. In: 2014 IEEE Symposium on Computers and Communication (ISCC), pp. 1–6 (2014)
10. Webber, J., Parastatidis, S., Robinson, I.: REST in Practice. OReilly Media, Inc., Sebastopol (2010)

From 2D to 3D: A Case Study of NPR and Stereoscopic Cinema

Victor Fajnzylber[1], Milán Magdics[2,3]([✉]), Macarena Castillo[1],
Constanza Ortega[1], and Mateu Sbert[2]

[1] University of Chile, Santiago, Chile
[2] University of Girona, Girona, Spain
magdics@iit.bme.hu
[3] Budapest University of Technology and Economics, Budapest, Hungary

Abstract. Our interdisciplinary research is dedicated to exploring the boundaries of stereoscopic filmmaking from an unusual viewpoint: we aim at creating 3D non-photorealistic cinema which allows conciliating a stereoscopic pre-visualization that is oriented to ensure visual comfort with concept tests of NPR applied to a 3D film. In this paper we describe the role of pre-visualization in stereoscopic cinema and our preliminary observations and experience of combining 3D cinema with non-photorealistic rendering approaches, from the filmmakers' point of view.

Keywords: Non-photorealistic rendering · Previsualization · 2D and 3D cinema · Visual comfort

1 Introduction

The history of cinema is indissolubly linked to technological development and photorealism. Since the beginning of the digital era, technological advances have not ceased to push further the boundaries of photorealism. A good example is the huge development of special effects and 3D animation, both oriented to reach the empathic effect of a photographic image. So, in general terms, photorealism has aesthetically dominated the history of cinema through the different stages of its technological development.

In the case of 3D cinema, photorealism is even more important, at least for two factors: the promise of sensorial hyperrealism is the main commercial argument of 3D experience in movie theaters, and at the same time, it is a sort of universally accepted standard for producing a visual comfort in the viewer. Thus, hyperrealism and visual comfort seem to be two inseparable characteristics of contemporary 3D cinema, both resting on the idea of photorealism as a conventional premise for stereoscopic filmmaking. We will question this premise by exploring the possibility of a non-photorealistic 3D cinema, in a two-step research.

The first step will consist of evaluating the use of non-photorealistic rendering (NPR) filters in 2D cinema on two types of users: general public (university students) and specialized public (film postproduction professionals).

© Springer International Publishing AG 2017
Y. Chen et al. (Eds.): SG 2015, LNCS 9317, pp. 87–98, 2017.
DOI: 10.1007/978-3-319-53838-9_7

The second step will consist of exploring the perceptual and technical problems of using NPR in stereoscopic cinema: on one hand, to understand the pre-visualization method as a way to guarantee visual comfort for the whole stereoscopic content, and on the other hand, to identify the technical and perceptual challenges of combining stereoscopic visualization with NPR.

Even though believable 3D relies on a realistic rendering model, realism is only one of the many artistic styles of storytelling and expressing emotions: choosing the proper visual style is an important aspect of art [9]. So, if we think of the aesthetics of 3D cinema as a spectrum of possibilities ranging from photorealism to non-photorealism, this idea expands the possibilities of cinematographic creativity. In this paper, we show experimental results of NPR applied to 2D cinema, and preliminary observations of NPR applied to 3D cinema. Thus, we aim at exploring the limits of merging the expressive possibilities of NPR with the narrative use of stereoscopy.

In Sect. 2, we describe visual comfort as the main perceptual challenge in 3D cinema and previsualization as a tool to achieve it. In Sect. 3, we describe the framework we have developed and used to test the role and applicability of NPR to stereoscopic cinema. Section 4 presents results of NPR for 2D cinema. In Sect. 5, we explore a two-pattern method to compare samples of stereoscopic contents processed with NPR filters. Finally, we conclude our paper in Sect. 6.

2 Visual Comfort as a Perceptual Challenge for 3D Cinema

Constant "depth scanning" is a natural characteristic of human vision. But even if the principle of binocularity is shared in stereoscopy, the 3D cinema of the 21st century still produces ocular discomfort, dizziness or headaches in many people [18]. About this aspect, in 2014 a French public agency published a series of recommendations on possible damage detected in children under 6 when exposed to stereoscopic content [1], in order to limit risks on children's health. The French agency that produced this report [2] states, however, that "given the lack of information on exposure to these technologies, the Agency considers necessary to promote new research".

The "know-how" for creating high quality stereo motion picture with stylized graphics is very limited. Even though it was shown that the mixture of stereoscopy with NPR can break 3D space perception [3], there has been little research on how to create visually pleasing NPR images or videos. Recent research focused on specific subproblems such as line drawings [4], painterly rendering [10,13] or simulating film grain effects [16]; however, a general framework to combine arbitrary styles (including post-production work that is applied in image space in 2D) with stereoscopic 3D visualization is yet to be established. In this paper we merely scratch the surface of this topic: we experiment with screen-space NPR stylization methods that are applied independently on the two images corresponding to the two eyes. Among other issues, we are interested in

how stylization influences the filmmaking procedure, including the quick generation of previews or pre-visualization (*"previz"*) with a set of different styles. It is not enough to just create solutions that optimize 3D conventional processes (such as geometric or light correction applied to stereo pairs); it is fundamental to experiment with the language of 3D cinema and, in the same process, analyze the user's responses to formal innovations. To achieve this, we have shot a stereoscopic film following the rules of a "secure" stereography, which means using pre-visualization as a tool to prevent disturbing transitions between scenes with different depths. This film would be used to test with NPR processing.

2.1 The Role of Cinematic Factors in Visual Comfort

The experience of filming in 3D is very didactic to understand the concept of visual comfort from an empirical perspective. In principle, the inconvenience is ocular [6,14]: eye fatigue results from the conflict between fixed accommodation on the screen (where we focus) and mobile convergence in scenic 3D space (where we look). In the 3D experience, although we can get used to this process after a few minutes, the quality of the film does the rest. The 3D quality of a film responds to decisions of *"mise en scène"* because they simultaneously involve several components of cinematography (photography, editing, post production). We shall call these the "cinematic factors" of eye fatigue.

If we compare the "physiological" and "cinematic" factors of eye fatigue, we should assume that, as medical research, optics and neuroscience do not submit new evidence on how to reduce the impact of physiological factors, our efforts should focus on cinematic factors. By properly using conventional resources of 3D cinema, we could produce films that are comfortable for the average viewer. One of these resources to avoid eye fatigue is the stereoscopic preview or 3D storyboard. The experience of shooting in 3D, which we describe below, incorporated the use of stereoscopic preview as one of the cinematic strategies to define a shooting plan aimed at visual comfort.

In July 2014, we shot a 3D film at the residence of Spanish filmmaker Luis Buñuel in Mexico City, based on a three-dimensional model of the house. This model allowed identifying the camera axes with greater visual depth, so that the shooting could take full advantage of depth perception in that house.

Once the script and the model of the house were completed, Frameforge [12] was used to simulate the material aspects (interior and exterior of the house, furniture, lighting, characters), optical factors (photographic focus, stereoscopic variables) and cinematic factors (fragmentation of history into scenes and shots). This stereoscopic preview was useful to generate the optimal amount of material for edition, which is very useful to solve problems in 3D postproduction.

Then, there is the aesthetic role of postproduction: what kind of "look" is better adapted to the fantastic spirit of the story. That was the beginning of our NPR real-time software testing. We wanted to develop a tool that was useful for matching the story and its aesthetics: to merge the expressive (NPR) and the narrative (3D) dimensions of the film. We knew that the natural environment of

3D cinema is photorealism, but the surreal context of the story gave us the aesthetic justification for a non-photorealistic treatment. The next step was testing the NPR filters in a 3D film conceived with cinematographic principles based on visual comfort [7].

3 Test Framework of NPR Effects for Cinema

From a technical point of view, NPR methods can be classified into object space and image space (or screen space) methods. Although in our case study the 3D model of the scene was available, in general, only film shots were available and so we chose image space methods for stylization. These approaches work with 2D image streams and therefore can use only color and texture data. However, we may assume that limited geometric information is available in the form of depth images, which may be extracted from the stereo images or directly captured using an additional depth sensor during film shooting. Thus, in addition to standard image processing methods we also considered depth-based effects that are also calculated in image space, but pixel data may correspond to depth.

Among image space NPR methods, we looked for ones that allow interactive performance. This may seem contradictory, as rendering methods used by cinematography are traditionally performed offline. On the other hand, we intended to include this stylization framework into the fast previz stage of film production where many different styles are tested rapidly, possibly during shooting, and thus performance is favored over high quality. Based on the preliminary results shown by the previz stage, high quality offline (possibly manual or semi-automatic) methods may be developed or selected in latter production stages.

Our previz tool is implemented as post-processing effects, using the Unity game engine [15]. We implemented a stand-alone video editor software in the same platform that supports various parameterized NPR effects. These effects execute basic image processing algorithms on the GPU and are capable of real-time performance. Thus, users can see the original shot and the immediately computed stylized results both at once. The selected effects are based on two principles: artists enhance relevant details and at the same time simplify the image by mitigating irrelevant details.

Relevant details are emphasized by drawing lines (i.e. applying edge detectors). We used the flow-based, extended difference-of-Gaussians (DoG) filters proposed by Winnemöller, as these were shown to produce aesthetically pleasing results [19] and can simulate various effects such as black and white or colored pastel. It is also related to edge detection by approximating the Laplacian of Gaussian (LoG) filter, which is equivalent to blurring the input with a Gaussian filter and then applying a Laplacian, i.e. second order edge detection. The result of the DoG filter is thresholded: smooth thresholding is used by applying the *tanh* function in order to produce aesthetic results [19]. To avoid noisy responses, smoothing along the flow field is used. First, we compute the smoothed structure tensor (i.e. the standard structure tensor for color images, blurred with a Gaussian filter), from which the gradient and tangent directions are extracted,

similarly to [5]. Then, in a second pass, line integral convolution that follows the edge tangent flow is applied. Line parameters such as color, width and smoothness are user-controlled parameters in our system; the parameters correspond to the reparameterization of the DoG filtered as proposed by Winnemöller in [19]. Black and white contour enhancement using the flow-based extended DoG filter is referred to later on as "Added contours". We also defined an effect that takes the original pixel color and use it as edge color, referred to as "Colored line drawing". Additionally, with proper threshold parameters, the DoG filter can produce pastel-like effects [19], which we consequently named "Pastel" and "Colored Pastel".

Image simplification methods consist of lowering image complexity in terms of texture details and color details. To reduce texture complexity, we used an extension of the flow-based implementation [5] of the bilateral filter [17,20], which is an edge-preserving smoothing filter. In our case, the bilateral filter is a product of two Gaussian filters; one is applied in the spatial domain, and the other is computed in the intensity domain. The intensity-dependent filter component ensures that neighboring pixels that are placed on the same side of a step-like signal as the center pixel have greater weight, while pixels from the other side of the edge contribute less to the filter output, better preserving the edge. The amount of blur is controlled by the variance parameter of the spatial domain Gaussian filter, while the amount of details kept is determined by the intensity domain variance parameter. In order to avoid color-bleeding artifacts, the bilateral filter is applied in the CIE-Lab color space [17]. Originally, the bilateral filter is non-separable, and thus expensive to compute. In real-time applications, usually the flow-based approximation [5] is used instead, which applies a one-dimensional bilateral filter along the gradient flow, and then another one-dimensional bilateral filtering on the tangent flow. Similarly to the flow-based DoG filtering, the gradient and the tangent flow directions are extracted from the smoothed structure tensor. The bilateral filter is usually performed iteratively several (2–5) times to produce visually appealing results.

Color complexity is lowered using luminance quantization, similarly to [20]. We refer to the output of the application of the bilateral filter and luminance quantization as a "Simplified" image. Another way of lowering color complexity is to reduce image saturation ("desaturation") in HSV on HSL color spaces.

The combination of these effects together can simulate different artistic styles. Additionally, the level of abstraction is parameterized in each of the effects: i.e. the line thickness and density in edge detection, the strength of details that are kept in texture simplification and the amount of desaturation. This allows us to guide the viewer's gaze [8,11], as well as to create the illusion of depth. The parameters corresponding to the level of abstraction may depend, in the first place, on camera depth, as a way to show objects in full detail in the foreground and as an abstraction in the background. Another typical use is to define the level of abstraction based on the radial distance from a particular point on the image, which guides the viewer's gaze to this particular point.

Effects are applied on the two stereo images independently — without modifying the stereoscopic parameters. This is known to break 3D perception [4]. However, in our case this is less noticeable for several reasons. First, contours are generated on each-eye basis, which was shown to be capable of avoiding binocular rivalry [4]. In most styles (except for line drawings), there is interior information between lines, mitigating binocular rivalry caused by line segments that are seen only by one eye. Additionally, lines are not textured, and thus line style is coherent. Finally, image simplification methods usually aim at removing less relevant details while preserving relevant ones. Thus, these approaches remove details instead of introducing new ones. This means that most of those details are present in the output image, which were also visible in the original, photorealistic shot; everything else is smoothed out.

Our preliminary user studies showed (results are not included in this paper) that the consistency of the two images can be high and thus disturbing artifacts may often not be present: 3D illusion is not affected by some of the NPR effects. We note that the effects are intended to be used for previz, and thus an offline stylization method that is used to render the film in its final form should be very carefully designed in order to achieve perfect 3D sensation.

4 NPR Rendering for 2D Cinema: Experimental Results

An experimental phase of the research was carried out in order to identify and analyze how cinematic perception in 2D is affected by NPR. Given the cultural centrality of our habit of 2D cinema, we considered a priority to compare three "extreme" or "polar" (clearly distinguishable) types of NPR filters. We worked with a young audience of university students, characterized by high audiovisual consumption. The experiment was conducted in October 2014 in Santiago, Chile, and it was conceived to identify the conditions in which visual abstraction of NPR processing can affect the narrative understanding of a 2D film. We applied three NPR filters, COLOR COMIC, PASTEL, PAINTING (Fig. 1), in a 7-min fragment of the feature film "Las Niñas Quispe" (Dir. Sebastián Sepúlveda, winner of best cinematography at Mostra de Venezia 2014). Then we organized a screening in a movie hall of these three NPR versions, divided into three groups of 10 students each, from a total of 30 college undergraduates of cinema

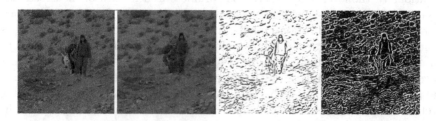

Fig. 1. Three samples of NPR filters: Native frame (left), COLOR COMIC (center-left), PASTEL (center-right), PAINTING (right).

and journalism, ages 19 to 22. After each screening, we combined a quantitative methodology (survey of 25 questions) and a qualitative questionnaire (three focus groups of 10 people each). The first part of the survey allowed us to validate the base line of a general high audiovisual consumption on that group of college students. The second part consisted of questions divided by themes: space-time perception, emotion identification, recognition of characters and backgrounds. The focus group results allowed us to build an analytical reading of the survey's results.

For the three groups of students, the qualitative consensus was that character recognition, more than backgrounds or objects, is the most important factor to evaluate the impact of NPR on film narrative. This result could suggest that the NPR do not affect depth perception because character recognition remains significant even in the "extreme" filters (Pastel and Painting), where the backgrounds and foregrounds seem to be combined in similar textures.

As we can see in the quantitative results (Fig. 2, left), the morphological perception of characters (facial features, sizes, textures) was clear in NPR1 (Color Comic); the vertical axis indicates the number of mentions. In NPR2 (Pastel) greater importance was given to voice as a differentiating criterion, due to the general darkness. However, in NPR3 (Painting), voice becomes the main element of recognition, leaving the morphology in the background. We concluded that one reason is the visual disturbance of the predominance of white, which seems to decrease visual perception and encourage auditory perception. Colors (blue component) was not mentioned as a recognition criterion, and a combination of factors, labeled as Others (violet component) was only mentioned in NPR1 and NPR3.

These results suggest that we do not need so much detail (as we found in photorealism) to understand a film narrative, because, in fact, much of the information comes from character identity, produced by the combination of body movement and voice. Therefore, when using NPR, subjects are able to abstract, relate and follow a story, even when we see more blots and stains than sharp facial expressions. NPR seems to bring a new atmosphere to the story, without affecting its dramatic understanding. The use of "extreme" filters, two of them clearly distant from the native realistic picture of the film, stimulates new interpretations of the characters emotions and intentions and the narrative importance of their environments. In short, understanding the story does not seem to be affected by NPR filters. The main conclusion to be drawn from this experiment of non-photorealistic 2D film lies in a dual dynamic generated by NPR: general narrative comprehension is unaffected but, by modulating the morphological aspects of characters and by increasing the perceptual importance of sound, new approaches to the film intentions are generated. The same story seems to produce new interpretative variants in its viewers. This seems to happen in 2D.

The second result, based on a panel of 12 professionals of film postproduction, is related to the use of NPR filters in cinematographic genres (Fig. 2, right). There was a genre in which professionals were more open to seeing NPR: Science Fiction. This suggests that post-producers imagine a possible use of NPR in

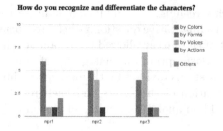
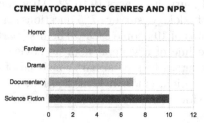

Fig. 2. Left: comparative factors for character recognition in NPR1, NPR2 and NPR3. Right: use of NPR in cinematographic genres. (Color figure online)

movies with non-realistic stories. But the surprise comes with the second genre (documentary), generally more associated with realistic characters or landscapes. If we confront the results of both groups (students and professionals), we find no contradiction: if NPR filters do not affect character recognition, the stories will be correctly understood. However, to explore passing NPR from 2D to 3D cinema we must remember the main perceptual difference between monocular and binocular vision: spatial understanding. In 2D, a singular visual scanning is enough to understand instantly the spatial nature of the scene, but in 3D, visual scanning is essentially comparative: an ocular backward and forward movement that could be called "depth scanning". Therefore, even if the characters remain the most important factor of NPR perception in 2D, it will be necessary to evaluate how this constant "depth scanning" of 3D perception could modify the impact of NPR.

5 Comparing Samples of 3D Frames Processed with NPR Filters

As we said before, "depth scanning" is an attribute of 3D perception. Buñuel's house, used for the shooting, was filled with objects in order to increase depth perception in the filmic space. We were also sure about the visual comfort of the photorealistic 3D content, that means, before the NPR processing. We also had the NPR software, so we needed to prepare the concept test of processing a scene with different NPR filters. And the final step — which we shall present as future work — should be the user-test of NPR 3D with viewers. So, we created a two-pattern method to compare the NPR 3D samples.

Instead of defining depth perception by optical principles, we first developed a comparative method of NPR effects with a specific validation criteria: the expressive and narrative needs of the film. We chose a scene with six different layers of depth, where the narrative intention was the sadness felt by the female character. The comparison of the resulting images after NPR processing, analyzed with anaglyph glasses, was described in terms of 3D quality (perceived layers) and related to the impact of NPR on stereoscopic illusion (whether it keeps the binocular depth or not). We know that the anaglyph is not the best

Table 1. Comparison of different NPR filters applied to a stereoscopic frame. In (B) and (G) pastel refers to the pastel-like effect from [19], in (C) and (D) (de)saturation means (lowering) increasing the saturation of colors based on the radial distance from the center of the image, in (E) the results of edge detection were added, (F) is an image abstraction method based on [5], while in (H) the result of an edge detector was taken and the original input was used as edge color.

	Native Shot	Non-Photorealistic Shots						
	(A) Photo-realistic	(B) Colored pastel	(C) De-saturated color	(D) Saturated color	(E) Added contours	(F) Simplified	(G) Pastel	(H) Colored line drawing
3D quality	clear layer separation	layers with ghosting	layers with ghosting	clear layer separation	clear layer separation	clear layer separation	no layer separation	no layer separation
Depth perception	binocular depth	monocular depth	weak binocular depth	intense binocular depth	realistic binocular depth	unrealistic binocular depth	monocular depth	monocular depth

way of visualizing 3D (polarized glasses are the cinema standard), but at the same time, all 3D contents available on the Internet are on anaglyph format. Currently, both kinds of glasses coexist, but in this exploratory phase, anaglyph visualization was sufficient. We must assume a general lack of "3D culture". Almost everyone has seen 2D films. But in adult ages, even among cinema students, the experience of watching 3D films is still rare. We should not forget these differences in cinema backgrounds for our future NPR 3D user tests. That is why we started with two intuitive criteria for the comparison: (a) 3D quality, and (b) depth perception. We had to conceive intuitive notions of 3D that could be easily expressed in a social context of users with no "3D culture".

We compared the "native" photo-realistic shot with seven non-photorealistic shots (Table 1), as a preliminary basis for a user test that will be presented as future work. From the point of view of perception, the choice of these seven non-photorealistic filters was oriented to produce a continuous scale of proximal types of depth, contrary to the 2D NPR experiment, in which we chose two "polar" filters and just one proximal filter to the "native" frame. Once the scene was processed with NPR filters, we could work on a questionnaire based on two patterns, that could be summarized in two kinds of questions: (a) about "3D quality": do you see "edge ghosts" when you compare the depth levels of the image? (b) about "depth perception": which samples seem to appear to you as normal 2D image?

A simple comparison of perceptions among the research team (we all have a different binocular vision) revealed a comparative panorama of which NPR filters produce different kinds of 3D illusion. For instance, NPR samples that reduce the stereoscopic illusion by producing a monocular depth perception (B, G and H in Table 1) are less suitable for stereoscopy. Something similar may be concluded for those samples that create a defective stereoscopic illusion (B and C

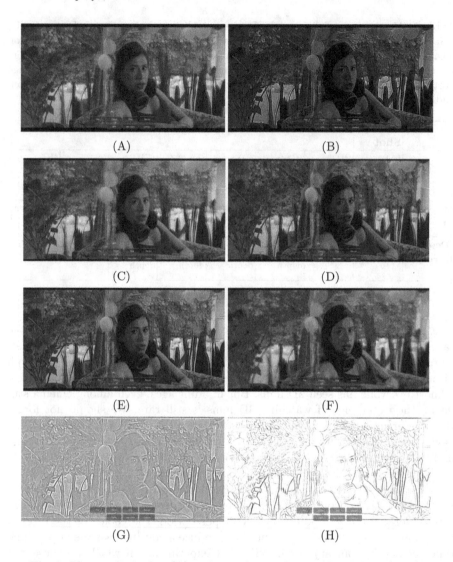

Fig. 3. Photorealistic shot (A) and non-photorealistic stylized shots (B–H).

in this case), by producing "ghosting" around the edges. Combining these two intuitive criteria we could select the most suitable NPR effects in terms of visual comfort (D, E, in F in Fig. 3).

Even if these preliminary results are just a first intuitive step in our methodological path towards a systematic experimental strategy, we can already identify some ideas to consider for our future work: (a) we could use optical solutions (as eye tracking devices) to corroborate the verbal identification of "ghosts" in the figure's edges; (b) for a qualitative approach, we should consider intuitive definitions of "3D quality" and "depth perception" if we want to consider the lack

of "3D culture"; and (c) also for a qualitative approach, we must define a set of descriptive attributes that would be useful to compare and establish differences between the expressive contribution of each NPR filter in the same 3D scene.

6 Concluding Remarks: Exploring the Limits of Photorealism in Cinema

The use of NPR in cinema means a challenge to the global tradition of photorealism. The common sense of our visual culture tells us that NPR and stereoscopy are destined to be separated. This paper suggests that this combination is not a perceptual contradiction. Our experimental results in 2D cinema indicate that narrative comprehension is not significantly affected by NPR. In 3D cinema we conducted a trial study that produced preliminary observations. These observations will be used in future research as the basis for a user study aimed at identifying NPR stylizations that may preserve the binocular depth of stereoscopy. Our current work indicates that a combination of the expressive quality of NPR with the immersive effect of stereoscopic cinema could produce a new form of augmented narrative.

Acknowledgements. This work was sponsored by TIN2013-47276-C6-1-R from the Spanish Ministry of Economy and Competitiveness, and 2014SGR1232 from Catalan Government.

References

1. ANSES: 3D technologies and eyesight: use not recommended for children under the age of six, use in moderation for those under the age of 13. https://goo.gl/jOMm5o (2014). Accessed 05 Feb 2014
2. ANSES: French Agency for Food, Environmental and Occupational Health and Safety. https://www.anses.fr (2014). Accessed 05 Feb 2014
3. Gooch, A.A., Willemsen, P.: Evaluating space perception in NPR immersive environments. In: NPAR, pp. 105–110 (2002)
4. Kim, Y., Lee, Y., Kang, H., Lee, S.: Stereoscopic 3D line drawing. ACM Trans. Graph. **32**(4), 57:1–57:13 (2013)
5. Kyprianidis, J.E., Döllner, J.: Image abstraction by structure adaptive filtering. In: Proceedings of the EG UK Theory and Practice of Computer Graphics, pp. 51–58 (2008)
6. Lambooij, M., Fortuin, M., Heynderickx, I., IJsselsteijn, W.: Visual discomfort and visual fatigue of stereoscopic displays: a review. J. Imaging Sci. Technol. **53**(3), 30201–1 (2009)
7. Liu, C.W., Huang, T.H., Chang, M.H., Lee, K.Y., Liang, C.K., Chuang, Y.Y.: 3D cinematography principles and their applications to stereoscopic media processing. In: Proceedings of the 19th ACM International Conference on Multimedia, MM 2011, pp. 253–262. ACM, New York (2011)
8. Magdics, M., Sauvaget, C., Garcia, R., Sbert, M.: Post-processing NPR effects for video games. In: 12th ACM International Conference on Virtual Reality Continuum and Its Applications in Industry: VRCAI 2013, pp. 147–156 (2013)

9. McCloud, S.: Understanding Comics the Invisible Art. Harper Paperbacks, New York City (1994)

10. Northam, L., Asente, P., Kaplan, C.S.: Consistent stylization and painterly rendering of stereoscopic 3D images. In: Proceedings of the Symposium on Non-Photorealistic Animation and Rendering, NPAR 2012, pp. 47–56. Eurographics Association, Aire-la-Ville (2012)

11. Redmond, N., Dingliana, J.: Influencing user attention using real-time stylised rendering. In: Tang, W., Collomosse, J.P. (eds.) Proceedings of the EG UK Theory and Practice of Computer Graphics, Cardiff University, United Kingdom, pp. 173–180. Eurographics Association (2009)

12. Innoventive Software: Frameforge (2014). http://www.frameforge3d.com/ Products. Accessed 05 Feb 2014

13. Stavrakis, E., Gelautz, M.: Image-based stereoscopic painterly rendering. In: Rendering Techniques 2004 (Proceedings of Eurographics Symposium on Rendering), pp. 53–60. Norrköping, Sweden, June 2004

14. Sun, G., Holliman, N.S.: Evaluating methods for controlling depth perception in stereoscopic cinematography. In: Woods, A.J., Holliman, N.S., Merritt, J.O. (eds.) Proceedings of SPIE Stereoscopic Displays and Applications XX, p. 72370I, vol. 7237. SPIE, Bellingham (2009)

15. Technologies Unity (2013). http://unity3d.com

16. Templin, K., Didyk, P., Myszkowski, K., Seidel, H.P.: Perceptually-motivated stereoscopic film grain. Comput. Graph. Forum **33**(7), 349–358 (2014)

17. Tomasi, C., Manduchi, R.: Bilateral filtering for gray and color images. In: Proceedings of the Sixth International Conference on Computer Vision, ICCV 1998. p. 839. IEEE Computer Society, Washington, DC (1998)

18. Ukai, K., Howarth, P.A.: Visual fatigue caused by viewing stereoscopic motion images: background, theories, and observations. Displays **29**(2), 106–116 (2008). Health and Safety Aspects of Visual Displays

19. Winnemöller, H.: Xdog: advanced image stylization with extended difference-of-gaussians. In: Collomosse, J.P., Asente, P., Spencer, S.N. (eds.) NPAR, pp. 147–156. ACM (2011)

20. Winnemöller, H., Olsen, S.C., Gooch, B.: Real-time video abstraction. ACM Trans. Graph. **25**(3), 1221–1226 (2006)

Research on Collaborative Visualization Application of Dynamic Monitoring Figure Spot

Ken Chen[1(✉)], Ping Liao[1], Fang Wang[2], Yuchuan Wang[1], and Pengfei Xiao[1]

[1] Sichuan Institute of Land Planning and Survey, Chengdu 610045, China
chenken@foxmail.com
[2] College of Computer Science and Technology,
Southwest University for Nationalities, Chengdu 610041, China

Abstract. Dynamic Monitoring is one of the most basic and the most important parts in geographical conditions monitoring, which provides basic data for geographical conditions monitoring and assists local governments with land survey and database updating quickly, accurately and completely. Based on the uniform principle, it can extract various types of figure spot for land using, by the HCI-based methods with the prototype system, through the registration and contrastive analysis of the remote sensing images, the land survey database of last annual, temporary polygons, etc. Binding the characteristics of Big Data environments, the complexity, isomerism and distributives of spatial information system as well as the diversity and personalization of user needs, determine Dynamic Monitoring should have the characteristics of universality and synergy. It also can improve the collaborative visualization efficiency of data service, by establishing a distributed collaborative system and a universal computing environment of spatial information.

Keywords: Figure spot monitoring · Collaborative show · Visualization · Cloud computing · HCI

1 Introduction

Dynamic Monitoring is one of the most basic and the most important parts in geographical conditions monitoring, which provides basic data for geographical conditions monitoring and assists local governments with land survey and database updating quickly, accurately and completely. As it relates to the initial step of monitoring, that is data acquisition, data processing, data processing, data storage, data retrieval, data applications, so its quality during the data is also directly related to the application effect of Dynamic Monitoring. Our country has an early start in the project of Dynamic Monitoring. Before 2010, it conducted monitoring in the changes of land use mainly for the large cities which have a population of 500000, the areas of rapid economic development and the key projects. From 2011, our country has implemented a

Y. Chen et al. (Eds.): SG 2015, LNCS 9317, pp. 99–107, 2017.
DOI: 10.1007/978-3-319-53838-9_8

nationwide Dynamic Monitoring for land use. It leads to a comprehensive and effective monitoring system, a strengthened land planning management and a strong support for land use monitoring. It also provides a scientific basis for state macro-control and government policy [1, 2]. As it mentioned in the report of Mrs. Feng, the deputy director of Cadastral Division of Ministry of Land and Resources, due to the national attention to the expansion of urban construction, the proportion of domestic satellites have improved dramatically in the National Land Use Dynamic Monitoring Project, while in the actual use of monitoring data, its accuracy rate is over 95%, according to local Government feedback information.

2 Research on Collaboration Based on Cloud

Cloud computing will distribute tasks to the virtual resource pool consisting of clouds, which can meet these new features of collaborative applications, such as dynamic, wide-ranging, large-scale, isomerism of data types and so on [3].

Cloud Architecture is Collaboration. DFS (Distributed File System) is one of the core components of cloud computing. The application mode of cloud computing is a new sharing architecture of fundamental service [4]. As a distributed conception, cloud service provides services in a heterogeneous environment, and solving the interoperability problem in a heterogeneous environment has become the core-component technology of building an integration framework. The collaborative environment of cloud computing is to provide such services.

Cloud Development is Collaboration. Cloud services can bring high expansibility and flexibility for collaboration and reduce overall running costs. Technology to expand and stretch characteristics, the overall operating cost savings. Due to its expansibility of integrating computing resources, cloud services can be considered as a virtual computer for users, which can easily get the Infrastructures of creating personalized collaborative applications, including network connectivity, bandwidth, storage, and performance. In the big data environment, developers no longer need to spend a lot of money and manpower to deploy network services [5]. Cloud services can provide a mass of resources shared by users, with high utilization.

Cloud Instantaneity is Collaboration. Breaking through the coupling relationship of data, application and services in a traditional mode, cloud services platform creates and manages virtual running environment on the physical servers, in order to achieve collaborative applications or instantaneity. Quick and handy environment is easy to achieve, test, create, apply and promote theories and methods.

Cloud Storage is Collaboration. Cloud storage is a distributed storage. Data resources are cut and distributed in the storage cloud through subdivision or pyramid technology, and each block has a redundant copy of data on multiple nodes, so as to ensure the integrity of data resources. It avoids its workload will be transferred when lost contact, By monitoring the cloud service nodes continuously. When accessing the

cloud, users can automatically select a node according to network topology information and collaboration strategies in accordance with the shortest delay, the maximum transmission rate, the lowest failure rate and other parameters, but do not rely on a node, the same token, if a node fails, the client can quickly switch to the next node, thus ensuring smooth and consistent application.

Cloud Service is Collaboration. Cloud service is an application structure based on pervasive computing in a distributed multi-integration information processing forms, which optimize the existing communications infrastructure mode, make the dynamic needs of the user more visual, and provides interactive forms based on streaming media technology.

The overall architecture of dynamic remote monitoring prototype system, based on client aggregation service coordination mechanism, is composed of Homeland cloud (cloud storage, network cloud, cloud physics), data registration centres, client collaborative model aggregation service composition. Overall architecture is shown in Fig. 1.

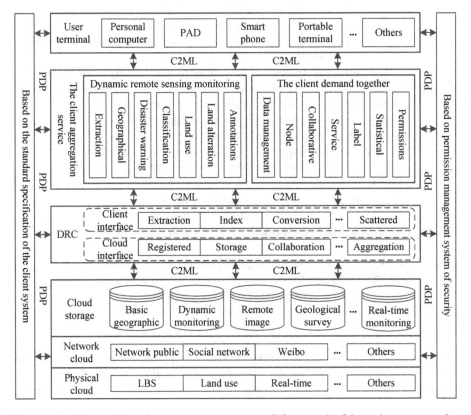

Fig. 1. The client collaborative prototype system overall framework of dynamic remote sensing monitoring

3 Technical Route of Collaborative Visualization Prototype System

Based on the uniform principle, it can extract various types of polygons for land using, by the HCI-based methods with the prototype system, through the registration and contrastive analysis of the remote sensing images, the land survey database of last annual, temporary polygons, etc. Top of the list is scientific and rational classification of polygons, as shown in Table 1, divided into five categories to 13 small classes.

Table 1. The classification of definition dynamic remote sensing figure spot

Figure spot type		Type description
Classify one		Front phase when vegetation coverage or obvious traces of construction, back phase images have obvious construction characteristics
	Type A	Residential district, certain factories, high-rise building, focus on large-scale residential areas and the foundation
	Type B	Single or scattered distribution of rural residence, or suspected color bond characteristics of low level, small projects
	Type C	Large hydraulic structures, port terminals, etc.
	Type D	Square, parking lot, driving land and other land is given priority to with surface hardening
	Type E	Park, golf, green space, the cemetery is given priority to with green land
Classify two		Front phase images have vegetation or obvious traces of construction, back phase images have obvious construction push filling characteristics
Classify three		Front phase are being built in vegetation coverage, obvious characteristics, back phase that there is a clear road, large canals
	Type A	New hardening or built roads, including the former phase under construction, after the hardening or built roads
	Type B	New bulldozing state road under construction
	Type C	Large network built or under construction
	Type D	Large canals built or under construction
Classify four		Front phase images for seawater cover, back phase image for landfill circumference
Classify five		Front phase as usual before the ground temporarily, back phase have obvious construction characteristics
	Type A	In the ground temporarily remain undisturbed
	Type B	Based on the original expansion, heightening further expansion

Dynamic remote monitoring prototype system is a typical application of digital land, and is also a digital storage and digital business platform of homeland industry information management system. Combined with the differences of dynamic remote

sensing in practical application on the aspects of data characteristics, applications fields, service targets; dynamic remote monitoring prototype system has the following features:

(1) It has a spatial resolution range above four levels and the maximum resolution of 0.5 m or less, to cover from the resolution performing the entire monitoring area to the resolution performing the single minimum polygon unit;
(2) It has uniform data standards and norms, consistent data structure and indexing scheme to support scale steeples zoom above four levels;
(3) It has independent security system, develops clear lines of authority and entrance, and sets different permissions for different users;
(4) It has a visual expression with a virtual environment, compatible with various data of different sources and different formats;
(5) Query mechanisms are required, which is data-centric and serves the users;
(6) It needs to be compatible with a variety of new technologies to constantly upgrade and improve digital land to overcome the restricts of storage bottlenecks, calculation bottleneck and network bandwidth bottlenecks, such as the new data pre-processing methods, data mining mechanism, data compression mode, the conversion and improvement of geographic data;
(7) It needs an appropriate agency to produce and coordinate the construction of basic data, such as DEM data, DOM data, dynamic remote sensing data, and all data needs to be seamlessly connected;
(8) It must provide a unified symbolic representation and iconic representation for land-related features;
(9) A management mechanism including information processing with large data characteristics, dynamic access, quick analysis, exchange and sharing, is required, based on cloud computing, the Internet and distributed architecture.

4 Design and Implementation of Collaborative Visualization Function

4.1 The Aggregation Service of the Client Collaboration with the Functional Requirements

Dynamic Remote Sensing monitoring prototype system which the main purpose is selected monitoring area of the present situation of land use change information extraction, and to know the type of its figure spot; Its main functions include such as data management, automatic figure spot, geographical conditions monitoring display and man-machine interactive operation functions [7].

(1) The State of Geographical Monitoring Displaying

The prototype system should possess comprehensive information visualization display function, including land remote sensing image display, the elevation of land

and resources information display, figure spot extraction results and other information display, etc., to provide consumers a more intuitive interface and the use of feedback.

(2) The Change Information Extraction

The change information extraction is a prerequisite for figure spot recognize, that system is required for the selected area of land use status quo to extract features. This function does not need to classification of the accurate definition of land use, but only need according to the Remote Sensing data to extract the before and after the change of the phase difference.

(3) The Figure Automatically Recognize

Combined with the extraction result of land use change information, the man-computer interaction recognize spot on the map, the prototype system needs, according to a given graph classification model combined with the characteristics of the pre-recorded libraries, etc., through algorithm comparing primary and secondary division spot on the map.

(4) The Data Management

Prototype system should also have certain data management function, so that the user to be able to the data management use of multi-source remote sensing image data and DEM data, the national second land use status quo survey data, extract figure spot, etc. Including the service of upload, download, update, and delete data, etc.

(5) The Man-Machine Interactive Operation

Prototype system should have more convenient way of man-computer interaction, in addition to providing remote sensing image processing system for common operations, such as mobile, scaling, rotating, way outside, still should provide change information extraction and figure spot automatic operation mode, including the monitoring area selection and submit operation, etc.

4.2 Interface Implementation

Dynamic Remote Sensing monitoring based on the DOA client together with the prototype system using Microsoft Visual Studio 2010 development environment, using C# language. Which can make full use of the .NET platform frame of the appearance and rapid development; complete the user interface as shown in the figure below (Fig. 2).

Fig. 2. Multi-source graphics collaborative visualization

5 Conclusion

Dynamic Remote Sensing monitoring figure spot collaborative visualization involving events perception, data acquisition, communication transport, information extraction, spatial analysis and decision support, that need organic collection of 3S technology, with the help of Cloud Computing, Internet of Things, as well as distributed file system

technology, the implementation of various spatial information fast, dynamic, accurate, reliable collection, processing, management, updating, and forecasting. The spatial information system, which is complexity, heterogeneity, distribution, industry and the diversity of user requirements and personalization, combined with the feature of Big Data environment, should possess universality and collaborative features. In the execution of the client through the establishment of a distributed collaborative system with characteristics of universal and spatial information computing environment, so as to improve the collaborative visualization of data service execution efficiency.

References

1. Yan, Q., Zhang, J.-X., Sun, X.-X.: IKONOS data in the application of land use dynamic monitoring method research. J. Surv. Mapp. Sci. **27**(2), 40–42 (2002)
2. Feng, D.-J., Jing-Shi, S., Li, Y.-S., et al.: Land use remote sensing dynamic monitoring for phase data management. J. Wuhan Univ. (Eng. Sci.) **36**(3), 125–128 (2003)
3. Chen, K., Zheng, W.-M.: Cloud computing: system instance and research the status quo. J. Softw. **20**(5), 1337–1348 (2009)
4. Chung, I.H., Hollingsworth, J.K.: Automated cluster-based web service performance tuning. In: Proceedings of the 13th IEEE International Symposium on High Performance Distributed Computing, pp. 36–44 (2004)
5. Grossman, R.L., Gu, Y.H.: On the varieties of clouds for data intensive computing. IEEE Data Eng. Bull. **32**(1), 44–50 (2009)
6. Chen, K., Miao, F., Yang, W.-H., et al.: Dynamic remote sensing monitoring prototype system design and implementation of land and resources. J. Geophys. Comput. Technol. **36**, 270–275 (2014)
7. Muttalibova, S., Pashayev, N., Ragimov, R.: Valuing processes of flood on the coastal regions of the Kur on the basis of data remote sensing. In: 2012 IV International Conference on Problems of Cybernetics and Informatics (PCI), Baku (2012)
8. Karunarathne, D., et al.: Mobile based GIS for dynamic map generation and team tracking. In: 2010 5th International Conference on Information and Automation for Sustainability (ICIAFs), Colombo (2010)
9. Changbao, Z., et al.: The dynamic monitoring and management of coastal zone with SAR remote sensing and fractal approach. In: 2002 IEEE International Geoscience and Remote Sensing Symposium, IGARSS 2002 (2002)
10. Mana, A., Munoz, A., Gonzalez, J.: Dynamic security monitoring for virtualized environments in cloud computing. In: 2011 1st International Workshop on Securing Services on the Cloud (IWSSC), Milan (2011)
11. Miede, A., et al.: Qualitative and quantitative aspects of cooperation mechanisms for monitoring in service-oriented architectures. In: 2009 3rd IEEE International Conference on Digital Ecosystems and Technologies, DEST 2009, Istanbul (2009)
12. Madureira, A., et al.: Cooperation mechanism for team-work based multi-agent system in dynamic scheduling through meta-heuristics. In: 2007 IEEE International Symposium on Assembly and Manufacturing, ISAM 2007, Ann Arbor, MI (2007)
13. Simzan, G., Akbarimajd, A., Khosravani, M.: A market based distributed cooperation mechanism in a multi-robot transportation problem. In: 2011 11th International Conference on Intelligent Systems Design and Applications (ISDA), Cordoba (2011)

14. Ming-Chuan, H., Don-Lin, Y.: An efficient fuzzy c-means clustering algorithm. In: 2001 Proceedings IEEE International Conference on Data Mining, ICDM 2001, San Jose, CA (2001)
15. Chen-Chia, C., Jin-Tsong, J., Chih-Wen, L.: Fuzzy c-means clustering algorithm with unknown number of clusters for symbolic interval data. In: SICE Annual Conference, Tokyo (2008)

Automation and Evaluation

Logic Control for Story Graphs in 3D Game Narratives

Hui-Yin Wu(✉), Tsai-Yen Li, and Marc Christie

IRISA/INRIA Rennes, National Chengchi University, Taipei, Taiwan
hui-yin.wu@inria.fr, li@nccu.edu.tw, marc.christie@irisa.fr

Abstract. With the rising popularity of engaging storytelling experiences in gaming arises the challenge of designing logic control mechanisms that can adapt to increasingly interactive, immersive, and dynamic 3D gaming environments. Currently, branching story structures are a popular choice for game narratives, but can be rigid, and authoring mistakes may result in dead ends at runtime. This calls for automated tools and algorithms for logic control over flexible story graph structures that can check and maintain authoring logic at a reduced cost while managing user interactions at runtime.

In this work we introduce a graph traversal method for logic control over branching story structures which allow embedded plot lines. The mechanisms are designed to assist the author in specifying global authorial goals, evaluating the sequence of events, and automatically managing story logic during runtime. Furthermore, we show how our method can be easily linked to 3D interactive game environments through a simple example involving a detective story with a flashback.

Keywords: Interactive storytelling · Game narrative · Logic control · Story graph filtering

1 Introduction

As readers of stories, our brains are engaged in a mix of perceptual, cognitive, and logical activities in an attempt to comprehend the unfolding of events and immerse us in the story world. According to Branigan, comprehension of the plot can be interpreted in terms of two processes: the bottom-up perception of individual actions and events as they occur, and the top-down structural understanding of story goals, temporal order, and logical inferences [2]. In interactive digital storytelling, where the viewer can participate and alter the outcome of the story, the replay value of the story increases and the viewers are more immersed through participation in the story outcome.

Yet with the growing complexity of the story and managing outcomes of interaction, the task of authoring with regards to story logic and content becomes a big challenge for the story designer. Computational algorithms and the mature understanding of narrative structures provides story designers with better tools

© Springer International Publishing AG 2017
Y. Chen et al. (Eds.): SG 2015, LNCS 9317, pp. 111–123, 2017.
DOI: 10.1007/978-3-319-53838-9_9

to create more personalized, engaging, and well-controlled narrative content. One structure is the branching structure, popularly adopted by existing games as game trees or story graph structures in existing research [9,12,15]. Yet maintaining logic over complex branching (and maybe even non-linear) stories at runtime is also a difficult task that requires laborious authoring to ensure that no illogicalities exist in the story graph. Also, user interactions may be greatly restricted or have low impact over the story due to the rigid structure of such graphs. Therefore, it is much desired to have a set of simple set of logic controls that integrates the story logic, user decisions, temporal arrangements, and authorial goals in one mechanism.

In this work, we propose a logic control algorithm specifically suited to maintain the logic control of the story graph structure. Our algorithm is suited to story graph structures that are interactive, require stronger control of logic, and possibly involve non-chronological story segments. The method takes as input a pre-authored (or generated) story graph and a set of user-defined authorial goals (e.g. "a murder and a happy ending"). Our method then outputs a subgraph of the original story graph, and at each interactive plotpoint, subsequently prunes the story graph to maintain logicality at runtime. Moreover, when the temporality of the story is non-linear, involving embedded scenarios, the algorithm ensures user interactions within and outside of the embedded scenario extend to other parts of the story, ensuring that no matter in what sequence the story events play out, the logic remains consistent. The algorithm is linked to an authoring interface and scene in Unity to demonstrate the effect of logic control on the discourse in a real-time 3D environment.

The main contributions of this work is the design of a logic control mechanism for narratives with embedded plot lines that (1) enforces local story logic (such as preconditions, and post-effects of story events) and authorial goals to be upheld without running into unresolvable plot points, (2) manages story logic over user interactions of non-linear stories at runtime, and (3) performs dynamically in 3D environments.

In the following sections, we first outline the related work. We then briefly describe the specifications of the story graph representation before focusing on the logic control algorithm over the story graph. In Sect. 6 we present the output of our method in a real-time 3D environment with authorial goals, temporal variations, and user interactions. We finally conclude with possible applications of our method.

2 Related Work

For more flexible narrative generative systems, Brooks [3] proposes a framework with structural, representational, and presentational environments. He also proposes that a computational narrative is comprised of a narrative structure, pieces of the story with representation information, and a reasoning strategy among the story pieces. Similar to Brooks' framework, we realize our story structure and logic control with (i) the story graph structure with story units, (ii) the logic

control algorithm, and (iii) the presentation in 3D environment. This section outlines the previous work on story structures and logic control mechanisms for 3D game and storytelling environments we observe in the design of our methods.

2.1 Story Structure and Units

To find a suitable story structure that provides enough flexibility for high-level plot arrangements, we survey previous approaches to branching and planning formalisms of interactive narrative.

Carmichael and Mould [4] adapts the story model of Chatman [5], using the concept of kernels and satellites to represent core events (kernels) and anticipated storylines (satellites) in open-world exploration games. This structure fits its original purpose to loosely-structured open-world exploration narratives by ensuring key events are played in order, but is too simplistic and general to construct multiple plotlines through variations of key events as story graphs could.

Our work is similar to the concept of plot-point graphs [15], and further explored by [9] where a number of important moments (i.e. plot points) are authored, and evaluation function is adopted to verify the sequencing of the plot points. However, this search-based approach is targeted towards story sequences that are linearly authored, requiring a full search algorithm over all permutations of plot points to construct an interactive story graph. Our work is targeted towards story graphs that were authored to be interactive.

Previous work on narrative formalisms come in the form of either planning or branching, leaning towards planning methods in generative systems. Though they are more restrictive in generative power than planning, branching structures are shown to be efficient when managing user decisions [13]. While planning algorithms provide the capacity for dynamicity in storytelling, their benefits are often insufficiently explored due to the limitations on the scalability of existing stories.

2.2 Logic Control in Interactive Storytelling

From the story point of view, logic control concerns the causal relations between events, as a key is to the lock it opens and a pen to the words it writes. When dealing with logic in stories, we are evaluating the causality of the author's creation in order to maintain believability in the audience. [12] constructs graph-like structures for multiplayer storytelling, and introduces a logical control mechanism that can adapt to user interactions dynamically. [6] introduces interactive behaviour trees as a more author-friendly and flexible option. However, these approaches could still result in dead ends when users take certain choices unexpectedly. Also, they were not designed to accommodate embedded and temporally rearranged narratives, which is one of our strengths.

For some stories, telling the story chronologically may seem like a natural decision, whereas for others, such as detective stories, readers may enjoy deciphering what happened. Currently, there are a number of papers situated to

discuss temporality in game narratives. We observe in text-based generative narratives, Montfort [8] focuses on syntactical issues, such as grammatical tense, using a tree representation of time. Lönneker [7] introduces an architecture for tense in "levels" of narrative, which is a basis for designing embedded story structures. Concerning logicality of temporal rearrangements, [10, 14] tackle problems of timing in character or agent-based planning. Similarly, Bae and Young [1] use planning methods to create temporal rearrangements, mainly to invoke surprise arousal in viewers by hiding certain information and revealing it at emotionally intense moments.

However, the aim of these methods is to generate an arrangement of events that are consistent in their presentation (discourse) into a linear story, and not to ensure logic consistency of story content when user choices can have a strong impact on the plot. In contrast, our method maintains logic through an algorithm that enforces pre- and post-conditions while maintaining interactivity by producing a subgraph of all feasible paths (and not just one arrangement).

3 Overview

For the implementation of story logic control, we design a workflow for game narratives comprised of three components: (1) authoring, (2) logic control over temporality and user interactions, and (3) 3D presentation. The relation between the components of the framework and the presentation platform are shown in Fig. 1.

Fig. 1. In the system, the author can design story and animation content, and set authorial goals. The logic control uses a double traversal algorithm that checks and filters story nodes and edges so that no dead ends would result from user decisions.

The authoring component involves authoring of the basic event of the story, and linking them up into a story graph. The logic control then takes over to ensure pre- and post- conditions on each event is upheld, and removes any illogicalities in the story graph. Finally, the method is linked to a 3D presentation and allows users to experience and interact with the story in real time. The next section begins to outline our method by explaining the story representation: the

basic story units, the story graph, and how the story graph represents complex structures such as embedded plotlines.

4 Story Representation

Here we introduce the authoring of the graph-based story representation for the purpose of demonstrating the logic control. Note that, in this section though we coin the term "authoring" to describe the process of building the story graph, the story graph does not necessarily have to be manually authored. We envision the capability of planning or search algorithms that could generate such a story graph. The story graph is therefore intended to be seen as a formalisation or a generalisation of graph-based representations of branching narratives that are widely used in current games.

4.1 The Building Blocks of Story

Interactive narratives for games are often comprised of basic units of action, dialogue, and visuals or audio effects. In this paper, we refer to these units as plotpoints.

To help the logic control identify the plotpoints, postconditions can be attached to the plotpoint, and serve as markers that the logic control can evaluate. Postconditions have either boolean values (e.g. the plotpoint concerns "Sara", "murder", and "mansion") or integer values (e.g. the plotpoint has the effects of "happy+=1"). Using the above postconditions as an example, if the story goes through a plotpoint that has the postconditions "murder;happy+=1" then the global parameter "murder" is assigned the value of "true" while the value of the global parameter "happy" is incremented by 1.

The plotpoints do not need to be authored in any specific order, and any postconditions can be attached to the plotpoints, which act like postconditions that can be evaluated later on in the story. We do not restrict the size, content, or scope of a plotpoint. A story, or even multiple varying stories can be composed out of the plotpoints simply by linking them in a specified order. The linking and maintaining of logic between plotpoints is described below.

4.2 Establishing Local Story Logic

On their own, each story plotpoint simply represents a unit within the story. When a number of plotpoints related to a same scene are grouped together, we call the grouped plotpoints a "move" adopting the terminology from [11] to describe a complete sequence.

But a number of questions remain: How is each plotpoint within a move related to other plotpoints? Arrangements of the plotpoints within the move are achieved by linking plotpoints to each other with directed edges that specify a total order between plotpoints. Plotpoints can exist in moves without any edges, but then signifies that the plotpoint has no logical relation with any other

plotpoint in the move. Every move has an empty entering and exiting plotpoint (Fig. 2). The first plotpoint in the move is the entering plotpoint, which directs to all the plotpoints that can serve as the first action in the move. All plotpoints that are the last plotpoint in the move point to an exiting plotpoint, which is either a concluding point in the story (thus a "The End" of the story), or the entrance point of another move.

The story representation can also allow embedding, which refers to the process of jumping back and forth to an external move B from a plot point in move A: Optionally, a plotpoint within move A can also embed to another move C. Upon finishing the plotpoint, the story plays the embedded move B (suspending the current point in move A) and when move B is finished, the story returns to the embedding plotpoint in move A.

Apart from the order of the events, edges are also a way to control logic. Preconditions can be placed on the edges, such as the boolean precondition "$murder = $ false" (meaning that a plotpoint with the postcondition tag "murder" must not precede this plotpoint) or "$happy \geq 2$" (meaning that the integer postcondition "happy" must have a value of 2 or more at this point). These preconditions can be grouped with boolean operators (**AND**, **OR**, and **NOT**) to form evolved preconditions to control the story. As edges can be placed between any two plotpoints that can logically follow each other, we can envision many circumstances when one node can have two or more exiting edges pointing to different story nodes respectively. Note that preconditions are placed on edges linking plotpoints, and not on plotpoints themselves, keeping the plotpoint as minimal as possible so that it may be reused in multiple stories flexibly. This is an important property in the story graph, where the plot line actually branches: the separation of the plot leading from a plotpoint is where user intervention can change the outcome of the story (by leading to different end nodes within the story graph).

5 Logic Control

Once the story graph has been either manually designed or generated by algorithms, we then demonstrate our method to perform logic control on this representation. Story logic comes into light as the author wants to achieve storytelling goals while managing user interaction in possibly non-chronological story lines. Like matching keys to their locks, the process of establishing story logic requires a series of pre- and postconditions; the more elaborate the plot design, the more complicated this web of preconditions, and the higher likelihood of dead ends, unresolvable user interactions, or unachievable story goals.

In this section, we introduce our logic control method over the generic story graph. The method is designed to assist the author in specifying global authorial goals, evaluate the sequence of events, and automatically manage story logic during runtime.

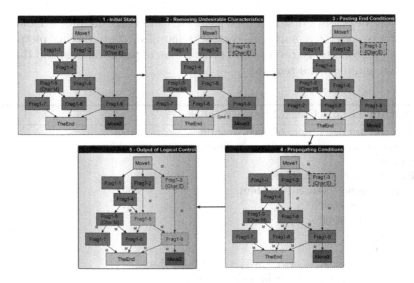

Fig. 2. Given an authored move and authorial goal ¬ E ∧ M ("(**NOT** Evil) **AND** Magic"), the algorithm (1) removes plotpoints contradicting the goal (E), (2) pastes the goal (M) as an end precondition, (3) reverses and (4) propagates the preconditions on all edges, and (5) removes dead ends. As a result, remaining paths ensure the story logic as well as authorial goals.

5.1 Authorial Goals

Authorial goals are defined as the storytelling goals that the author wants to achieve. The design of authorial goals corresponds with Chatman's theory of modes of plot, where certain combinations of postconditions will result in specific emotions in the audience. For example, Chatman defines that a good hero that fails will arouse sympathy, while an evil hero that succeeds invokes a feeling of disgust. Such statements can be easily expressed as preconditions on the story graph as an evaluation of the postconditions of the plotpoints that occur in the story. Taking tan example, "**AND** $(HeroFail = \text{true}; HeroKindness \geq 2)$" and "**AND** $(HeroFail = \text{false}; HeroKindness \leq -2)$" respectively, where in the story graph, there are ending nodes with boolean postconditions of $HeroFail$ and nodes that accumulate or decrement the value of the integer parameter $HeroKindness$. Authorial goals are to be placed on the whole story graph and seen as preconditions that must be fulfilled before the end of the story. If we have an authorial goal of "$Magic = \text{true}$" it would mean that somewhere in the story, there must exist a plotpoint tagged with the postcondition $Magic$.

We aim to ensure (1) that the local logic in the previous section did not resolve in any dead ends or unresolvable plot lines, and (2) that the authorial goals are ensured to be achieved (if a solution exists). We design the logic control algorithm for the purpose of upholding both the local logic and authorial goals (see Algorithm 1). The algorithm uses a double depth-first traversal to prune the story graph and output a subset of validated paths with reinforced preconditions

on the edges to ensure that authorial goals are met. There are four stages in the algorithm to carry out authorial control: removal of contradicting plotpoints, paste end preconditions, reversal and propagation of preconditions, and the final validation and dead end removal.

Algorithm 1. LogicControl (node N, goals G)

1: **if** G violates descriptors of node N **then**
2: remove node N, and node's incoming and outgoing edges
3: **end if**
4: **for all** sons s of node N **do**
5: **if** s has not been visited **then**
6: tag s as visited
7: LogicControl(s, G)
8: **end if**
9: **end for**
10: **if** all outgoing edges of N have preconditions **then**
11: **for all** outgoing edges e in node N **do**
12: $cond \leftarrow cond \vee$ preconditions in edge e
13: **end for**
14: **for all** descriptors d of node N **do**
15: $cond = $ negateDescription (d, $cond$)
16: **end for**
17: **for all** incoming edges e of node N **do**
18: add preconditions $cond$ to edge e
19: **end for**
20: **end if**

Removal of Contradictory Plotpoints. From the story representation, plotpoints can contain a number of boolean or integer postconditions. The removal of contradictory plotpoints excludes plotpoints containing undesirable boolean postconditions. The algorithm takes as input the boolean authorial goals, performs a DFS traversal on the story graph to remove any plotpoints with postconditions that contradict with the goal, where an authorial goal requires a boolean postcondition to be false. For example, for the authorial goal "**AND** ($HeroFail = $ `false`; $HeroKindness \leq -2$)" all plotpoints with the postcondition $HeroFail$ are automatically removed, since by definition, they automatically contradict the goal.

This ensures that no plotline will go through undesirable plotpoints. Boolean goals that are evaluated as true (i.e. "$SomeChar = $ `true`") as well as integer goals are not evaluated for this step.

Pasting End Preconditions. The algorithm then pastes the authorial goals as end preconditions on all the incoming edges of the end nodes. The reason for doing this is to ensure that, before the story concludes, these goals will be upheld. However, this step would result in possible unresolvable plot lines if not

all of the goals are fulfilled before the story comes up to this point. The next step, the reversal and propagation addresses this problem.

Reversal and Propagation of Preconditions. As mentioned previously, pasting goals alone cannot ensure that a story will conclude. It is possible to choose a path in the story graph that reach an end node, but cannot find any possible path that achieves the goal, thus causing the story to fail at runtime. To prevent this, our algorithm does a second traversal through the story graph bottom-up. For every plotpoint, it concatenates the preconditions from the outgoing edges, and pastes them to the incoming edges. We refer to this step as the propagation. However, this task is not just a copy-paste of preconditions from one edge to another.

Before preconditions are propagated, they are first reversed; the plotpoint checks its own postconditions against the preconditions. If a boolean precondition is fulfilled (for example, a plotpoint with the postcondition *HeroFail* is propagating the precondition "*HeroFail* = true") it will see the precondition as fulfilled, and will remove it. Integer preconditions such as "*HeroKindness* ≤ −2" are reversed by reversing the calculation done by the plotpoint (for example, the propagated precondition "*HeroKindness* ≤ −2" will be translated as a "− = 1" precondition when encountering the integer postcondition "*HeroKindness* ≤ −1"). This allows the integer value to increase and decrease freely throughout the story, thus creating highs and lows in the plotline. Finally, repeated boolean preconditions and redundant integer preconditions can be eliminated. Though not required, this step ensures that the preconditions are concise and do not expand much throughout the propagation.

Validation and Removal of Dead Ends. Since preconditions are propagated up to the top of the story graph, it is fast to identify which edges have preconditions that cannot be fulfilled. The remaining step traverses the graph once more removing any dead ends (i.e. a plotpoint with no feasible outgoing edges), then outputting the sub-graph with all the feasible plot lines.

Figure 2 illustrates this process.

5.2 Embedding

Our method can also control logic in embedded moves that represent temporal rearrangements, such as flashbacks. As described previously, an embedded move is an internal representation within the plotpoint allowing it to embed another existing move like a sub-plot.

Given a start point in the story, the story progresses sequentially and chronologically down a feasible story path. When deciding whether an embedding should occur, the algorithm checks whether the embedded move has been played before. If it hasn't, embedding occurs; otherwise, the story just continues to the next plotpoints. The algorithm automatically determines what sequence to show

events, whether an embedding should take place, records the progression of the story, and returns the story to the original point after the embedding occurs.

However, when embedding user interaction happen simultaneously, we need to ensure that user decisions extend to the embedded move at runtime. And vice versa, we need to ensure that decisions made within the embedded move extend to the rest of the story. For example, if at the story entry point, an event such as the murder of Actor C is assumed to have occurred, then in a flashback of the crime taking place, only story lines that lead up to the murder of Actor C should be feasible.

5.3 Managing of User Interactions for Embedded Storylines

The algorithm we have described above not only enforces the achievement of authorial goals over a story graph, but also reinforces local logic on the edges by propagating them until they are fulfilled. By definition of this logic control algorithm, it is guaranteed that all paths that the user may choose in the graph must have at least one feasible path (chronologically) that (1) can terminate the story, (2) achieves all the authorial goals, and (3) does not contain any illogicalities.

We designed a second algorithm for user interaction, Algorithm 2, to solve the problem of logic control for user decisions with embedding. It extends the previous algorithm by propagating, for each decision the user takes, the preconditions on the outgoing edges of the plotpoint throughout the story graph, as if they were new end preconditions. In this way, the plotpoint is ensured to be reachable and to be reached for all the remaining paths. The graph is then re-shaped for each decision. This algorithm also maintains a set of flags to record the current level of embedding, and the embedding point, ensuring that the story returns to the correct plotpoint after finishing embedding.

Algorithm 2. UserInteraction (Decision D)

1: **if** current node N has *embedding* **then**
2: *embedLevel* += 1
3: push node N into levels stack L
4: next node N' = embedding entrance point N_e
5: *embedFlag* = *true*
6: **end if**
7: **if** *embedFlag* is *false* and *embedLevel* > 0 **then**
8: current node N = pop L
9: **end if**
10: get next adjacent node N' from current node N and decision D
11: **for all** incoming edges e of node N' **do**
12: $cond \leftarrow cond \lor$ preconditions in edge e
13: **end for**
14: LogicControl(story entrance point s, *cond*)
15: **return** next node N'

Our mechanism for logic control in the stories is consistent with Branigan's mode of comprehension of narrative [2]. Each story plotpoint is understood as a bottom-up independent unit of action with certain postconditions in relation to its content, and the story graph is a top-down logic control unit, with a filtering algorithm that (i) preserves preconditions between narrative plotpoints, and (ii) assists the author in meeting authorial goals in the form of end preconditions.

6 Results

6.1 Demonstration

We integrated our logic control method and authoring interface into an interactive storytelling environment built on Unity called the "Theater". The Theater takes as input a pre-authored story graph as well as predesigned animation content for each plotpoint. It actively communicates with the logic control, presents the animation content for the plotpoints in the order designated by the logic control, requests suitable user choices and presenting them to users, and returns choices made by users.

We demonstrate the logic control on an example scenario involving a dissatisfied woman, her millionaire husband, her secret lover, and a local investigator. The woman is unhappy with her current life and wants to run away with her lover. She makes decisions on whether to confront her husband, which results in some conflicts, and the husband is killed. An investigator arrives and questions the woman. Based on the previous decision, the woman will have options to lie, to confess, to escape, or to protect her lover, each leading to different consequences.

The story has two possible initiating points: one from the chronological start, when the women decides to take action; and one is when the millionaire is already dead and the investigator arrives. The second initiating point will invoke a flashback on the woman when she recalls what had happened prior to the investigator's arrival. In both cases, the user is offered the same amount of decision, and the logic control ensures that all stories generated are plausible. The two plausible plot lines are shown in Fig. 3.

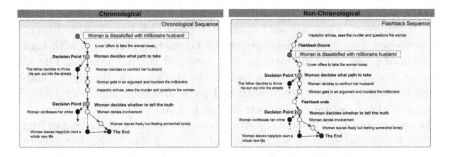

Fig. 3. The example story with two plot lines that involve non-chronological events.

The accompanying video shows the flashback version of this story, demonstrating how the logic control achieves story goals while ensuring all preconditions are met over user decisions and the non-linear storyline at runtime.

Link to video: https://vimeo.com/129289640

An addressing of all three aspects–temporality, interactivity, and authorial goals–for complex storyliens has not been displayed before in existing contributions.

6.2 Evaluation

Though an authoring interface is currently under development to evaluate the authoring potential of the story graph, we conducted a qualitative pilot study on 5 users to gain feedback on the logic control of the algorithm.

All five users were university students from different backgrounds. Each were asked to experience the story in four modes: (1) text, (2) non-interactive animated, (3) interactive animated, and (4) interactive animated with story goal (they were given the choice to select a story goal of "happy" or "sad").

In the post survey, users mentioned that while Mode 3 was more enjoyable, but Mode 4 had a higher capacity for creativity as an author. The selection of story goals offered them control over how they, as an author, would like the story to unfold. When asked what they would like to use the system for, all five users noted the control they had on the story in Mode 4, and its potential for creativity as an author. One user particularly noted from the perspective of narrative creation, he would be interested in using the system of Mode 4 by adding his own fragment to create a new storyline with a reinforced goal. Another user stated that Mode 4 would be helpful in creative writing with its branching narrative as compared to traditional linear narratives.

7 Discussion and Conclusion

One main drawback of our approach is, being a graph-based traversal, it cannot rank or evaluate the quality of a story line as planning algorithms do with well-designed heuristics. Every feasible path in the story graph is considered equally probable. Therefore, the algorithm cannot solve a problem such as searching for a best match. This maintains the simplicity of the algorithm, but limits its tolerance to what it would consider a good plot line. In this paper, we have proposed a method for logic control of interactive narratives with regards to authorial goals, user interaction, and temporal rearrangements. The algorithm we designed performs a traversal on the story graph, thereby re-shaping interactive story graphs to fulfil authorial goals and maintain story logic. We demonstrated the output of the logic control in a 3D virtual environment.

As an extension of evaluating story postconditions and understanding of story structure and content, we believe our approach can be further developed to enhance real-time context-aware storytelling techniques. The logic control could provide story level information such as emotion, timing, perspective, and

genre to the discourse level such that the virtual camera can make decisions on viewpoint and compute suitable sequences of shots. The mechanism for story filtering and authorial goal design also provides an exciting move towards even more tailored and personalised storytelling experiences for interactive digital storytelling.

References

1. Bae, B.-C., Young, R.M.: A use of flashback and foreshadowing for surprise arousal in narrative using a plan-based approach. In: Spierling, U., Szilas, N. (eds.) ICIDS 2008. LNCS, vol. 5334, pp. 156–167. Springer, Heidelberg (2008). doi:10.1007/978-3-540-89454-4_22
2. Branigan, E.: Narrative Comprehension and Film. Routledge, Abingdon (1992)
3. Brooks, K.M.: Do story agents use rocking chairs? The theory and implementation of one model for computational narrative. In: Proceedings of the Fourth ACM International Conference on Multimedia, MULTIMEDIA 1996, pp. 317–328. ACM Press (1996)
4. Carmichael, G., Mould, D.: A framework for coherent emergent stories. In: Proceedings of Foundations of Digital Games 2014, Florida, USA (2014)
5. Chatman, S.: Story and Discourse: Narrative Structure in Fiction and Film. Conell University Press, Ithaca (1980)
6. Kapadia, M., Falk, J., Fabio, Z., Marti, M., Sumner, R.W.: Computer-assisted authoring of interactive narratives. In: ACM SIGGRAPH Symposium on Interactive 3D Graphics and Games (i3D), vol. 2 (2015)
7. Lönneker, B.: Narratological knowledge for natural language generation. In: Wilcock, G., Jokinen, K., Mellish, C., Reiter, E. (eds.) Proceedings of the 10th European Workshop on Natural Language Generation (ENLG 2005), Aberdeen, Scotland, pp. 91–100, August 2005
8. Montfort, N.: Ordering events in interactive fiction narratives. In: Proceedings of the AAAI Fall Symposium on Intelligent Narrative Technologies, pp. 87–94 (2007)
9. Nelson, M.J., Mateas, M.: Search-based drama management in the interactive fiction anchorhead. In: Proceedings of the First Annual Conference on Artificial Intelligence and Interactive Digital Entertainment, pp. 99–104 (2005)
10. Porteous, J., Teutenberg, J., Charles, F., Cavazza, M.: Controlling narrative time in interactive storytelling. In: The 10th International Conference on Autonomous Agents and Multiagent Systems, AAMAS 2011, vol. 2, pp. 449–456. International Foundation for Autonomous Agents and Multiagent Systems, Richland (2011)
11. Propp, V.: Morphology of the Folktale, 2nd edn. University of Texas Press, Austin (1968)
12. Riedl, M., Li, B., Ai, H., Ram, A.: Robust and authorable multiplayer storytelling experiences. In: Proceedings of the Seventh International Conference on Artificial Intelligence and Interactive Digital Entertainment, pp. 189–194 (2011)
13. Ryan, M.: Avatars of Story. University of Minnesota Press, Minneapolis (2006)
14. Shoulson, A., Gilbert, M.L., Kapadia, M., Badler, N.I.: An event-centric planning approach for dynamic real-time narrative. In: Proceedings of the Motion on Games - MIG 2013, pp. 99–108. ACM Press, Dubin (2013)
15. Weyhrauch, P.W.: Guiding interactive drama. Ph.D. thesis, Pittsburgh, PA, USA (1997)

Usability Evaluation Methods of User Interface Based on Mobile Games Using Fuzzy Methods

Mengtian Cui[1] and Libo Zhu[2(✉)]

[1] School of Computer Science and Technology,
Southwest University for Nationalities, Chengdu 610041, China
[2] School of Computer and Information Engineering,
Inner Mongolia Normal University, Hohhot 010000, China
Happyzgl@163.com

Abstract. The usability evaluation methods of user interface based on mobile games was introduced in the paper. User usability evaluation model about mobile games were established based on user interview and questionnaire. Then, each evaluation item was analyzed and their weights were determined using the Delphi methods and mobile game interface usability index weight level distribution map was obtained. In addition, the methods of gray correlation analysis were proposed to optimize evaluation system model. Meanwhile, the methods of fuzzy comprehensive evaluation were given and the influence factors were found using the principle of maximum degree of membership. In the end, the example provided demonstrates the most satisfied user interface of mobile games is selected and it was proved that the methods proposed is efficient.

Keywords: User interface · Software usability · Fuzzy comprehensive evaluation · Delphi largest · Membership degree

1 Introduction

With the mobile Internet and mobile terminal performance continues to improve and perfect, the rapid growth of mobile phone game business is likely as a stone, and become a be worthy of the name "gold mine" [1, 2]. Along with the development of mobile phone game, the new supersedes the old-faster and homogeneity, resulting in greater range of users [3, 4]. Market competition situation is far more serious. The availability of this game software determines the success or failure of a mobile phone game [5, 6]. However, How to design the mobile games and how to evaluate them have been a focus. Indeed, it is important to evaluate the mobile games. In a recent study, many works have been done by researcher in the fields. During among them, the analytic hierarchy process has been paid more attention. The analytic hierarchy process (referred to as AHP) is proposed first by Saaty [7], which provides a novel, simple and practical modeling method for the decision making and ranking of this class of the more complex, more fuzzy problem, and it is especially suitable for solve the problem which is difficult to quantitatively analyze. Based on this, Zhang et al. [8] constructed trustworthy metrics models for internet based architecture to support reliable analysis, who first proposed the software trustworthiness evaluation should be the testing process

© Springer International Publishing AG 2017
Y. Chen et al. (Eds.): SG 2015, LNCS 9317, pp. 124–131, 2017.
DOI: 10.1007/978-3-319-53838-9_10

of trusted as the premise, which weakened the influence of subjective assessment of the results. Cai et al. [9] proposed software reliability model on the neural network approach. Erol and Ferrell [10] proposed a methodology for selection problems with multiple, conflicting objective and both qualitative and quantitative criteria. But these evaluation methods above and evaluation model are not suitable for the evaluation of the game's user interface. In the paper, the usability evaluation methods of user interface based on mobile games is proposed, AHP and Gray correlation comprehensive evaluation method are proposed to determine the weight of the sub-attributes and user interview and questionnaire is used to obtain the data, In the end, an example is used to illustrate the effectiveness of the model.

This paper includes five parts. In the first part, purpose of the paper is introduced and the user interface usability evaluation system based on mobile games is establishment in the second part. In the third part, user interface evaluation set based on mobile game is determined and the weight distributed. In the fourth part, establishment of comprehensive evaluation model of user interface. In the end, an example provided proved that the methods proposed are efficient.

2 Establishment of Usability User Interface Evaluation System on Mobile Games

In this paper, In order to ensure the objectivity and reliability of the index weight, 30 experts are invited to do the questionnaire in the paper and the weight of the index system was determined. About 200 questionnaires were issued, 176 valid questionnaires, the method for experts and scholars in related fields. The information feedback from experts is analyzed by the methods of Delphy Fa [7–10]. By using the fuzzy comprehensive evaluation method and the existing research foundation, established the evaluation index system U of the availability of mobile phone game software has credibility, which is shown in Table 1.

Table 1. The evaluation index system of the usability of the mobile phone game

First class index	Sub-level index
Understandability U_1	Tourist brochure U_{11}
	Function name U_{12}
	Manual U_{13}
Learnability U_2	None
Easy operation U_3	Friendlines s U_{31}
	Rationality U_{32}
	Simplicity U_{33}
Customization U_4	Iterative update U_{41}
	Independent customization U_{42}

3 Determination of Evaluation Set and Distribution of Weight

3.1 Determination of User Interface Evaluation Set

Suppose $v = \{v_1, v_2, \cdots, v_n\}$ is the evaluation of evaluation objects evaluation may make all the results of composition comment level sets [7–10].

Here, v_j is for the evaluation results of j, $j = 1, 2, \cdots, n$. Here, n is for the total number of evaluation results. Generally divided into levels 3 to 5. According to the fuzzy analysis method, the evaluation grade is divided into four grades, which is expressed as $v = \{excellent, good, intermediate, poor\}$, representing the user experience of mobile phone game software usability.

3.2 Determination of the Qualitative Index Membership Degree

For a Mobile Games software evaluation index U_i, through the evaluation of usability expert game software, construct the membership R_i which is belong to the collection of comments v. Here, the formula is $r_i = d_i/d$, where, d shows the number of experts involved in the evaluation and d_i refers to the number of experts to make the v_i evaluation of the U_i evaluation [7–10].

3.3 Establishment of Fuzzy Evaluation Matrix

In this part, First, Fuzzy Evaluation sets $v = \{excellent, good, intermediate, poor\}$ including sub-attitudes factors $U_{11}, U_{12}, U_{13}, U_{31}, U_{32}, U_{33}, U_{41}, U_{42}, U_{43}$. The eight single factor evaluation and fuzzy mapping are established, which is shown below:

$$f_i \to F(v), U_j^i \mapsto f_i\left(U_j^{(i)}\right) = \left(r_{j1}^{(i)}, r_{j2}^{(i)}, r_{j3}^{(i)}, \cdots, r_{jm}^{(i)}\right) \quad (j = 1, 2, \cdots, n) \tag{1}$$

Therefore, the fuzzy judgment matrix can be determined, which is shows as follows [7, 11–16]:

$$R_i = \begin{pmatrix} r_{11}^{(i)} & r_{12}^{(i)} & \cdots\cdots & r_{1m}^{(i)} \\ r_{21}^{(i)} & r_{22}^{(i)} & \cdots\cdots & r_{2m}^{(i)} \\ \vdots & \vdots & \ddots & \vdots \\ r_{n1}^{(i)} & r_{n2}^{(i)} & \cdots\cdots & r_{nm}^{(i)} \end{pmatrix}$$

Here, r_{nm} represent the membership degree of index $u_n^{(i)}$ which was named as v_i.

3.4 The Weight Distribution of User Interface Usability Evaluation Factors

In this paper, the popular game "happy diminish music" (referred to as A) was select as the objects of evaluation is given to illustrate the effectiveness and practicability of the

algorithm. Here, Delphy method [7–16] is introduced to determine the weight of user interface based on mobile games. The weight value of user interface each index of the mobile games A is obtained from references [7] and references [11–16]. The weight value of user interface each index of mobile game A is shown in Fig. 1.

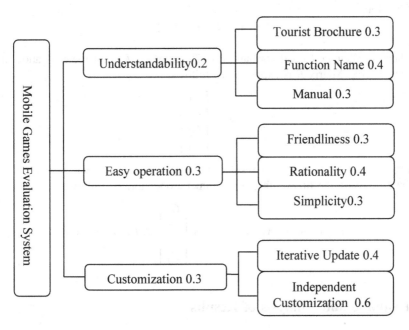

Fig. 1. The weight value of usability evaluation factors about user interface of mobile game A.

4 Establishment of Evaluation Model

In practice, the process of comprehensive evaluation is assessed using the mathematical model of multiple index comprehensive evaluation index of "synthetic" as a whole [12–14]. Here, according to the n evaluation objects, m evaluation indexes, the index value is $x_i = (x_{i1}, x_{i2}, \cdots, x_{im})(i = 1, 2, \cdots, n)$. The weight coefficient vector is corresponding to the $w = (w_1, w_2, \cdots, w_m)$. The comprehensive evaluation for the function structure $y = f(w, x)$. This is a comprehensive evaluation of the mathematical model.

Fuzzy evaluation vector is calculated according to the results of the last level index membership degree and weight step by step. First of all, by the formula (1) and formula (2), there are 12 fuzzy matrix, namely, $R_1, R_2, R_3, R_4, R_{11}, R_{12}, R_{13}, R_{31}, R_{32}, R_{33}, R_{41}, R_{42}$. Here, R_{11}, R_{12} and R_{13} is belonged to level R_1. R_{31}, R_{32} and R_{33} are belonged to level R_3. R_{41} and R_{42} is belonged to level R_4. According to the computing principle o R_{31}, R_{32}, R_{33} f step by step, The calculation formula of C_{41} and C_{42}, which are fuzzy comprehensive evaluation of the sub-attitude level index set.

$$C_{4i} = A_{4i} \circ R_{4i}, \ i = 1, 2 \tag{2}$$

$$R_4 = \left\{ \begin{array}{c} C_{41} \\ C_{42} \end{array} \right\} \tag{3}$$

Therefore,

$$C_i = A_i \circ R_i \quad i = 1, 2, 3, 4 \tag{4}$$

Then, to calculate C_i and normalized it. Here, matrix R is for the evaluation index of fuzzy matrix. Matrix R is expressed as follows.

$$R = \begin{bmatrix} C_1 \\ C_2 \\ C_3 \\ C_4 \end{bmatrix} \tag{5}$$

The vector B, the evaluation results, the indicators weight vectors A and R were obtained by using the fuzzy subset of arithmetic operator. As follows:

$$B = A \circ R = (A_1, A_2, A_3, A_4) \circ \begin{bmatrix} C_1 \\ C_2 \\ C_3 \\ C_4 \end{bmatrix} = (b_1, b_2, b_3, b_4) \tag{6}$$

5 Example and Analysis of Results

5.1 Example

In this paper the popular game "happy diminish music" was select as the objects of evaluation is given to illustrate the effectiveness and practicability of the algorithm. According to the mobile phone game software usability of five indicators and the "happy diminish music" game operation system table, asked 30 experts and scholars to fill out the form. The data obtained are shown in Table 2.

Table 2. User interface evaluation based on mobile games

Items	Evaluation			
	Excellent	Good	Intermediate	Poor
U_{11}	34	10	6	0
U_{12}	29	11	10	0
U_{13}	30	15	3	2
U_2	40	9	1	0
U_{31}	32	13	5	0
U_{32}	27	8	14	1
U_{33}	25	16	9	0
U_{41}	31	15	4	0
U_{42}	29	17	3	1

The membership is obtained from Table 2.

$$R_{11} = (0.68, 0.20, 0.12, 0)$$
$$R_{12} = (0.58, 0.22, 0.20, 0)$$
$$R_{13} = (0.60, 0.30, 0.06, 0.04)$$
$$R_2 = (0.80, 0.18, 0.02, 0)$$
$$R_{31} = (0.64, 0.26, 0.1, 0)$$
$$R_{32} = (0.54, 0.16, 0.28, 0.02)$$
$$R_{33} = (0.5, 0.32, 0.18, 0)$$
$$R_{41} = (0.62, 0.3, 0.08, 0)$$
$$R_{42} = (0.58, 0.34, 0.06, 0.02)$$

5.2 Analysis of Results

The result of fuzzy comprehensive evaluation is the evaluation of the grade of membership of fuzzy subsets. It is generally a fuzzy vector, rather than a point value. So it can provide more information than other methods. $B = (b_1, b_2, \cdots, b_n)$, which is fuzzy comprehensive evaluation results. Two methods are commonly used in it.

(1) The Principle of Maximum Degree of Membership

If the result of fuzzy comprehensive evaluation vector containing $\exists b_r = \max\limits_{1 \leq j \leq n} \{b_j\}$. Then the object to be evaluated overall belonging to B grade.

(2) The Weighted Average Principle

The grade as a relative position and make it continuous. In order to determine the amount of processing, may wish to use the level $1, 2, 3 \cdots, m$, and called it the rank of each grade. Then use the component corresponding to each grade, rank weighted summation, get the evaluation of the relative position of the object. The expression is as follows.

$$A = \frac{\sum\limits_{j=1}^{n} b_j^k \cdot j}{\sum\limits_{j=1}^{n} b_j^k} \tag{7}$$

Among them, the coefficient k is determined ($k = 1\ or\ 2$). Its purpose is to control the b_j induced effect. When $k \to \infty$, the weighted average principle is the principle of maximum degree of membership.

Here, the composition operator using the ordinary matrix multiplication algorithms. Then the following matrix is obtained from the formula (2) and formula (3).

$$R_1 = \begin{pmatrix} 0.204, 0.060, 0.036, 0.000 \\ 0.232, 0.088, 0.080, 0.000 \\ 0.180, 0.090, 0.018, 0.012 \end{pmatrix}$$

$$R_3 = \begin{pmatrix} 0.192, 0.078, 0.030, 0.000 \\ 0.216, 0.064, 0.112, 0.008 \\ 0.150, 0.096, 0.054, 0.000 \end{pmatrix}$$

$$R_4 = \begin{pmatrix} 0.248, 0.120, 0.320, 0.000 \\ 0.348, 0.204, 0.036, 0.012 \end{pmatrix}$$

The following results can be obtained from the formula (4) and formula (5).

$$R = \begin{pmatrix} 0.208, 0.080, 0.482, 0.000 \\ 0.160, 0.036, 0.004, 0.000 \\ 0.189, 0.078, 0.070, 0.003 \\ 0.308, 0.062, 0.150, 0.007 \end{pmatrix}$$

The following results can be obtained from the formula (6).

$$B = (0.2227, 0.0653, 0.1631, 0.0031)$$

It is concluded from references [7, 16] that the usability of user interface of mobile game A is evaluated as good by the principle of maximum membership degree of fuzzy comprehensive evaluation results of vector B to carry on the analysis.

6 Conclusions

Usability evaluation methods of user interface based on mobile games using fuzzy comprehensive evaluation is studied in the paper. The methods of the Delphi method were introduced and user usability evaluation influence factors model of mobile games were established based on user interview and questionnaire. Then, each evaluation item was analyzed and game software usability index weight level distribution map was obtained. In addition, the methods of gray correlation analysis were proposed to optimize evaluation system model, meanwhile, the gray correlation degree multidimensional comprehensive evaluation analysis were given and the influence factors were found using the principle of maximum degree of membership. In the end, the example provided demonstrates the most satisfied user interface of mobile games is selected and it was proved that the methods proposed is efficient.

Acknowledgements. This work was financially supported by the National Natural Science Foundation of China (Grant No. 61379019), Sichuan Provincial Science and technology projects (Grant No. 2015JY002), the Fundamental Research Funds for the Central Universities (Grant No. 2015NYB09), Major Project of Education Department in Sichuan (Grant No. 15ZA0387) and the fellowship from the China Scholarship Council (Grant No. 201508510004).

References

1. China Industry Research. Investigation of the present situation of Chinese mobile phone game market and future trend forecast report, no. 1355896 (2014)
2. Miller, J.: The user experience. IEEE Internet Comput. **9**(5), 22–35 (2005)
3. Chittaro, L., Ranon, R.: Web 3D technologies in learning, education and training: motivations, issues, opportunities. Comput. Educ. **49**, 3–18 (2007)
4. DeMacro Brow, D.: Agile User Experience design: A Practitioner's Guide to Making it Work, pp. 102–123. Mechanical Industry Press, Beijing (2014)
5. Law, E.L., Van Schaik, P.: Modelling user experience-an agenda for research and practice. Interact. Comput. **22**(5), 122–131 (2010)
6. Zhao, X., Shen, X., Qi, Y.: Interactive Web3D publishing system. Comput. Eng. **33**(22), 243–248 (2007)
7. Saaty, T.L.: The Analytical Hierarchy Process for Decisions in a Complex World. Strategy and Organization. Lifetime Learning Pub., Belmont (1982)
8. Zhang, Y., Fang, B., Xu, C.Y.: Trustworthy metrics models for internet software. Wuhan Univ. J. Nat. Sci. **13**(5), 47–552 (2008)
9. Cai, K.Y., Cai, L., Wang, W.D.: The neural network approach in software reliability modeling. J. Syst. Softw. **58**, 47–62 (2001)
10. Erol, I., Ferrell, W.G.: A methodology for selection problems with multiple, conflicting objective and both qualitative and quantitative criteria. Int. J. Prod. Econ. **86**, 187–199 (2003)
11. Heo, J., Ham, D., Park, S.: A framework for evaluating the usability of 3D websites based on multi-level, hierarchical model of usability factor. Interact. Comput. **21**(4), 46–54 (2009)
12. Hao, S.: Discrete Mathematics and Its Applications, pp. 142–150. Tsinghua University Press, Beijing (2014)
13. Xie, J., Liu, C.: The Method of Fuzzy Mathematics and its Application, pp. 89–102. Huazhong University of Science and Technology Press, Wuhan (2013)
14. Wang, P.: Fuzzy mathematics and optimization, pp. 153–162. Beijing Normal University Press, Beijing (2013)
15. Hongting, L.: Product Usability Research Methods. Fudan University Press, Shanghai (2013)
16. Zhao, Y., Luo, X.: Fuzzy evaluation method for web software trustworthiness. Comput. Appl. Res. **33**, 109–204 (2014)

A Robust Digital Image Watermarking Algorithm Based on DCT Domain for Copyright Protection

Zhen Zhou[1(✉)], Shuyu Chen[2], and Guiping Wang[3]

[1] School of Computer Science and Technology,
Southwest University for Nationalities, Chengdu, Sichuan, China
zhouzhen1302@163.com
[2] School of Software Engineering, Chongqing University, Chongqing, China
netmobilab@cqu.edu.cn
[3] College of Computer Science, Chongqing University, Chongqing, China
w_guiping@cqu.edu.cn

Abstract. With the rapid development of various digital multimedia tech-
nologies, the works, such as copying, downloading and publishing digital
multimedia works via the Internet, are made very convenient. However, it also
brings on a huge challenge to the copyright protection of digital multimedia
works. How to effectively protect and authenticate digital multimedia works on
the Internet has been a problem to be solved urgently. In this paper, a robust
digital image watermarking algorithm, which embeds a meaningful binary
image as the watermark, is proposed. Firstly, the watermarking algorithm
scrambles the binary image used as the watermark by the toral automorphism
system. Then, the discrete cosine transform on the blocks of a gay scale image
used as the carrier image are carried out and the quantization table depicted in
the JPEG standards, which are used when an image needs a relatively high
compression rate, is used to quantize the DCT coefficients. After the quantiza-
tion, some statistical characteristics of the coefficients which are still not equal to
zero will be used to implement the embedding of the watermark. Given the
embedding course of watermark mentioned above, this watermarking algorithm
is expected to have great robustness, especially to JPEG compressing. The
simulation experiment results also prove the effectiveness of the algorithm
proposed.

Keywords: Robust digital image watermark · Meaningful watermark · DCT ·
Toral automorphism · Copyright protection

1 Introduction

With the rapid development of various digital multimedia technologies, the works, such
as copying, downloading and publishing digital multimedia works via the Internet, are
made very convenient. However, it also brings on a huge challenge to the copyright
protection of digital multimedia works. How to effectively protect and authenticate
digital multimedia works on the Internet has been an increasingly important problem to

© Springer International Publishing AG 2017
Y. Chen et al. (Eds.): SG 2015, LNCS 9317, pp. 132–142, 2017.
DOI: 10.1007/978-3-319-53838-9_11

be solved. Now, the digital watermarking technology, which is a branch of the field of the information hiding technology, has been found one of the effective methods of achieving the copyright protection of digital multimedia works, and how to transmit hidden copyright information unaware via disclosed information transmissions is the major object of studies in the field of the information hiding technology.

There are many kinds of classification methods for digital watermarking techniques from different stand points. According to the location for a watermark to hide, digital watermarking techniques can be classified into two types, the time domain and transform domain digital watermarking technique. Time domain digital watermarking techniques adapt the relatively simple watermark embedding method and are of poor robustness in face of geometric attacks. Moreover, it is difficult to make a tradeoff between the capacity of a watermark embedded and its invisibility with time domain digital watermarking techniques. Compared with time domain digital watermarking techniques, transform domain digital watermarking techniques, which are of good robustness against geometric attacks and invisibility, currently get more attentions and used frequently in practical applications. Transform domain digital watermarking techniques can implement the embedding of a watermark in different transform domains, such as the DCT, DWT and DFT, and have various algorithms to hide a watermark. The variances of transform domain digital watermarking techniques in the transform domain and hiding algorithm used make the watermark embedded not vulnerable to attacks and to hardly be found. In this paper, we focus on studying and discussing the digital watermarking algorithm based on DCT. Currently, great efforts have been made to improve the performance of the digital watermarking algorithm based on DCT [1–5].

For the shortcomings of the existing digital watermarking algorithms based on DCT mentioned above, an improved one will be proposed in this paper, which applies the following four measures:

① Using a binary image, called the watermark image in this paper, which is meaningful, as the watermark to embed;
② Applying the toral automorphism mapping to scramble the watermark image before it is embedded;
③ Using the JPEG's standard quantization table to quantize the DCT coefficients (the aim of this measure will be explained in the part "Carrier Image Processing" of the Sect. 3.1);
④ Embedding the watermark by the statistic characteristics of the quantized DCT coefficients, making the watermark embedded be of better robustness, especially to the JPEG compress operation on an image;

2 Preliminaries

2.1 Meaningful Watermark

A meaningful watermark itself is understandable to people, whose advantage is that it can still be identified depending on the visual observation and understanding of people even when it is damaged because of attacks or other causes. Leveraging the strong

identifying and understanding ability of people, the meaningful watermark gets remarkably enhanced in its robustness.

2.2 Toral Automorphism Mapping

A given image, for example, the watermark image, can be scrambled and become completely amorphous by conducting the toral automorphism mapping on it. In fact an image can be seen as the sequence of pixel values arranged in a two-dimensional grid. So pixels of an image can be seen as points in a two-dimensional space with the coordinates: (i,j), $i = 1,2,\ldots,L$, $j = 1,2,\ldots,W$, where L and W respectively denotes the length and width of the image. Next an image G with size $L \times W$ will be used to illustrate the toral automorphism mapping operation on an image. For a arbitrary pixel $p(i,j)$, which has the coordinate (i,j), $1 \leq i \leq L$, $1 \leq j \leq W$, in the image G, the two-tuples $\left(X_0^{p(i,j)} = i, \ Y_0^{p(i,j)} = j \right)$ denotes the original location of $p(i,j)$ in the image G and then the toral automorphism mapping of $p(i,j)$ can be seen as a sequence of the executing of the transform F below:

$$F : \begin{bmatrix} X_{n+1}^{p(i,j)} \\ Y_{n+1}^{p(i,j)} \end{bmatrix} = \begin{bmatrix} 1 & 1 \\ k & k+1 \end{bmatrix} \begin{bmatrix} X_n^{p(i,j)} \\ Y_n^{p(i,j)} \end{bmatrix} (\text{mod} N), \ n = 0,1,2,\ldots\ldots \tag{1}$$

In the formula (1), $\left(X_n^{p(i,j)}, Y_n^{p(i,j)} \right)$ is the new coordinate of $p(i,j)$ after undergoing n times of the transform F; k acts as the secret key, which can be set arbitrarily, n denotes the current times of the transform F having been executed and N is the number of the pixels of the image G, i.e., $N = L \times W$. The principle of the toral automorphism mapping's scrambling a given image is that the image has the original locations, i.e., the original coordinates, of its pixels changed by repeatedly conducting the transform F to its pixels many times. It is note that the coordinate transform of pixels based on the toral automorphism mapping is periodic, which means after T times, i.e., the periodicity of the toral automorphism mapping, of transform F the coordinates of the pixels of an image will get same to the original ones in the image and the image will change back to the original one. The periodicity T is determined jointly by the two parameters, k and N, and obviously, it is impossible to get the original image from the scrambled one without knowing the secret key k.

Applying the toral automorphism mapping on a watermark image can not only encrypt it, but also effectively scramble it at the same time. Compared with an original watermark image, after being embedded, a scrambled one can have better robustness in face of the cutting operations on the carrier image, which is contributed to by the following two factors: 1. After being scrambled, the local information of each part of a watermark image, i.e., the pixels in each part of it, have been scattered chaotically in the scrambled one. 2. In the embedding process, the scrambled watermark image is divided into multiple blocks and the information, i.e., the pixels, included in these blocks are embedded respectively in the different blocks of the carrier image. Considering the two factors above, we can see that having been scrambled before being embedded, the watermark image can be extracted successfully having unequal amounts

of pixels in different parts rather than all pixels in a single part of it lost when the carrier image undergoes cutting operations, which means cutting operations just reduce the quality of the extracted watermark image rather than damage the integrity of it. The above discussions show that scrambling the watermark image before embedding it can effectively enhance its robustness to the shear attacks on the carrier image.

3 The Robust Digital Image Watermarking Algorithm Based on DCT Domain

3.1 Watermark Embedding

The watermark embedding operation of the algorithm proposed in this paper consists of three steps, i.e., watermark image processing, carrier image processing and watermark image embedding. In the rest part of this section the three steps will be detailed respectively.

Watermark Image Processing. In this step, the original watermark image is scrambled by the toral automorphism mapping [6, 7] and the scrambled one is to be used as the watermark image to embed. To facilitate the explanation of this step, in this paper the original watermark image W_o is set to be a binary one with the size of 32×32. To scramble W_o, the transform F shown in the formula (1) is to be executed n times $(n < T)$ for a arbitrary pixel $p(i,j)$, $1 \leq i, j \leq 32$, in W_o and each pixel will get its new coordinate $\left(X_n^{p(i,j)}, Y_n^{p(i,j)}\right)$. According to their new coordinates, the pixels in W_o will be reorganized to form the scrambled watermark image W_s.

Carrier Image Processing. The two main tasks of this step are adopting DCT transform to the carrier image and having the obtained DCT coefficient matrix quantized by the JPEG's standard quantization table. In this paper, a gray level image with the size of 256×256 is used as the carrier image O.

The DCT Transformation of the Carrier Image O. First, as shown in the Fig. 1, the carrier image O is divided into 32×32 non-overlapped blocks B_{ij}, $1 \leq i, j \leq 32$, each of which has the size of 8×8.

Then, the DCT transform is adopted respectively to image blocks obtained and then the corresponding DCT coefficient matrices $DCT(B_{ij})$, $1 \leq i, j \leq 32$, for them are

Fig. 1. The partition of the carrier image O

generated. The DCT coefficient matrix of an 8×8 image block can be illustrated with the following Fig. 2.

The symbol DC in the top left corner of the Fig. 2 represents the DCT coefficient corresponding to the direct-current (DC) component of the image block and the symbols AC_{ij}, $0 \leq i, j \leq 7$, represent the DCT coefficients corresponding to the alternating-current (AC) components of it. The frequency of the AC components AC_{ij}, $0 \leq i, j \leq 7$, correspond to increase along the two directions from DC to AC_{07} and from DC to AC_{70}, and AC_{77} is the DCT coefficient corresponding to the component with the highest frequency. It is obvious that the DCT coefficients corresponding to the direct-current (DC), middle frequency and low frequency components of the image block converge on the upper left part of the DCT coefficient matrix, while the DCT coefficients corresponding to the high frequency components on the lower right part.

Fig. 2. The DCT coefficient matrix of an 8×8 image block and the Zig-Zag scan on it

The Quantization of the DCT Coefficient Matrices of the Carrier Image O. JPEG is an effective and widely used image compression technology, which can effectively reduce the storage and network bandwidth resources needed by an image when it is stored and transmitted. Hence, to be of practical value a digital image watermarking algorithm must make the embedded watermark robust to the JPEG compression operation conducted on the carrier image. When a carrier image which has a watermark embedded in it DCT domain is compressed by JPEG, the quantization of the carrier image's DCT coefficient matrices involved in the compression process of JPEG may cause damage to the watermark embedded, imposing a negative impact on the successful extracting of the watermark as well as the correctness of the watermark extracted.

Considering the problem mentioned above the digital watermarking algorithm proposed in this paper embeds the watermark by the statistic characteristics of the carrier image's DCT coefficients which have been quantized by the standard quantization table of JPEG, making the JPEG compression operation on the carrier image friendly to the watermark embedded. For each of the DCT coefficient matrices $DCT(B_{ij})$, $1 \leq i,j \leq 32$, of the carrier image O, the quantization process, in fact, is quantizing each DCT coefficient in $DCT(B_{ij})$ respectively by different quantization step length designated. The quantization operation on DCT coefficients can be concretely defined as the following formula:

$$C^*_{km} = round(C_{km}/Q_{km}, 0), \quad 1 \leq k, \ m \leq 8 \tag{2}$$

In the formula (2), C_{km} denotes the original value of the element with the coordinate (k, m) in $DCT(B_{ij})$, Q_{km} denotes the value of the element with the coordinate (k, m) in the JPEG's standard quantization table QT, which is also a matrix with size of 8×8 and elements of which are positive integers and represent different quantization step length, and C^*_{km} denotes the quantization result of $C_{km}.DCT(B_{ij})^*$, $1 \leq i, \ j \leq 32$, will be used to denote the DCT coefficient matrices having been quantized. It is worthwhile to note that there are two types of standard quantization tables in JPEG used to respectively quantize the different components of a YUV color image, i.e., Y, U and V component, and the carrier image O in this paper being a gray level one, the standard quantization table for the Y component (i.e., luminance component) is used as QT.

Watermark Image Embedding. In this section, the concrete embedding process of the watermark image will be detailed. According to the previous description, in our algorithm the object to practically be embedded is the scrambled watermark image W_s. The 32×32 bits of information of W_s, b_{ij}, $1 \leq i, \ j \leq 32$, are respectively embedded in the corresponding $DCT(B_{ij})$, $1 \leq i, \ j \leq 32$, of the carrier image O.

In the rest part of this section, it will be further described how the embedding of b_{ij} is implemented based on the matrix shown in the Fig. 3, which is a sample of $DCT(B_{ij})^*$.

8	4	2	1	0	0	0	0
3	9	1	0	0	0	0	0
-7	-5	1	0	0	0	0	0
-3	0	-1	0	0	0	0	0
-2	0	0	0	0	0	0	0
0	0	0	0	0	0	0	0
0	0	0	0	0	0	0	0
0	0	0	0	0	0	0	0

Fig. 3. A sample of $DCT(B_{ij})^*$

In our algorithm the relationship between the amount of positive and negative numbers in $DCT(B_{ij})^*$ is used to implement the embedding of b_{ij}, which can be defined as the following inequalities (3).

$$\begin{cases} N_p > N_n, \text{ the bit embedded in } DCT(B_{ij}) \text{ is } 1 \\ N_n > N_p, \text{ the bit embedded in } DCT(B_{ij}) \text{ is } 0 \end{cases} \tag{3}$$

In the inequalities (3), N_p and N_n respectively denote the number of the positive and negative integers in $DCT(B_{ij})^*$. Then, when $b_{ij} = 1$ or $b_{ij} = 0$, the procedure of embedding b_{ij} in $DCT(B_{ij})$ can be illustrated with the Fig. 4.

In the Fig. 4, the sequence, $(C^*_{km})_1, (C^*_{km})_2, \ldots, (C^*_{km})_{64}$, generated by the operation with the number ① is the result of the Zig-Zag scan, which can be illustrated with the

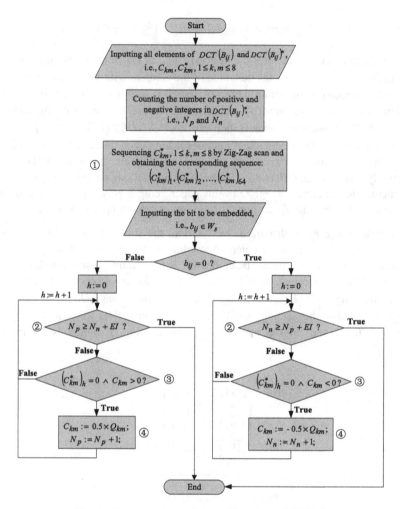

Fig. 4. The procedure of embedding b_{ij} in $DCT(B_{ij})$

Fig. 2. For an arbitrary $(C^*_{km})_h$, $1 \leq h \leq 64$, the subscript h outside the parenthesis denotes the order of C^*_{km} in the sequence. In the conditional statements with the number ②, EI is a positive integer, which denotes the watermark embedding intensity. Generally speaking, the larger EI, the more robust the watermark embedded. However, if EI were too large, the watermark embedding would cause the quality impairment of the carrier image and the usability of it would be affect adversely. In our algorithm the embedding of b_{ij} in $DCT(B_{ij})$ is achieved by making some given modifications to the elements (i.e.,C_{km}) in $DCT(B_{ij})$ selected by the conditional statements with the number ③ and then making the quantized $DCT(B_{ij})$, i.e.,$DCT(B_{ij})^*$, meet one of the two inequalities in (3) for $b_{ij} = 1$ or $b_{ij} = 0$. In order to mitigate the quality impairment of the carrier image caused by the watermark embedding, the C_{km} in $DCT(B_{ij})$ which is

greater than zero and the quantized value of which, i.e., C_{km}^*, is equal to zero is regarded as suitable to be modified and as shown in the operation with the number ④, the modifying of the selected C_{km} is to replace it with the half of the value of the corresponding Q_{km} in QT, i.e., $0.5 \times Q_{km}$, which makes the change of the selected DCT coefficients caused the modifying operations as small as possible. An instance of the watermark embedding by our algorithm is shown in the Fig. 5, where one bit information, "1" or "0", is embedded in the sample of $DCT(B_{ij})$ shown in the Fig. 3.

It is note that in Fig. 5 the replacing of the "0" elements in $DCT(B_{ij})^*$ with "0.5" or "-0.5" respectively for embedding "1" or "0" is used to simply represent the real modification of elements in $DCT(B_{ij})$ for embedding "1" or "0".

Fig. 5. An instance of embedding by our algorithm

3.2 Watermark Extracting

Watermark extracting is the reverse course of watermark embedding. In this section, the symbol O' denotes the carrier image containing the watermark image W_o; O'_{ij}, $1 \leq i, j \leq 32$, denotes the 32×32 non-overlapped blocks of O', each of which has the size of 8×8; $DCT(O'_{ij})$ and $DCT(O'_{ij})^*$, $1 \leq i, j \leq 32$, are respectively the DCT coefficient matrices corresponding to O'_{ij} and the $DCT(O'_{ij})$ quantized by the quantization table QT, which is the JPEG's standard quantization table for the Y component of a color image; W_s^E denotes the version of W_s extracted from O' and W_o^E of W_o. Then the watermark extracting procedure of our algorithm can be concretely illustrated with the Fig. 6 as follows.

Fig. 6. The watermark extracting procedure of our algorithm

It should be noted that in the descriptive statement below the arrow from the symbol W_s^E to W_o^E, T is the periodicity of the toral automorphism mapping and n is the times of the transform F taken for W_o to change to W_s.

4 Evaluation

To prove the effectiveness of the algorithm proposed in this paper, we have done correlative simulation experiments based on Matlab 6.5. In these experiments the standard 256×256 gray level image "Lena" is used as the carrier image and a 8×8 binary image as the watermark image. The parameters EI (see the correlative explanations for Fig. 4) and k (see the correlative descriptions in Sect. 2.2) involved in our algorithm are set during the experiments by the same way, that is, $EI = 5$ and $k = 5$. Concretely, we design two groups of experiments for different evaluation objectives. In the first group, the watermark image is embedded in the carrier image by our algorithm and then the PSNR (peak signal-to-noise ratio) of the carrier image is computed to evaluate the quality of it after the embedding of the watermark image. Our experiment result show the PSNR of the carrier image containing the watermark image is 35.662.

In the second group, first, the watermark image is embedded in the carrier image by our algorithm; then, different operations, such as shearing, JPEG compression, noise adding and filtering, are executed on the carrier image; at last, the watermark image is extracted and the Normalized Correlation of the original watermark image W_o and extracted one W_o^E, $NC(W_o, W_o^E)$, is computed according to the formula (4) to evaluate the similarity between them. The $NC(W_o, W_o^E)$ for the time when different operations mentioned above are executed on the carrier image are shown respectively in the Fig. 7 and the Tables 1, 2 and 3.

Different shearing operations on the carrier image

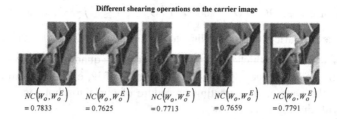

$NC(w_o, w_o^E)$ $NC(w_o, w_o^E)$ $NC(w_o, w_o^E)$ $NC(w_o, w_o^E)$ $NC(w_o, w_o^E)$
$= 0.7833$ $= 0.7625$ $= 0.7713$ $= 0.7659$ $= 0.7791$

Fig. 7. The $NC(W_o, W_o^E)$ with shearing operation on the carrier image

Table 1. The $NC(W_o, W_o^E)$ with JPEG compression operation on the carrier image

Quality	70%	60%	50%	40%	30%
$NC(W_o, W_o^E)$	0.9981	0.9897	0.9786	0.9399	0.9165

Table 2. The $NC(W_o, W_o^E)$ with noise adding operation on the carrier image

The types of noise added	Gauss noise $(\mu = 0,\ \delta = 0.005)$	Salt noise $(strength = 0.04)$
$NC(W_o, W_o^E)$	0.9867	0.9541

Table 3. The $NC(W_o, W_o^E)$ with filtering operation on the carrier image

The types of filtering	Median filtering (3×3)	Low-pass filtering (3×3)
$NC(W_o, W_o^E)$	0.9356	0.9459

$$NC(W_o, W_o^E) = \frac{\sum_i \sum_j W_o(i,j) \times W_o^E(i,j)}{\sum_i \sum_j W_o(i,j)^2} \qquad (4)$$

The experiment results above show that our algorithm can embed the watermark image with limited quality impairment happening on the carrier image and that the watermark image embedded by our algorithm is robust to JPEG compression as well as various shearing, noise adding and filtering operations.

5 Conclusion

In this paper, we propose a robust digital image watermarking algorithm based on DCT domain, which has the following features and superiority. First, in our algorithm the statistical characteristics of the DCT coefficients which correspond to the middle and high frequency components of the carrier image are used to implement the embedding of the watermark image, which makes the watermark image robust to the noise adding and smoothing operations (such as, low-pass filtering) on the carrier image. Second, our algorithm uses a meaningful binary image as the watermark image, enhancing the identifiability and then the robustness of the watermark image greatly when it is damaged because of attacks or other causes by leveraging the strong identifying and understanding ability of people. At the same time, our algorithm has the watermark image scrambled by the toral automorphism mapping, which gets the local information (i.e., bits) of each part of the watermark image dispersedly embedded in the carrier image, enhancing the robustness of the watermark image effectively in the face of the local tampering or shearing attacks on the carrier image. Third, in our algorithm the watermark image is embedded by the statistic characteristics of the carrier image's DCT coefficients which have been quantized by the standard quantization table of JPEG, which makes the JPEG compression operation on the carrier image friendly to the watermark image, making the watermark image robust to the widely used JPEG compression.

The effectiveness of our algorithm has been proved by the results of the correlative simulation experiments in the Sect. 4 and in the future the similar research will be made for different types of watermark carriers, such as, color images and videos.

Acknowledgements. We are grateful to the editor and anonymous reviewers for their valuable comments on this paper. The work of this paper is supported by National Natural Science Foundation of China (Grant No. 61272399).

References

1. Lamri, L., Omar, T.: A semi-blind robust DCT watermarking approach for sensitive text images. Arab. J. Sci. Eng. **40**(4), 1097–1109 (2015)
2. Aherrahrou, N., Tairi, H.: An improved images watermarking scheme using FABEMD decomposition and DCT. In: Elmoataz, A., Mammass, D., Lezoray, O., Nouboud, F., Aboutajdine, D. (eds.) ICISP 2012. LNCS, vol. 7340, pp. 307–315. Springer, Heidelberg (2012). doi:10.1007/978-3-642-31254-0_35
3. Phadikar, A., Santi, P.M., Verma, B.: Region based QIM digital watermarking scheme for image database in DCT domain. Comput. Electr. Eng. **37**, 339–355 (2011)
4. Tewari, T.K., Saxena, V.: An improved and robust DCT based digital image watermarking scheme. Int. J. Comput. Appl. **3**(1), 28–32 (2010)
5. Hernández, J.R., Amado, M., Pérez, G.F.: DCT-domain watermarking techniques for still images: detector performance analysis and a new structure. IEEE Trans. Image Process. **9**(1), 55–56 (2000)
6. Arrowsmith, D.K., Place, C.M.: An Introduction to Dynamical System. Cambridge University Press, Cambridge (1990)
7. Voyatzis, G., Pitas, I.: Digital image watermarking using mixing system. Comput. Graph. **22**(4), 405–416 (1998)

Image Processing

The Performance Analysis of Low-Resolution Paintings for Computational Aesthetics

Juan Zhu[1], Yuan yuan Pu[1,2(✉)], Dan Xu[1,2], Wen hua Qian[1], and Li qing Wang[2]

[1] School of Information Science and Engineering,
Yunnan University, Kunming 650091, China
km_pyy@126.com
[2] Digital Media Technology Key Laboratory of Universities in Yunnan,
Yunnan University, Kunming 650091, China

Abstract. In the study of computational aesthetics, we always use high-resolution paintings to analyze painting style, but actually the paintings we obtain mostly are low-resolution. In this paper, the contrast experiments based on sparse coding are carried out between high and low resolution paintings. Different features are extracted in frequency domain and Gabor domain from the basis function of sparse coding (SC). Then the normalized mutual information (NMI) is figured out to analyze the effect of different features for painting style. At last, the features with better performance are used to classify the paintings' style. The results of experiments show that, to a certain extent, the features extracted from low-resolution paintings still have the ability to characterize the painting style, among which the Gabor energy has the best effect in the painting style analysis.

Keywords: Computational aesthetics · Image resolution · Sparse coding · Feature extraction · Normalized mutual information

1 Introduction

Computational aesthetics is a very important field in compute vision. In 1933, George David Birkhoff firstly proposed the quantification theory of aesthetics in his book "Aesthetic Measure" [1]. We call it the beginning of the computation aesthetic because the calculation method is used in this theory. In 2005, Hoenig [2] defined the computational aesthetics: computational aesthetics is a kind of computational method that can make the aesthetics judgment with respect to human. By 2012, Galanter [3] evaluated the past and future of computational aesthetics. So far, there have been a lot of methods used in computational aesthetics. For example, Miquel Feixas and others used the method of information theory [4–6] to analyze Van Gogh's paintings. Graham et al. [7] used the method of Multi-scale to test and research the similarity among art works. Taylor et al. [8] used the fractal analysis method to analyze Pollock's drip paintings. Claro et al. [9] used the microspectrofluorimetry method to analyze and identify the red parts between Van Gogh's works and ancient Indian imitations. In addition, harmonic analysis [10], Digital analysis of Van Gogh's complementary

© Springer International Publishing AG 2017
Y. Chen et al. (Eds.): SG 2015, LNCS 9317, pp. 145–154, 2017.
DOI: 10.1007/978-3-319-53838-9_12

colours [11], wavelet analysis [12], information entropy [13] and other methods have been widely used in the painting style analysis.

Sparse coding is an interdiscipline of computer graphics, biology neuroscience, psychology and statistics. The method decomposes the images that have the same style into a series of linear combination of the basis function and the sparse coefficient. The basis function trained by standard sparse coding algorithm can reflect the essential characteristics of paintings and has the relative stability and universal applicability. It can also remove image redundancy effectively and get the independent painting features and enlarge distance of different kinds of image features at the same time. Hughes et al. [14] used sparse coding to distinguish Pieter Bruegel's paintings from the fake. And then, Hughes et al. [15] analyzed the painting style by comparing higher-order spatial statistics and perceptual judgments based on sparse coding. Liu et al. [16, 17] used sparse coding to analyze Van Gogh's painting style. These studies have achieved good results, but they were made based on the high-resolution paintings. In reality, the high-resolution paintings are difficult to obtain. In order to reduce the image storage and be easy to network transmission, the resolution of paintings is decreased in digital process. The paintings of famous artists that we can enjoy in the website almost are low-resolution. If we use these low-resolution paintings obtained from the network to analyze painting style, what will the result be?

Based on sparse coding, contrast experiments were carried out on high and low resolution paintings in this paper. The basis functions of sparse coding were trained from the same paintings of high and low resolution. And features were extracted in Gabor domain and frequency domain from the trained basis functions. Then the normalized mutual information (NMI) was figured out, the value of NMI was used to analyze the painting style. At last, we used the feature with better performance to judge the painting style.

2 Paintings Used in This Paper

The paintings we used were a collection of Van Gogh, Monet, Renoir and Da Vinci. Van Gogh, Monet and Renoir are the representatives of impressionist, and their painting style is different from Da Vinci's. Van Gogh's paintings were used to evaluate the ability of features extracted from high and low resolution paintings in analyzing painting style. Monet, Renoir and Da Vinci's paintings were used to classify the paintings' style. The quantity, resolution and representative works of different artists used in this paper are shown in Table 1.

3 Experiments and Results Analysis

3.1 Performance Evaluation of Features Extracted from Low-Resolution Paintings

Liu et al. [16] found the basis functions of the high-resolution paintings can well represent the different styles of paintings, to a certain extent. Whether or not can we get

Table 1. The quantity, resolution and representative works of paintings

Category		Van Gogh	Monet	Renoir	Da Vinci
High-resolution	Quantity	100	50	20	20
	Resolution	> 1024*1024	> 1024*1024	> 1024*1024	> 1024*1024
Low-resolution	Quantity	100	30	0	0
	Resolution	256*256 ~ 1024*1024	256*256 ~ 1024*1024	256*256 ~ 1024*1024	256*256 ~ 1024*1024
Representative works					

the same conclusion that the basis functions of the low-resolution paintings can represent the painters' style as well as those of the high-resolution paintings? In this paper we use the same methods in [16] to find the answer.

The experiment steps in [16] are as follows.

(1) Use standard SC algorithm to train images of Paris Period, Arles Period, Saint-Rémy Period, Auvers Period and the overall group to obtain the basis function.

(2) Work out the statistics of the base function including Gabor energy, peak direction, peak space frequency, direction bandwidth, space frequency bandwidth, peak direction-peak space frequency joint distribution and direction bandwidth-space frequency bandwidth joint distribution.

(3) Work out NMI using cluster analysis between the overall group and other groups.

(4) Compare the NMI of the different parameters and draw the conclusion.

In order to make a comparison with the results of [16], the same Van Gogh's paintings in [16] with high and low resolution are used in this paper. The group and quantity of these paintings are shown in Table 2.

Table 2. The group and quantity of Van Gogh's paintings

Group	High-resolution	Low-resolution
Paris Period (1886.3–1888.2)	20	20
Arles Period (1888.2–1889.5)	20	20
Saint-Rémy Period (1889.5–1890.5)	20	20
Auvers Period (1890.5–1890.7)	20	20
Overall of Van Gogh	20 (5 of each period)	20 (5 of each period)

3.1.1 The Comparison of Basis Functions Trained from High and Low Resolution Paintings

We compare the basis functions of Van Gogh's low-resolution paintings with that in [16], the results are shown in Fig. 1.

From Fig. 1, we can see that the length of lines in Auvers Period's basis function is shorter than that of Paris Period's. This is consistent with critics' view that Van Gogh was influenced by pointillist style, and his brush became short in his late year paintings. Liu et al. worked out the length of lines in Van Gogh's basis functions in [17], also found that the length of lines in Auvers Period's basis function is shorter than Paris Period's. Compared with the results of Van Gogh's high-resolution paintings, we find that the length of lines in basis functions of Van Gogh's low-resolution paintings also showed the same result. That is to say, the basis functions of low-resolution paintings have the ability to represent artists' painting style.

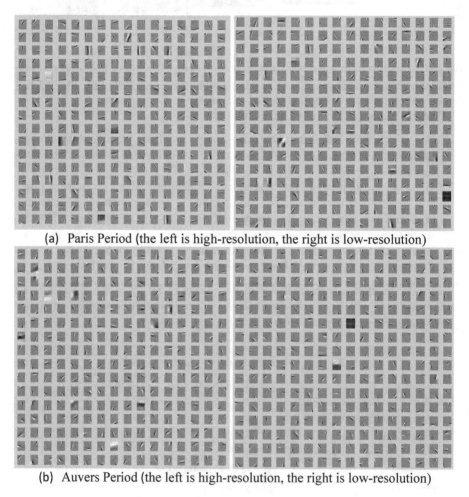

(a) Paris Period (the left is high-resolution, the right is low-resolution)

(b) Auvers Period (the left is high-resolution, the right is low-resolution)

Fig. 1. Comparison of basis functions of Van Gogh's high and low resolution paintings

3.1.2 The Performance Comparison of Features Between High and Low Resolution Paintings

From basis functions, although we can observe the differences of painting style visually, how to quantify them? We extract the same features in [16] from low-resolution paintings in this paper, and analyze whether these features have the same performance with the ones of the high-resolution paintings in [16].

We extract features from Van Gogh's overall group and other four groups in this paper, and work out the NMI of features between the overall group and other groups. The NMI is a method that can used to measure the similarity between two groups of set, the higher NMI, the more similar two groups of set are.

Specific calculation steps of *NMI* are as follows.

(1) Cluster the basis functions of group Van Gogh overall and each other group for each characteristic into matrix X and Y.

(2) Calculate the Mutual Information between X and Y.

$$
\begin{aligned}
I(X;Y) &= \sum_i \sum_j P(x_i, y_j) \log \frac{P(x_i, y_j)}{P(x_i)P(y_j)} \\
&= \sum_i \sum_j P(x_i|y_j)P(y_j) \log \frac{P(x_i|y_j)P(y_j)}{P(x_i)P(y_j)}
\end{aligned}
\tag{1}
$$

(3) Calculate the Information Entropy between X and Y respectively.

$$
H(X) = -\sum_i P(x_i) \log P(x_i)
\tag{2}
$$

$$
H(Y) = -\sum_j P(y_j) \log P(y_j)
\tag{3}
$$

(4) Calculate the Normalized Mutual Information

$$
NMI(X, Y) = \frac{I(X;Y)}{[H(X) + H(Y)]/2}
\tag{4}
$$

Since the paintings in this experiment were all drawn by Van Gogh and share the same style of drawing, a high NMI shows that the specified measure of characteristic has better effect in style analysis. The NMI of low-resolution paintings and the NMI of high-resolution paintings in [16] are shown in Fig. 2.

In the left column of Fig. 2, it can be seen that the NMI calculated by Gabor energy is obviously higher than that calculated by other features, which means Gabor energy is more effective in style analysis. In contrast, the NMI of low-resolution also shows the same result. That is to say features extracted from low-resolution paintings have the ability to descriptive painting style, and Gabor energy has the best effect in style analysis.

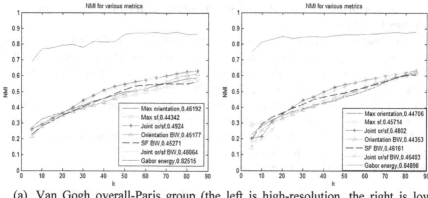

(a) Van Gogh overall-Paris group (the left is high-resolution, the right is low-resolution)

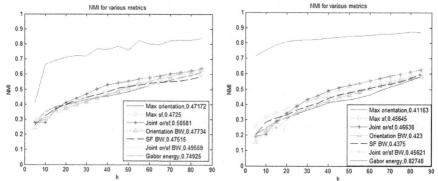

(b) Van Gogh overall-Auvers group (the left is high-resolution, the right is low-resolution)

Fig. 2. NMI of high and low resolution paintings

3.1.3 The Comparison Analysis of van Gogh's Paintings Based on Gabor Energy

To further test the performance of Gabor energy, we use it to analyze Van Gogh's style. As stated before, Van Gogh's paintings are divided into four periods: Paris Period, Arles Period, Saint-Rémy Period, and Auvers Period, but among the four periods, which one has the most representative for Van Gogh's painting style? In [16], for the high-resolution paintings, it was proved that in the four periods of Van Gogh's artworks, those of the Paris Period is more similar to the overall artworks. In other words, artworks of the Paris Period can represent Van Gogh's art style best, followed by Arles Period and Saint-Rémy Period. Can Van Gogh's low-resolution paintings also get a similar conclusion? We repeat the experiments of [16] using low-resolution paintings. Meanwhile, in order to compare the differences among artists, we added Monet's paintings. The results are shown in Fig. 3.

From Fig. 3(b), we can see the value of NIM of Paris Period paintings is the highest. It means that the Paris Period is more similar to the overall. And the value of

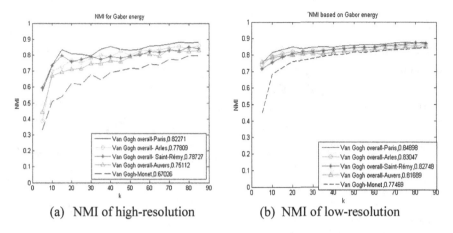

(a) NMI of high-resolution (b) NMI of low-resolution

Fig. 3. NMI of Gabor energy for high and low resolution paintings

NMI of Van Gogh-Monet group is obviously lower than the other groups, showing the biggest difference. That is to say, paintings of Monet are the most different from the Van Gogh style, and Gabor energy can used to distinguish Van Gogh and Monet's paintings. These agree with those in [16] based on high-resolution paintings. So features extracted from low-resolution paintings can be used to analyze the painting style.

In conclusion, based on sparse coding, high and low resolution paintings can obtain similar results in analyzing painting style. So, the low-resolution paintings can be used for painting style analysis.

3.2 The Experiments for Painting Style Classification

Because Gabor energy has the best performance for painting style analysis, we use it to classify the painting styles. Van Gogh, Monet, Renoir and Da Vinci's paintings are used in the style classification experiment. Firstly, we use Van Gogh, Monet, Renoir and Da Vinci's paintings to train four basis functions and calculate their Gabor energy. We call them style detectors, respectively named by T_v, T_m, T_r and T_d. Secondly, select 60 paintings of Van Gogh and 60 paintings of Monet as test images and extract Gabor energy from their basis functions. Thirdly, figure out the values of NMI between the test images and the four detectors respectively. The style of the test painting will be determined by the style of detector which has the highest value of NMI. The classification results are shown in Fig. 4.

As can be seen from Fig. 4(a), all of the values of NMI between Van Gogh's test paintings and Van Gogh's detector are the highest than those of the other three detectors. It means that the entire test paintings of Van Gogh are classified as the Van Gogh style correctly. For example, the values of NMI of Van Gogh's "self-portrait" with the detectors of T_v, T_m, T_r and T_d are 0.79933, 0.77381, 0.75504 and 0.71770. The max value of NMI is from the detector of T_v. For the same, from Fig. 4(b) we can see that, all of the values of NMI between Monet's test paintings and Monet detector

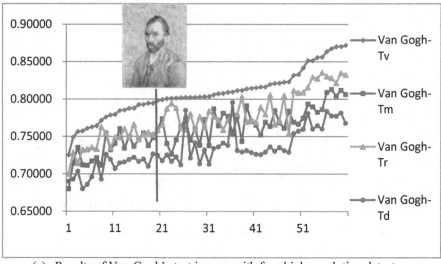

(a) Results of Van Gogh's test images with four high-resolution detectors

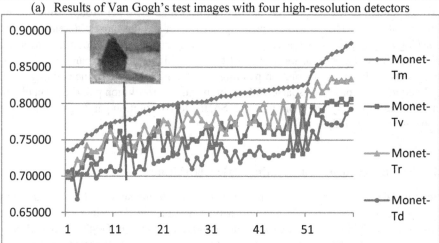

(b) Results of Monet's test images with four high-resolution detectors

Fig. 4. Classification results of Van Gogh and Monet's test paintings

are the highest than those of the other three detectors. So, all of test paintings of Monet
are classified as the Monet style correctly too. For Monet's "haystacks", the values of
NMI of this painting with the detectors of T_v, T_m, T_r and T_d are 0.73841, 0.77717,
0.74621 and 0.75314 respectively. The highest value is from the detector of Monet too.
These show again that the Gabor energy can describe the artists' painting style well and
can be used to classify the painting style.

4 Conclusion

Based on sparse coding, the contrast experiments are carried out between high and low resolution paintings to analyze painting style in this paper. We obtained that, to some extent, base functions of low-resolution paintings have the similar characteristics with those of high-resolution paintings. Then, features extracted from low-resolution paintings have similar performance with those from high-resolution paintings, and Gabor energy has the most performance in painting style analysis. Last, the classifiers of painting style designed on Gabor energy can recognize Van Gogh and Monet's paintings correctly. The results of these experiments indicate that features extracted from low-resolution paintings, to some extent, still reflect artists' painting style, and low-resolution paintings can be used in the study of painting style analysis.

There are some deficiencies in this paper. For example, the features we extracted are from the gray paintings, without considering the color features. While, we only studied the feature of the Gabor energy, other features can be used to do further research.

Acknowledgment. It is a project supported by Natural Science Foundation of P.R. China (No. 61271361, 61263048, 61163019, 61462093), the Research Foundation of Yunnan Province (2014FA021, 2014FB113), and Digital Media Technology Key Laboratory of Universities in Yunnan.

References

1. Birkhoff, G.D.: Aesthetic Measure. Harvard University Press, Cambridge (1933)
2. Hoenig, F.: Defining computational aesthetics. In: Proceedings of the First Eurographics Conference on Computational Aesthetics in Graphics, Visualization and Imaging, pp. 13–18. Eurographics Association (2005)
3. Galanter, P.: Computational aesthetic evaluation: past and future. In: McCormack, J., d'Inverno, M. (eds.) Computers and Creativity, pp. 255–293. Springer, Berlin (2012)
4. Rigau, J., Feixas, M., Sbert, M.: Image information in digital photography. In: Koch, R., Huang, F. (eds.) ACCV 2010. LNCS, vol. 6469, pp. 122–131. Springer, Heidelberg (2011). doi:10.1007/978-3-642-22819-3_13
5. Rigau, J., Feixas, M., Sbert, M., et al.: Toward Auvers period: evolution of Van Gogh's style. In: Proceedings of the Sixth International Conference on Computational Aesthetics in Graphics, Visualization and Imaging, pp. 99–106. Eurographics Association (2010)
6. Feixas, M., Bardera, A., Rigau, J., et al.: Information theory tools for image processing. Synth. Lect. Comput. Graph. Animat. **6**(1), 1–164 (2014)
7. Graham, D.J., Friedenberg, J.D., Rockmore, D.N., et al.: Mapping the similarity space of paintings: image statistics and visual perception. Vis. Cogn. **18**(4), 559–573 (2010)
8. Taylor, R.P., Micolich, A.P., Jonas, D.: Fractal analysis of Pollock's drip paintings. Nature **399**(6735), 422 (1999)
9. Claro, A., Melo, M.J., de Melo, J.S.S., et al.: Identification of red colorants in Van Gogh paintings and ancient Andean textiles by microspectrofluorimetry. J. Cult. Herit. **11**(1), 27–34 (2010)

10. Donoho, D.L., Flesia, A.G.: Can recent innovations in harmonic analysis 'explain' key findings in natural image statistics? Netw.: Comput. Neural Syst. **12**(3), 371–393 (2001)
11. Berezhnoy, I., Postma, E., Herik, D.: Digital analysis of Van Gogh's complementary colours. In: Proceedings of 16th Belgian-Dutch Conference on Artificial Intelligence, (BNAIC 2004), pp. 163–170 (2004)
12. Jafarpour, S., et al.: Stylistic analysis of paintings using wavelets and machine learning. In: European Signal Processing Conference (2009)
13. Rigau, J., Feixas, M., Sbert, M.: Informational aesthetics measures. IEEE Comput. Graph. Appl. **28**(2), 24–34 (2008)
14. Hughes, J.M., Graham, D.J., Rockmore, D.N.: Quantification of artistic style through sparse coding analysis in the drawings of Pieter Bruegel the Elder. Proc. Natl. Acad. Sci. **107**(4), 1279–1283 (2010)
15. Hughes, J.M., Graham, D.J., Jacobsen, C.R., et al.: Comparing higher-order spatial statistics and perceptual judgments in the stylometric analysis of art. In: EUSIPCO-2011, pp. 1244–1248 (2011)
16. Liu, Y., Pu, Y., Xu, D.: Computer analysis for visual art style. In: SIGGRAPH Asia 2013 Technical Briefs, p. 9. ACM (2013)
17. Liu, Y., Pu, Y., Xu, D., Ren, Y.: Digital analysis for Van Gogh's paintings. J. Syst. Simul. **27**(4), 779–785 (2015)

Using Mutual Information for Exploring Optimal Light Source Placements

Yuki Ohtaka[1], Shigeo Takahashi[2](✉), Hsiang-Yun Wu[3], and Naoya Ohta[4]

[1] The University of Tokyo, Chiba 277-8561, Japan
[2] University of Aizu, Fukushima 965-8580, Japan
takahashis@acm.org
[3] Keio University, Minato, Kanagawa 223-8522, Japan
[4] Gunma University, Maebashi, Gunma 376-8515, Japan

Abstract. Exploring optimal light sources for effectively rendering 3D scenes has been an important research theme especially in the application to computer graphics and visualization problems. Although conventional techniques provide visually plausible solutions to this problem, they did not seek meaningful correlations between proper light sources and their related attribute values. This paper presents an approach to exploring optimal light source placements by taking into account its correlations with such attribute values. Our idea lies in the novel combination of existing formulations by taking advantage of information theory. We first employ the quantized intensity level as the first attribute value together with the conventional illumination entropy so as to find the best light placement as that having the maximum mutual information. Meaningful relationships with viewpoints as the second attribute value are then studied by constructing a joint histogram of the rendered scenes, which is the quantized version of a 3D volume composed by the screen space and intensity levels. The feasibility of the proposed formulation is demonstrated through several experimental results together with simulation of illumination environments in a virtual spacecraft mission.

Keywords: Optimal light source placements · Mutual information · Joint histograms · Scene perception

1 Introduction

The placement of light sources significantly influences on the shape perception of the target 3D object especially in computer graphics and visualization. This is because it directly controls shading effects on its surfaces, and thus provides important depth cues for the 3D scene perception. Several techniques have been proposed to design effective and structured illumination setups, while it is still difficult to assess how much a specific light source can enhance the 3D perception of shape features in the corresponding 3D scene. It is also true that such shading effects also depend on the choice of the viewpoint from which we project the target object onto the projection plane. Indeed, the optimal selection of viewpoints

© Springer International Publishing AG 2017
Y. Chen et al. (Eds.): SG 2015, LNCS 9317, pp. 155–166, 2017.
DOI: 10.1007/978-3-319-53838-9_13

itself is another major research theme and a large amount of work has been done so far [16]. Although this issue has been empirically studied in photography and cinematography [10], to the best of our knowledge, only little has been done for understanding the meaningful correlation between the light source placement and viewpoint selection as computational algorithms.

In this paper, we first present an approach to quantitatively evaluating the goodness of the single light source. This is accomplished by incorporating mutual information criteria used for finding optimal viewpoints [6] and extending the conventional work on illumination entropy [7]. This formulation further motivated us to explore the meaningful relationships between the design of light sources and viewpoints. For this purpose, we newly construct a joint histogram with respect to the light sources and viewpoints, by quantizing the 2D screen space and the intensity range occupied by the rendered scene. Mutual information again helps us elucidate the robustness of the selection of light sources in terms of a set of viewpoints in this framework. Several experimental results together with simulation of illumination environments in a virtual spacecraft mission will clarify the effectiveness of the proposed approach.

The remainder of this paper is structured as follows: Sect. 2 conducts a brief survey on previous work relevant to our approach. Section 3 describes our first technical contribution for calculating of the optimal placement of a single light source using mutual information. Section 4 then presents a novel formulation for seeking meaningful correlation between the selection of light sources and viewpoints as our second contribution. Section 5 provides the simulation of illumination environments in a virtual spacecraft navigation as an application study. Finally, we conclude this paper and refer to future work in Sect. 6.

2 Related Work

Light source placement has been an important subject in computer graphics and visualization due to its potential application to enhanced 3D scene perception and lighting design. Gumhold [7] presented an entropy-based measure called illumination entropy, which evaluates the goodness of light source placement by referring to the histogram of the number of pixels with respect to intensity value. The lighting problem has been intensively studied to design interactive systems for placing light sources for illumination of 3D scenes [8,12,15] and volume visualization [24,26]. Perceptual aspects of lighting design have also been researched in recent years [14].

Optimal viewpoint selection has been tackled successfully in the relevant research areas [16]. Again the entropy-based measure has played a significant role for exploring the best viewpoints. Vázquez et al. opened this line of research where they invented the viewpoint entropy measure [21], and later incorporated the concept of view stability and depth maps of the 3D scenes [20]. The formulation of mesh saliency [13], which reveals the distribution of the visual attractiveness of the object surface shapes, has effectively been incorporated into the viewpoint selection problems [4,11]. Several different ideas were also proposed that include clustering similar views on the viewing sphere [25]. Recently,

researchers investigated the viewpoint selection problem through machine learning techniques [23] and perceptual studies [17]. Furthermore, the problem was extended to volume visualization, where several techniques have been also developed [1,9,18,19].

The formulation of mutual information has been also incorporated for sophisticating the aforementioned entropy-based formulation. Mutual information can be thought of as a tool for evaluating the degree of dependence between two probability distributions, and has been employed to define the optimal viewpoint with respect to the relative face areas of target 3D objects [6] and quality measure of volume visualization images [2].

Our idea here is to employ the concept of mutual information to retrieve meaningful correlation between the light source placement and other relevant attributes. Although the previous work [22] explored this problem in terms of viewpoint selection, this still remains to be a variant of conventional formulation of illumination entropy [7]. On the other hand, our approach takes advantage of the mutual information criteria [6] to further extend this formulation for computing the optimal placement of a single light source.

3 Optimizing Light Positions Using Mutual Information

This section describes optimal light source placement based on mutual information as the first contribution of this work.

3.1 Illumination Entropy

We first explain the illumination entropy devised by Gumhold [7], which is the conventional measure for evaluating the goodness of light source placement. Indeed, this measure employs the Shannon entropy, so as to maximize the uniform distribution of pixel values over the dynamic range of intensity levels. Suppose that \mathcal{X} represents a finite set and $p(x)$ is the probability that $X = x \in \mathcal{X}$, where X is a random variable. The Shannon entropy $H(X)$ is defined as

$$H(X) = -\sum_{x \in \mathcal{X}} p(x) \log_2 p(x). \tag{1}$$

In this formulation, finding the optimal light source placement amounts to maximally equalizing the occurrence of pixel intensity values in the histogram where the range of intensity values is divided into a specific number of bins. Suppose that p_i represents the normalized occurrence of pixel values that falls into the i-th bin of the histogram. The entropy in Eq. (1) can be rewritten as

$$H = -\sum_{i=1}^{M} p_i \log_2 p_i, \tag{2}$$

where M represents the number of quantization bins in the histogram. Here, we assume that color pixel values (R, G, B) are converted to the corresponding

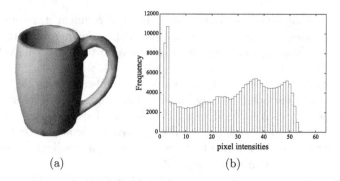

Fig. 1. Calculating the illumination entropy: (a) A shaded image of a cup model and (b) its corresponding histogram with respect to the quantized intensity levels.

grayscale value $Y = 0.21262 \cdot R + 0.71514 \cdot G + 0.07215 \cdot B$ [7]. Figure 1 shows an example where the histogram of the quantized intensity levels is computed by scanning the pixel intensity values in the color frame buffer. Note that the number of quantization levels is set to be 64 by default. We will base our new approach on this conventional formulation of the illumination entropy.

3.2 Mutual Information for Light Source Placement

The conventional illumination entropy calculates the Shannon entropy by referring to the probability distribution of the pixels with respect to the intensity value. This leads us to the idea for evaluating meaningful dependence between the light source positions and intensity values. In our approach, we achieved this by introducing the existing framework of mutual information [6] into the formulation of the illumination entropy.

Here, we first assume that we search for the optimal placement of a single light source, and locate its position on the viewing sphere that encloses the target scene. For this purpose, we first take sample points uniformly over the sphere by referring to the vertex positions of a regular icosahedron. Of course, we can increase the number of samples by refining the icosahedron using the common rules of subdivision surfaces. We compute the quality of the light placed at each sample point and find the best placement that maximizes the quality measure.

Now suppose that \mathcal{X} corresponds a finite set of light sources on the viewing sphere and \mathcal{Y} is a set of quantized intensity level. Actually, we consider the information channel between a set of light sources as input and intensity values as output. In our approach, the *relative entropy* (i.e., the *Kullback-Leibler divergence*) $I(x; Y)$ represents how much the occurrences of quantized intensity levels are correlated with respect to the specific light source x_i, and is defined as

$$I(x_i; Y) = \sum_{j=1}^{m} p(y_j|x_i) \log_2 \frac{p(y_j|x_i)}{p(y_j)}, \tag{3}$$

attribute values

$p(X)$		$p(Y\|X)$					y_1	\cdots	y_n
$p(x_1)$		$p(y_1\|x_1)$	\cdots	$p(y_m\|x_1)$		x_1	$n(x_1, y_1)$	\cdots	$n(x_1, y_n)$
\vdots		\vdots	\ddots	\vdots	\Longleftarrow light	\vdots	\vdots	\ddots	\vdots
$p(x_n)$		$p(y_1\|x_n)$	\cdots	$p(y_m\|x_n)$	sources	x_n	$n(x_n, y_1)$	\cdots	$n(x_n, y_n)$

$p(Y)$	$p(y_1)$	\cdots	$p(y_m)$

(a) (b)

Fig. 2. Calculation of relative entropy values. (a) A table of conditional probabilities $p(y_j|x_i)$ where $i = 1, \ldots, n$ and $j = 1, \ldots, m$. (b) The joint histogram with respect to light sources $\{x_i\}$ $(i = 1, \ldots, n)$ and viewpoints $\{y_j\}$ $(j = 1, \ldots, n)$.

where Y is a random variable and $p(y_j)$ is the probability that $Y = y_j$. The *conditional probability* $p(y_j|x_i)$ is the probability of $Y = y_j$ on the condition that $X = x_i$, and can be given by

$$p(y_j|x_i) = \frac{n(x_i, y_j)}{\sum_{j=1}^{m} n(x_i, y_j)}, \tag{4}$$

where $n(x_i, y_j)$ indicates the number of pixels having at the quantization intensity level y_j when the target 3D scene is illuminated from the light source x_i. The *mutual information* between X and Y is defined to be

$$I(X;Y) = \sum_{i}^{n} p(x_i) \sum_{j}^{m} p(y_j|x_i) \log_2 \frac{p(y_j|x_i)}{p(y_j)}. \tag{5}$$

Note that, from $p(x_i)$ and $p(y_j|x_i)$, we can compute the probability $p(y_j)$ as

$$p(y_j) = \sum_{i=1}^{n} p(x_i) p(y_j|x_i). \tag{6}$$

Figure 2 shows the relationships among $p(y_j|x_i)$, $p(x_i)$, $p(y_j)$, and $n(x_i, y_j)$.

The above formulation implies that we can identify x_i as the optimal light source placement when the corresponding relative entropy $I(x_i;Y)$ becomes maximum. This is because the corresponding light source produces shading effects that reflect the shape details of the target 3D scene more faithfully, as compared with those having lower entropy values since they are less sensitive to the shape features of the scene. Figures 3(a) and (b) show the comparison between shaded images with the maximum and minimum relative entropy values. This comparison clarifies that the light source with the maximum entropy value can successfully introduce large variation in the distribution of intensity values while that with the minimum entropy produces poor shading effects that spoil the visual quality of the 3D scene.

3.3 Experimental Results

We conducted an experiment in order to fully discriminate our approach from the conventional illumination entropy. Figures 3(c) and (d) show such a comparison where we rendered the wireframe sphere according to the quality of the light positions using two approaches. Here, we employ the color gradation that ranges from blue to red according to the quality values. Figure 3(c) presents the distribution of the relative entropy obtained using our approach while Fig. 3(d) corresponds to that of the conventional illumination entropy. Note that in these figures we employ the same viewpoint for both of the two approaches. The comparison undoubtedly indicates that the light positions of high quality are concentrated in the vicinity of the viewpoint in Fig. 3(c) when compared with that in Fig. 3(d). Furthermore, we can confirm that the two directional vectors of the light source and viewpoint span an angle ranges from 15° to 30° in general, which coincides with the fact derived from the perceptual studies in [14]. These results demonstrate that the proposed approach can take into account the perceptual quality of the shaded effects in the 3D scene when selecting the optimal light positions. Note that the same consideration can also be applied to a knot model as shown in Fig. 4.

(a) (b) (c) (d)

Fig. 3. Evaluating illumination effects on the cup model using the mutual information. Results with the (a) maximum and (b) minimum relative entropy. Spherical distribution of the (c) relative entropy and (d) illumination entropy. (Color figure online)

(a) (b) (c) (d)

Fig. 4. Evaluating illumination effects on the knot model using the mutual information. Results with the (a) maximum and (b) minimum relative entropy. Spherical distribution of the (c) relative entropy and (d) illumination entropy. (Color figure online)

4 Correlation Between Light Sources and Viewpoints

Results presented in the previous section clearly suggest that the optimal light placement strongly depends on the choice of the viewpoint. This definitely inspires us to seek meaningful correlation between the light sources and viewpoints. In this section, we present our second contribution of this work, in which we formulated such dependence again by taking advantage of the mutual information.

4.1 Constructing the Joint Histograms

Suppose that this time \mathcal{X} and \mathcal{Y} are finite sets of light sources and viewpoints, respectively, where both are identical with a finite set of samples over the enclosing sphere as described earlier. In this case, the information channel runs between a set of light sources as input and viewpoints as output, or vice versa. This channel actually provides the meaningful correlation between the light source placement and viewpoint selection. Our first task is to compute the joint probability $p(x_i, y_j)$ $(i, j = 1, \ldots, n)$, which represents the probability that $X = x_i$ and $Y = y_j$ where n is the number of samples over the sphere. This is accomplished by computing the joint histogram with respect to \mathcal{X} and \mathcal{Y}, which can be thought of as a matrix where each (i, j)-th entry $n(x_i, y_j)$ contains the number of specific occurrences when $X = x_i$ and $Y = y_j$ as shown in Fig. 2(b). Normalizing the number of such occurrences at each entry gives us the joint probability as

$$p(x_i, y_j) = \frac{n(x_i, y_j)}{\sum_{i=1}^{n} \sum_{j=1}^{m} n(x_i, y_j)}. \tag{7}$$

Bayes' theorem allows us to compute the conditional probabilities (cf. Fig. 2(a)):

$$p(y_j | x_i) = \frac{p(x_i, y_j)}{p(x_i)} \quad \text{and} \quad p(x_i | y_j) = \frac{p(x_i, y_j)}{p(y_j)}, \tag{8}$$

where $p(x_i) = \sum_{j=1}^{m} p(x_i, y_j)$ and $p(y_j) = \sum_{i=1}^{n} p(x_i, y_j)$. Note that this formulation coincides with Eq. (4), and helps us compute the relative entropy values $I(x_i; Y)$ and $I(y_j; X)$ to assess the dependence of the light source x_i on a set of viewpoints $\{y_j\}$ and the viewpoint y_j on a set of light sources $\{x_i\}$, respectively.

4.2 Counting the Number of Occurrences

We are now ready to define the specific occurrences for constructing the joint histogram of the target 3D scene in terms of light sources and viewpoints. Our idea here is to transform the 3D scene into the frame buffer by projecting it onto the screen space, and then quantize the pixel coordinates and intensity values to compose a 3D volume as shown in Fig. 5. In this figure, the resolution of the 3D volume is $8 \times 8 \times 4$ while in our implementation we employed $32 \times 32 \times 16$ for the resolution. We then count the number of voxels occupied by the quantized

Fig. 5. Transforming the 3D scene into a volume representation by quantizing the screen space and intensity values.

version of the projected scene, as the number of occurrences for the specific light source x_i and viewpoint y_j. Note that we quantize both the 2D screen space and intensity range to evaluate how uniformly the projected scene fills out the quantized 3D volume by counting the number of occupied voxels. Here, we can again identify proper light sources and viewpoints by respectively computing the following relative entropy values:

$$I(x_i; Y) = \sum_{j=1}^{m} p(y_j|x_i) \log_2 \frac{p(y_j|x_i)}{p(y_j)}, \quad \text{and} \tag{9}$$

$$I(y_j; X) = \sum_{i=1}^{n} p(x_i|y_j) \log_2 \frac{p(x_i|y_j)}{p(x_i)}. \tag{10}$$

4.3 Experimental Results

We still need to provide a specific interpretation of the light sources and viewpoints that have the minimum or maximum relative entropy values. If a light source has the minimum relative entropy in Eq. (9), it will give a consistent illumination effects regardless of the selection of the viewpoints. If it has the maximum relative entropy, its illumination effects will drastically change according to the choice of the viewpoints. Figure 6 presents the variation of the relative entropy Eq. (9) of the cup model and its representative snapshots with the light sources having the minimum and maximum relative entropy values. Note that representative snapshots are taken from 12 viewpoints that coincide with the 12 vertices of the regular icosahedron as described earlier. Good light sources appear diagonally above the cup model to better illuminate its inside as shown in Fig. 6(a). Furthermore, the light source of the minimum relative entropy value produces consistent illumination effects as shown in Fig. 6(b) while that of the maximum entropy value yields unstable illumination that drastically differs among the viewpoints as shown in Fig. 6(c).

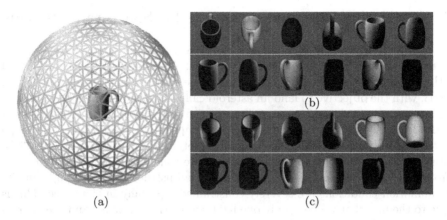

Fig. 6. Light source placement for a cup model. (a) Distribution of the relative entropy values for the light sources over the sphere. Representative snapshots with the light sources with the (b) minimum relative entropy and (c) maximum relative entropy.

As a side effect, on the other hand, we can potentially take advantage of the viewpoints having the minimum and maximum relative entropy values. The viewpoint having the minimum relative entropy commonly adds important 3D depth cues in the corresponding projected images, while that of the maximum entropy value cannot fully guarantee the quality of the projected images with a specific subset of light sources. Figure 7 clearly demonstrates this trend.

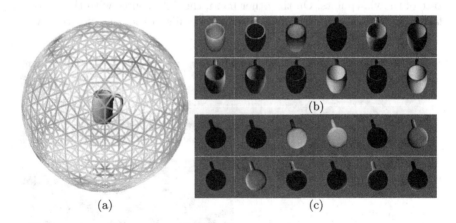

Fig. 7. Viewpoint selection for a cup model. (a) Distribution of the relative entropy values for the viewpoints over the sphere. Representative snapshots with the viewpoints with the (b) minimum relative entropy and (c) maximum relative entropy.

5 Simulating Illumination Effects for Spacecraft Missions

In this section, we simulate illumination effects on an asteroid to seek the better control of a virtual spacecraft mission. A well-known spacecraft called "Hayabusa" was launched by Japan Aerospace eXploration Agency (JAXA) in 2003, with the objective to land an asteroid called "Itokawa" and collect samples of asteroid materials, and successfully returned to the earth with the samples in 2010. In this spacecraft mission, it was very important to reconstruct the shape details of Itokawa for analyzing its spatial motion and formation process [3,5]. For recovering the 3D shape of the asteroid, we usually take photograph images from the spacecraft and investigate them to reconstruct its 3D shape, while its illumination conditions are severely constrained especially in the space. This is due to the fact that we have only one light source (i.e. the sun), and the degrees of freedom of the spacecraft navigation are quite low due to the influence of gravity and limited amount of fuel. Therefore, precomputing the illumination conditions is indeed beneficial provided that a rough model of the target asteroid is available. This also lets us effectively navigate the spacecraft in the sense that we can maximally search for specific light conditions and viewpoints to extract more information about the details of the asteroid shape.

In our experiment, we took the 3D shape of Itokawa [5] as an input, and computed the relative entropy values of the light sources to evaluate which light conditions are effective for the mission. Figure 8 shows the distribution of the relative entropy values of the light sources over the sphere in terms of the viewpoints. Again, in this case, minimizing the relative entropy allows us to find an optimal light position that produces steady illumination effects regardless of the choice of the viewpoints. On the other hand, the light source with the maximum relative entropy often fails to exhibit shape details of the asteroid when we see

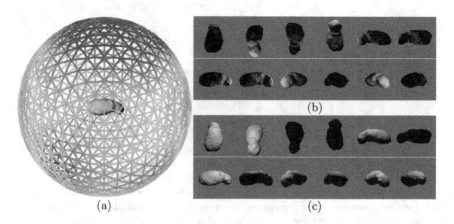

(a) (c)

Fig. 8. Light source placement for the Itokawa model. (a) Distribution of the relative entropy values for the light sources over the sphere. Representative snapshots with the light sources with the (b) minimum relative entropy and (c) maximum relative entropy.

from different viewpoints. In this way, our approach for finding optimal light conditions is effective in controlling the illumination effects, which are severely constrained often in the spacecraft missions.

6 Conclusion

This paper has presented an approach to effectively evaluating the illumination quality produced by a single light source. Our technical contribution is two fold; the first is to formulate the optimal placement of a light source in terms of the distribution of the intensity values and the second is to seek the optimal illumination condition that is robust against the choice of the viewpoints. Mutual information has been introduced to elucidate the optimal placement of a light source in the sense that the associated illumination condition is consistent among pixel intensity values and a possible set of viewpoints. We presented several experimental results together with the simulation of illumination effects in the virtual spacecraft mission, to demonstrate the applicability of our approach.

Our future work includes more rigorous understanding of the relative entropy for the attribute values. In practice, the relative entropy in Eq. (10) enables us to find optimal viewpoints that are robust against the choice of light sources as shown in Fig. 7. Nonetheless, this process sometimes fails because the minimum entropy value can correspond to the viewpoint yielding a smaller projected area of the target 3D scene to avoid the influence by the choice of light sources. Incorporating multiple light sources into our formulation is another interesting research theme. Extending the proposed assessment of illumination effects to volume visualization is also left as our future work. More rigorous perceptual studies for the assessment of our approach still remain to be made.

Acknowledgement. This work has been partially supported by MEXT under Grants-in-Aid for Scientific Research on Innovative Areas No. 25120014, and JSPS under Grants-in-Aid for Scientific Research (B) No. 25287114.

References

1. Bordoloi, U.D., Shen, H.W.: View selection for volume rendering. In: Proceedings of IEEE Visualization 2005, Vis 2005, pp. 487–494. IEEE (2005)
2. Bramon, R., Ruiz, M., Bardera, A., Boada, I., Feixas, M., Sbert, M.: An information-theoretic observation channel for volume visualization. In: Computer Graphics Forum, vol. 32, no. 3pt4, pp. 411–420 (2013)
3. Demura, H., et al.: Pole and global shape of 25143 Itokawa. Science **312**(5778), 1347–1349 (2006)
4. Feixas, M., Sbert, M., González, F.: A unified information-theoretic framework for viewpoint selection and mesh saliency. ACM Trans. Appl. Percept. 6(1) (2009). Article No. 1
5. Gaskell, R., et al.: Landmark navigation studies and target characterization in the Hayabusa encounter with Itokawa. In: Proceedings of AIAA/AAS Astrodynamics Specialist Conference and Exhibit (2006)

6. González, F., Sbert, M., Feixas, M.: Viewpoint-based ambient occlusion. IEEE Comput. Graph. Appl. **28**(2), 44–51 (2008)
7. Gumhold, S.: Maximum entropy light source placement. In: Proceedings of IEEE Visualization 2002, Vis 2002, pp. 275–282. IEEE (2002)
8. Ha, H.N., Olivier, P.: Lighting-by-example with wavelets. In: Butz, A., Fisher, B., Krüger, A., Olivier, P., Owada, S. (eds.) SG 2007. LNCS, vol. 4569, pp. 110–123. Springer, Heidelberg (2007). doi:10.1007/978-3-540-73214-3_10
9. Ji, G., Shen, H.W.: Dynamic view selection for time-varying volumes. IEEE Trans. Vis. Comput. Graph. **12**(5), 1109–1116 (2006)
10. Kahrs, J., Calahan, S., Carson, D., Poster, S.: Pixel cinematography: a lighting approach for computer graphics. In: SIGGRAPH Course Notes (1996)
11. Kim, Y., Varshney, A., Jacobs, D.W., Guimbretière, F.: Mesh saliency and human eye fixations. ACM Trans. Appl. Percept. 7(2) (2010). Article No. 12
12. Lee, C.H., Hao, X., Varshney, A.: Geometry-dependent lighting. IEEE Trans. Vis. Comput. Graph. **12**(2), 197–207 (2006)
13. Lee, C.H., Varshney, A., Jacobs, D.W.: Mesh saliency. ACM Trans. Graph. **24**(3), 659–666 (2005)
14. O'Shea, J.P., Banks, M.S., Agrawala, M.: The assumed light direction for perceiving shape from shading. In: Proceedings of the 5th Symposium on Applied Perception in Graphics and Visualization, APGV 2008, pp. 135–142 (2008)
15. Pellacini, F., Battaglia, F., Morley, R.K., Finkelstein, A.: Lighting with paint. ACM Trans. Graph. 26(2) (2007). Article No. 9
16. Polonsky, O., Patané, G., Biasotti, S., Gotsman, C., Spagnuolo, M.: What's in an image? Vis. Comput. **21**, 840–847 (2005)
17. Secord, A., Lu, J., Finkelstein, A., Singh, M., Nealen, A.: Perceptual models of viewpoint preference. ACM Trans. Graph. 30(5) (2012). Article No. 109
18. Takahashi, S., Fujishiro, I., Takeshima, Y., Nishita, T.: A feature-driven approach to locating optimal viewpoints for volume visualization. In: Proceedings of IEEE Visualization 2005, Vis 2005, pp. 495–502. IEEE (2005)
19. Tao, Y., Lin, H., Bao, H., Dong, F., Clapworthy, G.: Structure-aware viewpoint selection for volume visualization. In: Proceedings of the 2nd IEEE Pacific Visualization Symposium, Pacific Vis 2009, pp. 193–200. IEEE (2009)
20. Vázquez, P.P.: Automatic view selection through depth-based view stability analysis. Vis. Comput. **25**, 441–449 (2009)
21. Vázquez, P.P., Feixas, M., Sbert, M., Heidrich, W.: Viewpoint selection using viewpoint entropy. In: Proceedings of 6th International Fall Workshop on Vision, Modeling, and Visualization, VMV2001, pp. 273–280 (2001)
22. Vázquez, P.-P., Sbert, M.: Perception-based illumination information measurement and light source placement. In: Kumar, V., Gavrilova, M.L., Tan, C.J.K., L'Ecuyer, P. (eds.) ICCSA 2003. LNCS, vol. 2669, pp. 306–316. Springer, Heidelberg (2003). doi:10.1007/3-540-44842-X_32
23. Vieira, T., Bordignon, A., Peixoto, A., Tavares, G., Lopes, H., Velho, L., Lewiner, T.: Learning good views through intelligent galleries. Comput. Graph. Forum **28**(2), 717–726 (2009)
24. Wang, L., Kaufman, A.E.: Lighting system for visual perception enhancement in volume rendering. IEEE Trans. Vis. Comput. Graph. **19**(1), 67–80 (2013)
25. Yamauchi, H., et al.: Towards stable and salient multi-view representation of 3D shapes. In: Proceedings of IEEE International Conference on Shape Modeling and Applications, SMI 2006, pp. 265–270 (2006)
26. Zhang, Y., Ma, K.L.: Lighting design for globally illuminated volume rendering. IEEE Trans. Vis. Comput. Graph. **19**(12), 2946–2955 (2013)

Extracting Important Routes from Illustration Maps Using Kernel Density Estimation

Fumiya Sato[1], Hsiang-Yun Wu[2(✉)], Shigeo Takahashi[3],
and Masatoshi Arikawa[4]

[1] The University of Tokyo, Tokyo 113-8565, Japan
fumiya@csis.u-tokyo.ac.jp
[2] Keio University, Kanagawa 223-8522, Japan
hsiang.yun.wu@acm.org
[3] University of Aizu, Fukushima 965-8580, Japan
takahashis@acm.org
[4] The University of Tokyo, Chiba 277-8561, Japan
arikawa@csis.u-tokyo.ac.jp

Abstract. Illustration maps often direct our visual attention to the specific route with geographic symbols and annotation labels associated with important landmarks. This inspires us to evaluate the quality of such maps by analyzing the spatial distribution of visual attention over the map domain. In this paper, we introduce kernel density estimation in order to identify important routes that are implicitly designated by the map designers. Our algorithm begins by composing the density field as a combination of Gaussian kernels centered on the landmarks. The algorithm then allows us to extract an important route on the map as the trajectory of a ball running along the valley of the density field. We conducted a user study where we compared the routes reconstructed from the sequence of landmarks specified by the participants and their originally intended routes, and report some insight into possible aesthetic criteria in illustrating such maps.

Keywords: Map analysis · Route estimation · Kernel density field

1 Introduction

Nowadays, commercially available web map services, such as Google Maps, provide us with an effective means of exploring geographic features in our daily life. Most of these services produce geographic maps that are precise enough to make detailed travel plans and simulate virtual travels. On the other hand, hand-drawn illustrated maps successfully schematize geographic maps to emphasize important routes, and thus users can easily recognize such routes on the map and further memorize their geographic positions for their future travels.

However, little has been done for quantitatively evaluate the quality of such hand-drawn maps primarily because it strongly depends on the design intention of professional cartographers. For example, Fig. 1 shows a representative map

© Springer International Publishing AG 2017
Y. Chen et al. (Eds.): SG 2015, LNCS 9317, pp. 167–174, 2017.
DOI: 10.1007/978-3-319-53838-9_14

Fig. 1. Nanbu Tetsudo Zue illustrated by Hatsusaburo Yoshida in 1926. (Color figure online)

drawn by Hatsusaburo Yoshida, who is a famous pioneer of bird's eye views maps in Japan. In practice, this map successfully directs visual attention from map users on the railway line running from top-right to bottom-left, by highlighting the route in red and placing geographic symbols and annotation labels around it. This artwork has commonly been recognized as high quality while formulating such aesthetic quality of hand-drawn maps still remains to be tackled from a technical viewpoint.

In this paper, we introduce *kernel density estimation* as a tool for evaluating the saliency of such important routes implicitly designated by map designers. In our approach, the density field over the map domain is composed as a combination of Gaussian kernels centered at the landmarks, and corresponds to the distribution of visual attention on the geographic features such as landmarks, roads, and railways. We can also compute important routes over the map domain by tracking the trajectory of a ball running along the valley of the density field.

The remainder of this paper is structured as follows: Sect. 2 conducts a survey on relevant conventional techniques. Section 3 describes our approach to computing the density field from hand-drawn illustrated maps. After having presented several experimental results in Sect. 4, we conclude this paper and refer to future work in Sect. 5.

2 Related Work

Although it is important to provide precise geographic information on the maps as done in contemporary geographic information systems (GISs), schematic design of map contents has recently attracted much attention from map users due to its simple and clear representation of geographic information. Hatsusaburo Yoshida is one of the pioneering cartographers in the schematic

map design, and many of his hand-drawn maps were intensively studied by researchers in cartography. A typical study was presented by Hotta [3], where he classified Yoshida's maps into different scene composition styles. Also, Yoshida himself left his own design process in a document of map design [12]. Another important direction is to directly distort map images in an aesthetic fashion. Dougenik et al. [1] proposed an algorithm for transforming country shapes while retaining topology of the entire maps, and further sophistication was done by House and Kocmoud [4]. Quite recently, the schematization of map contents has been further pursued in more elegant fashion, including navigation tool based on hand-drawn maps [8], annotated railway maps [10,11], and 3D route maps [2].

As mentioned before, the objective of this study is to identify important routes implicitly specified by the map designers. Only little has been done on this study while route selection estimation was conducted for car navigation systems [6] and the mobile devices were tracked in a traffic system for inferring typical route choices [9]. In this paper, we employ kernel density estimation where the density field represents aggregated area in the distribution of visual attention over the map. Kernel density estimation has also been employed for visualizing dynamic distribution data [7] and bundling network edges [5].

3 Extracting Routes from Density Fields

This section describes how to create our density field as a combination of Gaussian kernels associated with landmarks and along the specified route. We begin with an overview of our system and then move on the details of the proposed algorithm.

Figure 2 gives an overview of our prototype system. Firstly, we generate a constant density field (Fig. 2(A)) over the input map (Fig. 2(a)). Secondly, we ask map users to provide landmarks such as geographic symbols and annotation labels in which they are interested. In practice, we allow users to design their kernel density field by themselves by selecting interesting features on the map (Fig. 2(b)). This can be done manually, and the density field can be composed of Gaussian kernels centered at the specified landmarks as shown in Fig. 2(B). More details of the algorithm will be described in Sect. 3.1. In addition, all the roads

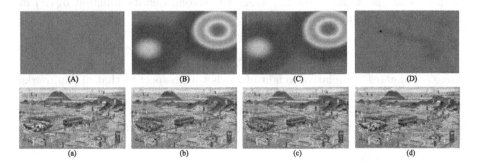

Fig. 2. A system overview of the present algorithm.

on the map are also incorporated (Fig. 2(c)), in the same way, into the density field so that we can further accommodate Gaussian kernels along the roads (Fig. 2(C)). Finally, the users are also expected to specify the initial position of the route. As mentioned previously, the trajectory of a ball running on the density field indicates the important route by passing through landmarks one by one. In our formulation, every time when the ball passes through a landmark, we exclude the kernel associated with the landmark and then update corresponding kernel density field. This procedure continues until all the landmarks are visited (Fig. 2(D)), and the final trajectory is drawn on the map as shown in Fig. 2(d).

3.1 Kernel Density Estimation over the Map Domain

Suppose we have a density field $\mathcal{M} \subseteq \mathbb{R}^2$, and the domain \mathcal{M} coincides with the entire map domain. Let us denote a sample point on the hand-drawn illustrated map by a 2D vector $\boldsymbol{x} \in \mathcal{M}$. In our formulation, a density value $\rho(\boldsymbol{x})$ at $\boldsymbol{x} \in \mathcal{M}$ is defined as a sum of the two density functions as:

$$\rho(\boldsymbol{x}) = \rho_{\mathcal{L}}(\boldsymbol{x}) + \rho_{\mathcal{R}}(\boldsymbol{x}). \tag{1}$$

Assume that user specifies the position of the i-th landmark as \boldsymbol{y}_i, and its size by manually outlining the landmark area as s_i. Note that the weight value s_i indicates the *degree of attraction* of the landmark. The first density function $\rho_{\mathcal{L}}(\boldsymbol{x})$ in terms of landmarks is defined as follows:

$$\rho_{\mathcal{L}}(\boldsymbol{x}) = \frac{\sum_{i=1}^{N} s_i K(\frac{|\boldsymbol{x} - \boldsymbol{y}_i|}{h})}{\sum_{i=1}^{N} s_i}, \tag{2}$$

where K represents the kernel function and h is a bandwidth given by the users for smoothing the distribution. Here, we employ the Gaussian function for K.

As for the computation of the road density, we first define M roads on the hand-drawn illustrated map, where roads $\mathcal{R}_1, \mathcal{R}_2, \ldots, \mathcal{R}_M$ are represented as sequences of n points as:

$$\mathcal{R}_i = \langle \boldsymbol{z}_{i,1}, \boldsymbol{z}_{i,2}, \ldots, \boldsymbol{z}_{i,n_i} \rangle \quad \text{where} \quad \boldsymbol{z}_{i,j} \in \mathbb{R}^2. \tag{3}$$

Moreover, we define $\xi_i(\boldsymbol{x}) \in \mathbb{R}^+$ as the minimum distance between \boldsymbol{x} and all the points on the segments of \mathcal{R}_i. Thus, the second density function $\rho_{\mathcal{R}}(\boldsymbol{x})$ in terms of roads is defined as follows:

$$\rho_{\mathcal{R}}(\boldsymbol{x}) = \alpha K(\frac{1}{h} \min_{i \in \{1,\ldots,M\}} (\xi_i(\boldsymbol{x}))), \tag{4}$$

where α indicates the relative weight of roads with respect to that of landmarks and is set to 0.05 empirically.

We place a ball at the specified starting point so that it will illuminate the important route as its trajectory when running along the valley of the density field $\rho(\boldsymbol{x})$. The trajectory of the ball can be obtained by calculating the following differential equation:

$$\frac{d\boldsymbol{x}}{dt} = h \frac{\nabla \rho}{||\nabla \rho||}. \tag{5}$$

Moreover, once the ball passes through some landmark, we remove the kernel function centered at the landmark and update the density function $\rho(x)$, until all the landmarks will be excluded from the definition of $\rho(x)$.

4 Results

Our prototype system has been implemented on a laptop PC with 1.7GHz Intel Core i7 CPU and 8GB RAM, and the source code was written in C++ using OpenGL for rendering. We also incorporated an interface for specifying landmarks and roads on the map. As described earlier, the system extracts an important route by simulating a running ball on the estimated kernel density field.

Fig. 3. The resultant images about the hand-drawn map for hiking, that is Sunmata-kyo Irasuto Map by Kawanehoncho Town in 2005 (courtesy of Kawanehoncho Town Hall, Japan). (1) Left: Participants designed the routes on the map. The routes are colored in red. (2) Middle: Kernel density fields were calculated by referring to the landmarks the participants selected. (3) Right: From each kernel density field, important route was extracted, where the black dotted line represents the original trajectory while the red line corresponds to the route that are fit to the closest road. (a)–(d) corresponds to the results given by the four participants. (Color figure online)

To demonstrate the usability of our prototype system, we compared the route manually indicated by a participant and the one retrieved using our prototype system by taking as input a sequence of specified landmarks. Four participants were recruited in this user study, including three males and one female aged from 23 to 28, and they are all non-experts in cartography.

In the study, we asked each participant to explore the hand-drawn illustrated map, and specify his intended route as a first step. We first asked the participant to provide a sequence of landmarks together with their weights along the intended route, and then also designated the intended route directly on the map as the ground truth. Our study aims at comparing these two routes in order to understand the underlying structure of the hand-drawn illustrated maps.

Two hand-drawn maps are employed in our user study. The first map is prepared for hiking in a gorge named Sunmata-kyo as shown in Fig. 3. The second map is an antique hand-drawn map for sightseeing the region around

Fig. 4. The resultant images about the antique hand-drawn map, that is Nanbu Tetsudo Zue. (1) Left: Participants designed the routes on the map. The routes are colored in green. (2) Middle: Kernel density fields were calculated by referring to the landmarks the participants selected. (3) Right: From each kernel density field, important route was extracted, where the black dotted line represents the original trajectory while the green line corresponds to the route that are fit to the closest road. (a)–(d) corresponds to the results given by the four participants. (Color figure online)

Tokyo area (see Fig. 4). Our experimental results suggests that the order of landmarks around the extracted route can be completely different from that user originally intended, even when the overall routes are similar to each other.

5 Conclusion and Future Work

This paper has presented an approach to extracting important routes specified by the map designers using kernel density estimation, which helps us evaluate the quality of hand-drawn illustrated maps by analyzing the spatial distribution of visual attention over the map domain. Moreover, a user study has also been conducted to find meaningful insights into possible aesthetic criteria by comparing the route reconstructed from the sequence of landmarks specified by the participants and their originally intended one. Our future extensions include the mathematical formulation of the extracted aesthetic criteria from the kernel density field so as to automatically generate the hand-drawn maps based on the formulation.

Acknowledgements. The work has been conducted in part as the joint research (No. 398) using spatial data provided by Center for Spatial Information Science, The University of Tokyo, and also partially supported by JSPS KAKENHI under Grants-in-Aid for Scientific Research Scientific Research (B) No. 24300033, Challenging Exploratory Research No. 15K12032, and Young Researchers (B) No. 26730061.

References

1. Dougenik, J.A., Chrisman, N.R., Niemeyer, D.R.: An algorithm to construct continuous area cartograms. Prof. Geogr. **37**(1), 75–81 (1985)
2. Hirono, D., Wu, H.Y., Arikawa, M., Takahashi, S.: Constrained optimization for disoccluding geographic landmarks in 3D urban maps. In: Proceedings of the 6th IEEE Pacific Visualization Symposium (PacificVis 2013), pp. 17–24 (2013)
3. Hotta, Y.: Reading the Bird's-eye Views of Hatsusaburo Yoshida (Yoshida Hatsusaburo no chokanzu wo yomu). The Kawade Shobou Company, Tokyo (2009)
4. House, D.H., Kocmoud, C.J.: Continuous cartogram construction. In: Proceedings of the Conference on Visualization, pp. 197–204 (1998)
5. Hurter, C., Ersoy, O., Fabrikant, S.I., Klein, T.R., Telea, A.C.: Bundled visualization of dynamic graph and trail data. IEEE Trans. Vis. Comput. Graph. **20**(8), 1141–1157 (2014)
6. Ioannou, G., Kritikos, M.N., Prastacos, G.P.: Map-route: a GIS-based decision support system for intra-city vehicle routing with time windows. J. Oper. Res. Soc. **53**(8), 842–854 (2002)
7. Lampe, O.D., Hauser, H.: Interactive visualization of streaming data with kernel density estimation. In: Proceedings of the 4th IEEE Pacific Visualization Symposium (PacificVis 2011), pp. 171–178 (2011)
8. Lu, M., Arikawa, M.: Location-based illustration mapping applications and editing tools. Cartographica: Int. J. Geogr. Inf. Geovisualization **48**(2), 100–112 (2013)
9. Tettamanti, T., Demeter, H., Varga, I.: Route choice estimation based on cellular signaling data. Acta Polytech. Hung. **9**(4), 207–220 (2012)

10. Wu, H.Y., Takahashi, S., Hirono, D., Arikawa, M., Lin, C.C., Yen, H.C.: Spatially efficient design of annotated metro maps. Comput. Graph. Forum **32**(3), 261–270 (2013)
11. Wu, H.Y., Takahashi, S., Lin, C.C., Yen, H.C.: Travel-route-centered metro map layout and annotation. Comput. Graph. Forum **31**(3), 925–934 (2012)
12. Yoshida, H.: How are the bird's-eye views in Hatsusaburo-fashion produced? (Ikani shite Hatsusaburo shiki chokanzu ha umaretaka?). Journey Noted Places **1**, 6–13 (1928)

Fast Fractal Image Encoding Algorithm Based on Coefficient of Variation Feature

Gao-ping Li$^{(\boxtimes)}$ and Shan-shan Li

College of Computer Science and Technology,
Southwest University for Nationalities, Chengdu 610041,
People's Republic of China
pinggaoli@163.com

Abstract. In order to improve the drawback of fractal image encoding with full search typically requires a very long runtime. This paper thus proposed an effective algorithm to replace algorithm with full search, which is mainly based on newly-defined coefficient of variation feature of image block. During the search process, the coefficient of variation feature is utilized to confine efficiently the search space to the vicinity of the domain block having the closest coefficient of variation feature to the input range block being encoded, aiming at reducing the searching scope of similarity matching to accelerate the encoding process. Simulation results of three standard test images show that the proposed scheme averagely obtain the speedup of 4.67 times or so by reducing the searching scope of best-matched block, while can obtain the little lower quality of the decoded images against the full search algorithm. Moreover, it is better than the moment of inertia algorithm.

Keywords: Image compression · Fractal · Fractal image coding · Coefficient of variation feature

1 Introduction

Although the full search fractal image coding algorithm based on partitioned iterated function system (PIFS) was proposed by Jacquin [1], make full use of the local self-similar to eliminate redundant information within the image, with the quantitative parameters of the compression affine transformation to express image. The technique has many advantages, such as resolution independence, fast decoding process, and competitive rate-distortion curve. But this method in the encoding process need to spend a lot of time [2], which limits its use in the field of image compression.

In recent years, researchers have a lot of improvement method is proposed for encoding time consuming problem, and one of the most characteristic is feature vector method. But it suffers from several drawbacks, such as, high-dimensional feature vector

G. Li—Fund Project: Supported by Application Foundation Projects in Sichuan province (No. 2013 JY0180), and Supported by Foundation of Sichuan Educational Committee (No. 15ZA0384), and Supported by Foundation of Southwest University for Nationalities (No. 2012NYT001).

© Springer International Publishing AG 2017
Y. Chen et al. (Eds.): SG 2015, LNCS 9317, pp. 175–183, 2017.
DOI: 10.1007/978-3-319-53838-9_15

need additional storage, and the higher dimension, the worse performance [3–5]. Thus, an alternative feature method to reduce fractal encoding time is proposed recently [6–10]. This paper continues to study the algorithm, newly-defined the coefficient of variation feature of image blocks, and proved an inequality linking the root mean square and the coefficient of variation feature mathematically. The proposed scheme is based on the premise that two equal-sized image blocks cannot be closely matched unless their coefficient of variation feature is relatively large. In the coding phase, the best matching domain block of an range is the vicinity of the domain block having the closest coefficient of variation feature to the input range block being encoded, greatly reduces the search scope to speed up the coding process. Besides, on the basis of the characteristics of human visual sensitivity also proposes two measures to reduce the quantity of domain blocks in the codebook blocks respectively. And no search is needed for the shade range block coding. Simulation experiments results of three test images show that the coefficient of variation feature algorithm averagely obtain the speedup of 4.67 times or so, while can obtain the little lower quality of the decoded images against the full search algorithm. Moreover, it is better than the moment of inertia algorithm [10].

2 Review of Fractal Image Compression

During fractal encoding process, an input image is first partitioned into the non-overlapping range blocks of size $n \times n$ in a suitable manner, and a set of over-lapping domain blocks of size $2n \times 2n$ is created from the same image by sliding a window of size $2n \times 2n$ around the same image from the top left corner of the image, at integral steps in both the horizontal and vertical directions. Each of the domain blocks is decimated (e.g., by pixel value averaging) to match the size of the range block, eight isometric operators (rotations and flips) are applied to all decimated domain blocks to construct an extended domain pool denoted by Ω. Which are used as the codebook to approximate each range block with an intensity affine mapping. For convenience, \mathscr{R} and \mathscr{D} denote the vectors of $\mathbf{R}^{n \times n}$ (R is the real number set) by the gray value of the range block and domain block form in a special scanning order, respectively. In practice, we compare a range and domain block using the simplified root-mean-square criteria, therefore, for an input range \mathscr{R} of size $n \times n$ and the candidate transformed domain block \mathscr{D}, the corresponding contrast factor s_i and brightness offset o_i is determined by solving the minimizing problem as follows

$$\|\mathscr{R} - (s \cdot \mathscr{D}_\mathbf{m} + o\mathscr{I})\| = \min_j \left\{ \min_{s,o \in \mathbf{R}, |s| < 1} \|\mathscr{R}_i - (s \cdot \mathscr{D}_i + o \cdot \mathscr{I})\| \right\} \tag{1}$$

where $\mathscr{D}_\mathbf{m}$ is regard as the best-matched block of the range \mathscr{R}, \mathscr{I} represents the constant vector whose intensities are all ones, and $\| \cdot \|$ stands for the Euclidean norm. The term $s \cdot \mathscr{D} + o \cdot \mathscr{I}$ is an intensity affine mapping to adjust the contrast and brightness of the block \mathscr{D}. The contrast factor is subject to $|s| < 1$ in order to ensure theoretically convergence of the iterations in the decoding. The fractal code for an input range block consists of the position of its best-matched domain block, the index of

isometric operators and the quantized parameters for the intensity affine mapping. A collection of the fractal codes for all the range blocks constitutes the fractal code for the input image, which gives the description of a contractive transformation that makes the input image invariant approximately.

The inner minimum in (1) is a constrained minimization problem, if the contrast factor is not taken into account for a while. Which don't satisfy the constraint, are then truncated to $[-1, 1]$, the factors s and o can be computed directly by

$$s = \frac{<\mathcal{R} - \bar{r}\mathcal{I}, \mathcal{D} - \bar{d}\mathcal{I}>}{\|\mathcal{D} - \bar{d}\mathcal{I}\|^2}, o = \bar{r} - s\bar{d} \tag{2}$$

And the error calculation part becomes

$$E(\mathcal{R}, \mathcal{D})^2 = \|\mathcal{R} - \bar{r}\mathcal{I}\|^2 - s^2\|\mathcal{D} - \bar{d}\mathcal{I}\|^2 \tag{3}$$

where \bar{x} represents the mean intensity of the block X, $<\cdot, \cdot>$ is the inner product in the Euclidean space.

The fractal decoding is a relatively simple iterative process, in which the decoded image is obtained by iterating the contractive transformation denoted in the fractal code on an arbitrary initial image with the predefined number of iterations.

3 Analysis of the Proposed Algorithm

The outer minimum in (1) constitutes the time consuming part of the encoding process because it requires exhaustive search in the codebook Ω that is usually very large. Therefore, it is essential to develop fast encoding algorithms before fractal image coding can be widely used for various applications. By defining the image blocks features, the search space of best-matched domain block of an input range block will be confined to the vicinity of the initial-match block (i.e., the domain block having the closest feature to the input range block being encoded).

For an image block $\mathcal{X} = [x_{i,j}] \in \mathbf{R}^{n \times n}$, its coefficient of variation feature is defined as

$$C(\mathbf{x}) = \sigma(\mathbf{x})/E(\mathbf{x}) \tag{4}$$

where $\sigma(\mathbf{x}) = (\sum_{i,j=1}^{n} (x_{i,j} - \bar{x})^2)^{1/2}, E(\mathbf{x}) = \bar{x}$. The coefficient of variation feature of this definition is its standard deviation divide mean, because of standard deviation and mean of dimension is consistent, so the coefficient of variation feature is a dimensionless quantity, facilitate the comparison of two image blocks. Due to (3), we have

$$E(\mathcal{R}, \mathcal{D})^2 = n^2\sigma(\mathcal{R}) - s^2 n^2 \sigma(\mathcal{D}) = n^2\bar{r}^2 C^2(\mathcal{R}) - s^2 n^2 \bar{d}^2 C^2(\mathcal{D})$$
$$> n^2 [\bar{r}^2 C^2(\mathcal{R}) - \bar{d}^2 C^2(\mathcal{D})] \tag{5}$$

The inequality (5) below will be employed in the proposed algorithm. It implies that, for the range block \mathscr{R}, and any codebook block \mathscr{D}, if $E(\mathscr{R}, \mathscr{D})$ is small enough, their coefficient of variation feature must be close enough. Whereas if their coefficient of variation feature differ greatly, $E(\mathscr{R}, \mathscr{D})$ might be too large for \mathscr{R} and \mathscr{D} to constitute a close match. In other words, inequality (5) implies that the range block \mathscr{R} and the codebook block \mathscr{D} can not be closely matched unless their coefficient of variation feature is as close as possible. Therefore, the best-matched block $\mathscr{D}_{\mathbf{m}}$ to the input range block \mathscr{R} should be the neighbour in the sense of the coefficient of variation feature. Subsequent simulation experiments also verify that it is true.

Encoding process time consuming with the number of range block being encoded, and the codebook capacity and search way is closely related, the following is respectively discussed.

First, determine the number of range block being encoded. Due to (3), $E(\mathscr{R}, \mathscr{D}) \leq n\sigma_R \leq n\sigma_R$, it implies that, if σ_R is very small, any codebook block $\mathscr{D} \in \mathbf{R}^{n \times n}$ all can be used as the best-matched block of the range \mathscr{R}, these range block could be approximated well by its intensity averaged version, and can directly give the fractal code without searching. Under the background of different intensity of illumination, the eyes can discern the illumination difference is different, but in quite a wide range of luminance value $\Delta I/I$ is approximately equal to 0.02 (called Weber ratio). In image coding, look the average gray value of range block being encoded as background illumination value, and regard standard deviation as ΔI. The range block being encoded divided into two categories based on these ideas, if $\sigma_R \leq 0.02\bar{r}$ the block \mathscr{R} is regarded as a shade block, otherwise as a non-shade block, thus the amount of range block being encoded is the number of non-shade range block.

Second, determine the codebook capacity. To satisfy the constraints $|s| < 1$, should be able to rule out shade domain block of codebook block \mathscr{D} in advance. Therefore, the capacity of original codebook Ω can be reduced to allow codebook Ω_η for non-shade range block being encoded, namely $\Omega_\eta = \{D \in \Omega : \sigma_D \geq 0.02 \, \bar{d}\}$.

Finally, determine the search way of non-shade range block being encoded in Ω_η. According to (5), the range block \mathscr{R} and the codebook block \mathscr{D} can not be closely matched unless their coefficient of variation feature is as close as possible. Therefore, the best-matched block $\mathscr{D}_{\mathbf{m}}$ to the input non-shade range block \mathscr{R} should be the vicinity of the initial-matched block $\mathscr{D}_{\mathbf{init}} \in \Omega_\eta$ (i.e., the domain block having the closest coefficient of variation feature to the input non-shade range block being encoded) in the sense of the coefficient of variation feature. As a result, we sort all the domain blocks in Ω_η according to their coefficient of variation feature value in ascending order; that is, in the sorted domain blocks denoted by $\{\mathscr{D}_1, \mathscr{D}_2, \ldots, \mathscr{D}_N\}$, the relabelled blocks satisfy $C(\mathscr{D}_i) \leq C(\mathscr{D}_{i+1})$. After that, for an input non-shade range block \mathscr{R}, we can use the bisection method (or other methods) to find out $\mathscr{D}_{\mathbf{init}} = \{\mathscr{D} \in \Omega_\eta | \min |C(\mathscr{R}) - C(\mathscr{D})| \}$. Next, find out the best-matched domain block \mathscr{D}_m in the nearest k-neighbours of the $\mathscr{D}_{\mathbf{init}}$ during the search process, namely, $N(D_{\mathbf{init}}, k) = \{D_i \in \Omega_\eta : |i - init| \leq k\}$. And then store the corresponding index m, quantitative parameters \bar{s}, \bar{o}, isometric transformation index t of domain block D_m, these constitute fractal code (m, \bar{s}, \bar{o}, t) of the non-shade range block \mathscr{R}.

Obviously, $N(\mathbf{D}_{init}, k) \subset \Omega_\eta \subset \Omega$, the search space from global search to a local search, there is no doubt that the coding time will be reduced as a result, the search space diminish so as to realize the purpose of speed up the encoding process. Accelerated speed depends on the size of the neighbourhood radius k, for the various non-shade range blocks \mathscr{R}; the distance of their best-matched domain block in the sense of whole search (called global matching block) to initial matching block \mathscr{D}_{init} is different. For a given k, the global matching block of some non-shade range block is not in the nearest k-neighbours of the \mathscr{D}_{init}, and thus to find the local matching block within the k-neighbours is not global matching blocks, lead to local matching block instead of global matching block, the decoded image quality is not guaranteed. To avoid this kind of situation, the key is whether the image blocks features defined accurately. The following experiment will demonstrate the effectiveness of this paper define the coefficient of variation features.

4 Simulation Test Results

In the experiment, we only employ the uniform partitioning scheme, the range blocks and domain blocks are respectively of sizes 4×4 and 8×8, and the sliding step is eight pixels. The experiments are done under C++Builder6.0 on PC with AMD Athlon x2-250 processor 3.01 GHz and Windows XP, in which test images Lena, Peppers and Boat (512×512, 8 bits/pixel) are utilized to evaluate the algorithms.

4.1 Demonstrate the Effectiveness of Coefficient of Variation Features

Through simulation experiment to measure the global matching block fall into the $U(\mathscr{D}_{init}, k)$ in the sense of coefficient of variation features, the quantity of global matching block of range block being encoded fall into $U(\mathscr{D}_{init}, k)$ about three test images, which list in Table 1. Logo "M–N" in the table show the value interval $(|\Omega| \times M\%, |\Omega| \times N\%]$, where $|\Omega|$ is the capacity of codebook block.

Can be seen from Table 1, for the selected three images, when $k \leq |\Omega| \times 10\%$, the average quantity percentage of the global matching block of the range block being encoded fall into neighbor interval $[0, 0.1|\Omega|]$ is respectively 19.2%, 21.1% and 19.8%; when $k \leq |\Omega| \times 30\%$, the proportion is respectively 45.1%, 46.6% and 46.3%; when $k \leq |\Omega| \times 50\%$, the proportion is respectively 63.9%, 64.3% and 64.9%; that fall into neighbor interval $[0.9\,|\Omega|, |\Omega|]$ is respectively 5.6%, 5.9% and 5.5%. The results show that, most of the global matching block of the range block being encoded is near its initial matching block \mathscr{D}_{init}, don't need to do a full search could find, verify the neighborhood search is feasible.

The simulation experiment results to measure the global matching block fall into the $U(\mathscr{D}_{init}, k)$ in the sense of moment of inertia feature [10] are tabulated in Table 1 by using the same method. Taking the average of three test image experiment data in Table 1 to make Fig. 1, it shows the number of global matching block at different

Table 1. Quantity of the range block of full best-matched domain block fall into neighbours $U(\mathcal{D}_{init}, k)$ (Moment of inertia feature [10] (labelled I) and coefficient of variation feature (labelled II))

Value interval M–N (%)	The quantity of global matching block of range block being encoded					
	Lena512		Pepper512		Boat512	
	I	II	I	II	I	II
0 ~ 10	1170	3147	892	3458	1530	3273
10 ~ 20	1439	2297	1111	2387	1342	2301
20 ~ 30	1521	1949	1251	1787	1605	2004
30 ~ 40	1728	1564	1548	1528	1544	1649
40 ~ 50	1772	152	1954	1375	1775	1402
50 ~ 60	1783	1389	1895	1309	1739	1341
60 ~ 70	1702	1271	2003	1176	1826	1350
70 ~ 80	1747	1198	2137	1164	1618	1147
80 ~ 90	1918	1130	1903	1230	1684	1023
90 ~ 100	1604	918	1690	975	1721	894

Fig. 1. Quantity of the global matching block of the range block for the different searching scope

search space. Under the same search space, the quantity of the global matching block of the range block being encoded fall into the $U(\mathcal{D}_{init}, k)$ based on coefficient of variation features is more than moment of inertia feature. Show that the coefficient of variation feature than the moment of inertia feature is more accurately depict image blocks information comprehensively.

4.2 The Proposed Algorithm Verification

Fast encoding scheme in this paper, the quantity of the shade range block without being encoded, and the capacity of depends on its characteristics of human visual sensitivity. According to this article take the simulation image and segmentation approach, the quantity of the range block and the codebook block is respectively 16384 and 32768. The quantity of the shade range blocks without search encoding and allow the codebook capacity Ω_η are shown in Table 2.

Table 2. Quantity of the shade range block and reduced codebook

Simulation image 图像	Lena512	Pepper512	Boat512
Quantity of the shade range block	4660	2119	5653
Allow the codebook capacity Ω_η	28440	20160	22896

From the data in Table 2 it is easy to calculate, for the three test image, the number proportion of the shade range block is 28.4%, 12.9% and 34.5% respectively. Allow codebook capacity Ω_η reduces the codebook capacity Ω ratio of 13.2%, 38.5% and 30.1% respectively. The time needed for coding is the less. The encoding process expended less time as these percentage values is the greater.

The radius of neighbourhood k have more influence on the coding performance in the proposed algorithm, through the experiment to determine the values of neighbourhood radius k. Figure 2 shows the changing of three decoding image quality under different search space percentage. When $k \leq |\Omega| \times 50\%$, the quality of decoded image have the larger extent increases with the increase of the neighbourhood radius k, but $k \geq |\Omega| \times 50\%$, only have the less extent increase, considering two factors, time coding and decoding image quality in search space percentage is 50% more appropriate.

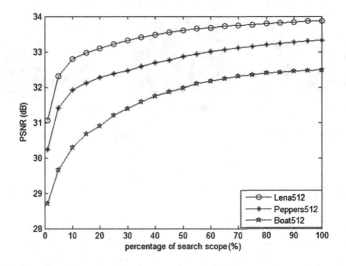

Fig. 2. The decoding image quality changes along with the percentage of the search space

In order to demonstrate the effectiveness of the proposed fast algorithm, choose encoding time (in seconds) and peak signal-to-noise ratio PSNR (dB) for testing the performance parameters. In this paper, the contrast experiment results of the proposed algorithm $(k = |\Omega| \times 50\%)$ with full search algorithm listed in Table 3.

Table 3. Comparison of the coding results between the proposed algorithm and the full search algorithm

Test image	Full search algorithm		The proposed algorithm		
	Time (s)	PSNR (dB)	Time (s)	PSNR (dB)	To speed up the multiple
Lena512	248.7	33.79	65.41	33.60	3.80
Pepper512	249.2	33.37	50.67	32.87	4.92
Boat512	248.1	32.47	46.97	31.98	5.28

From Table 3 shows that the selection of the three simulation images, the proposed algorithm is averagely about 4.67 times faster than full search algorithm with just about 0.39 dB decline. Figure 3 reveals reconstructed images of two algorithms.

From the perspective of the subjective quality of Fig. 3, the decoding image quality of the proposed algorithm with full search algorithm is not much difference.

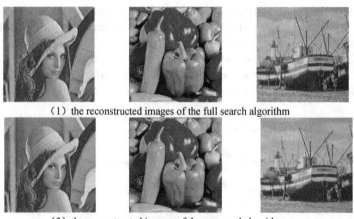

(1) the reconstructed images of the full search algorithm

(2) the reconstructed images of the proposed algorithm

Fig. 3. Comparison of the decoded images between the proposed algorithm and the full search algorithm

5 Conclusions

In this paper, we defined the coefficient of variation feature as the criterion for the similarity of two images block, and it is utilized to confine efficiently the search space to the vicinity of the initial-matched block, so as to effectively select only appropriate

domain blocks before matching. Thus, the best-matched domain block can be captured much more quickly than the full search method. Simulations show that the proposed algorithm not only can reduce significantly the encoding time in the case of decoding image quality with a little down, but also the performance of the proposed algorithm is better than moment of inertia feature [10]. Therefore, the presented scheme provides a good tradeoff between matching accuracy and complexity, and has better applied foreground than full search algorithm.

References

1. Jacquin, A.E.: Image coding based on a fractal theory of iterated contractive image transformations. IEEE Trans. Image Process. 1(1), 18–30 (1992)
2. Fisher, Y. (ed.): Fractal Image Compression: Theory and Application. Springer, New York (1995)
3. Saupe, D.: Accelerating fractal image compression by multi-dimensional nearest neighbour search. In: Proceedings of Data Compression Conference, vol. 3, pp. 222–231 (1995)
4. Wohlberg, B., De Jager, G.: A review of the fractal image coding literature. IEEE Trans. Image Process. 12, 1716–1729 (1999)
5. Selvi, S.S., Makur, A.: Variable dimension range and domain block-based fractal image coding. IEEE Trans. Circuits Syst. Video Technol. 4, 343–347 (2003)
6. He, C., Yang, S.X., Xu, X.: Fast fractal image compression based on one-norm of normalised block. Electron. Lett. 40(17), 1052–1053 (2004)
7. He, C., Huang, X.: Fast fractal image coding based on local cross trace. Chin. J. Comput. 28 (10), 1753–1759 (2005)
8. He, C.-J., Shen, X.-N.: Improving cross trace based algorithm for fractal image coding. Chin. J. Comput. 30(12), 2156–2163 (2007)
9. Li, G.-P., Xiang, H.-F., Zhao, Z.-W.: Fast fractal image encoding algorithm based on quartiles feature. Comput. Eng. Appl. 47(22), 145–148 (2011)
10. Sun, H.-S., Liu, X.-D., Dang, J.-T., Wu, S.-H.: Fast fractal image encoding based on moment of inertia. Microelectron. Comput. 26(5), 92–95 (2009)

A GNC Method for Nonconvex Nonsmooth Image Restoration

Xiao-Guang Liu[1(\boxtimes)] and Qiu-fang Xue[2]

[1] School of Computer Science and Technology,
Southwest University for Nationalities,
Chengdu 610041, Sichuan, People's Republic of China
dtcr-gg@163.com
[2] The Department of Applied Mathematics,
Xi'an University of Technology, Xi'an 710054, Shaanxi, People's Republic of China
qiufangxue@163.com

Abstract. The augmented Lagrangian duality method have superior restoration performance for nonconvex nonsmooth images. However, an effective initial value could not be obtained for the augmented Lagrangian duality when it is used alone. To overcome this drawback, a hybrid method based on the augmented Lagrangian duality method and the graduated nonconvex method(GNC) is proposed. The better restored performance of the proposed method are illustrated by some numerical results.

Keywords: Nonconvex nonsmooth · Augmented lagrangian · GNC method

1 Introduction

Digital image restoration has a wide application [1]. In general, the relationship between the original image $\hat{f} \in F$ and the observed image $g \in R^q$ is:

$$g = A\hat{f} + b, \tag{1}$$

where $b \in R^q$ is the additive noise, the matrix $A \in R^{q \times l}$ represents the degradation systems caused by problems such as motion blur, $l = l_1 l_2$ with l_1 and l_2 being the number of rows and columns respectively when images expressed as a matrix.

The objective of the image restoration is to estimate the original image \hat{f} according to A, b and g. However, it often tends to be very ill-conditioned when the reverse process of (1) is only used. Thus one of the effective ways to solve these problems is to combine some priori information of the original image and

This work was supported in part by grants from the Fundamental Research Funds for the Central Universities of Southwest University for Nationalities (2015NZYQN30).

Y. Chen et al. (Eds.): SG 2015, LNCS 9317, pp. 184–191, 2017.
DOI: 10.1007/978-3-319-53838-9_16

define the regularization solution, *i.e.*, the ideal estimation f^* is a minimum point of the following cost function:

$$J(f) = \theta(Af - g) + \alpha\Phi(f), \tag{2}$$

where $\theta: R^q \to R$ is the measure of the difference between Af and g, the regularization term Φ embodies the priori information and a regularization parameter $\alpha > 0$ is used to control the tradeoff between the terms θ and Φ.

In this paper, we set $\Phi(f^*) = \beta\Phi(g)$, *i.e.*, to estimate $\Phi(f^*)$ using $\Phi(g)$(for simplicity, let $q = l$), where the parameter $\beta > 0$ is used to control the tradeoff between $\Phi(f)$ and $\Phi(g)$. Then (2) becomes:

$$(P) \qquad \begin{cases} \min\limits_{f \in F} & \theta(Af - g), \\ s.t. & \Phi(f) = \beta\Phi(g). \end{cases} \tag{3}$$

β and $\Phi(f)$ can be called as regularization parameter and regularization term, respectively.

For (3), $\theta(x) = \|x\|_2^2$ or $\theta(x) = \|x\|_1$. We let $\theta(x) = \|x\|_2^2$ in this paper, and the proposed methods can be extended easily to $\theta(x) = \|x\|_1$ by using some ideas in [2].

The regularization term $\Phi(f) = \sum\limits_{i \in I} \phi(\|D_i f\|_2)$, where $I = \{1, 2, \cdots, l\}$, $\phi : R \to R_+ = \{t \in R : t \geq 0\}$ is a continuous potential function generally. $D_i : R^l \to R^p$ is the difference operator which can be seen as an $p \times l$ matrix and used to create the difference vector between ith pixel and its p (here $p = 2$) neighboring pixels.

It is well known that the potential function ϕ plays a key role in the image restoration [2–5]. For the images with neat boundaries, the nonconvex nonsmooth potential functions $\frac{\lambda t}{1+\lambda t}, log(\lambda t + 1)$ and so on have reflected superior restoration performance from the theories and numerical experiments [3–5], but they also cause several difficulties in numerical computation. Therefore, the graduated nonconvex method(GNC) is widely employed [6,7]. To get an initial value with good performance to capture the optimum point of (2) or (3), this method adopts a range of nonconvex smooth or nonconvex nonsmooth approximate potential functions $\phi_{\varepsilon_k}(\varepsilon_0 = 0 < \varepsilon_1 < \cdots < \varepsilon_n = 1$ and $\phi_{\varepsilon_n} = \phi)$ gradually to approach ϕ. Experiment results show that the efficiency and the restored quality are better than many other famous methods such as simulated annealing [8].

On the other hand, it is noteworthy that the augmented Lagrangian Duality [8,9] reflects excellent performance to deal with nonconvex nonsmooth problem. In general, the augmented Lagrangian L associated with problem:

$$\begin{cases} \min\limits_{f \in F} \varphi(f), \\ s.t. \quad \varphi_0(f) = 0 \end{cases} \tag{4}$$

is defined as:

$$L(f, c, e) = \varphi(f) + c\sigma(\varphi_0(f)) - \langle\varphi_0(f), e\rangle, \tag{5}$$

where the functions φ, φ_0, σ are continuous, and σ satisfy: $\sigma \geq 0$, $\min \sigma = 0$, $\arg\min \sigma = 0$. Here, $c \geq 0$ is the penalty multiplier associated with the augmenting term, and vector e is the dual variable, $\langle ., . \rangle$ is the scalar product. Then the dual function H induced by the augmented Lagrangian L is defined as:

$$H(c, e) = \min_{f \in F} L(f, c, e). \tag{6}$$

Thus the dual problem of (4) is

$$(D) \qquad \max_{(c,e)} H(c, e). \tag{7}$$

This problem is concave and can be usually solved by nonsmooth convex optimization techniques such as subgradient method and their extensions [4,8].

In (3), F is compact, so the zero duality gap is attained(min(P)=max(D)) when ϕ is continuous and a feasible solution exists. Thus a solution of the original problem (3) can been obtained by solving (7) regardless of convexity and smoothness. Even though a global minimum point of (7) can be founded from theoretical viewpoint, it may be a very challenging task generally, especially for the nonconvex nonsmooth problems. To overcome this difficulty, we propose a hybrid method to solve nonconvex nonsmooth problem based on the GNC method and augmented Lagrangian duality in this paper. It is not only beneficial to get a effective initial value for the original augmented Lagrangian duality method, but also an adaptive energy function is generated by the dual iterations. Finally, the performance of the new method are illustrated by numerical results.

The outline of this paper is as follows. Some preliminaries are stated in Sect. 2. A hybrid method based on the GNC method and augmented Lagrangian duality for (3) is proposed in Sect. 3. The numerical examples are given in Sect. 4. Finally, some concluding remarks are given in Sect. 5.

2 Preliminaries

In this section, we propose the specific duality approach for solving problem (4) and state some properties used in this paper.

Based on (7), given a current dual iterate (c^m, e^m) in a suitable space of dual variables:

$$(c^m, e^m) = (c^{m-1}, e^{m-1}) + t^{m-1}d^{m-1}, \tag{8}$$

a primal iterate is computed through the rule

$$f^m \in \arg\min_{f \in F} L(f, c^m, e^m), \tag{9}$$

where t^{m-1} is the step, d^{m-1} is the direction associated with the subgradient of H at (c^{m-1}, e^{m-1}) that will be given in Sect. 4.

For problem (3), let $\sigma(t) = |t|$ (the absolute of scalar t) in (5), then the augmented Lagrangian L of (3) is

$$L(f, c, e) = \|Af - g\|_2^2 + c|\Phi(f) - \beta\Phi(g)| - \langle\Phi(f) - \beta\Phi(g), e\rangle. \tag{10}$$

Clearly e in (10) is real number. Then it is very beneficial to compute.

In following discussions, we denote $R_+^* = \{t \in R : t > 0\}$, $R^+ = \{t \in R : t \neq 0\}$ and $Ker(A) = \{x \in R^n | Ax = 0\}$.

3 Algorithm

In this section, we will propose a hybrid method based on the GNC method and the augmented Lagrangian duality. Firstly, let the augmented Lagrangian $L(f, c, e)$ be approached gradually by the following series of functions:

$$L_{\varepsilon_k}(f, c, e) = \|Af - g\|_2^2 + c|\Phi_{\varepsilon_k}(f) - \beta\Phi_{\varepsilon_k}(g)| - \langle\Phi_{\varepsilon_k}(f) - \beta\Phi_{\varepsilon_k}(g), e\rangle, \tag{11}$$

where $\Phi_{\varepsilon_k}(f) = \sum_{i \in I} \phi_{\varepsilon_k}(\|D_if\|_2)$ and ϕ_{ε_k} is nonconvex nonsmooth function. Let $\alpha_{\varepsilon_k} = \phi'_{\varepsilon_k}(0^+)$, then ϕ_{ε_k} can be rewritten as follows(see [7]): $\phi_{\varepsilon_k}(t) = \psi_{\varepsilon_k}(t) + \alpha_{\varepsilon_k}|t|$. Thus

$$L_{\varepsilon_k}(f, c, e) = \|Af - g\|_2^2$$
$$- \begin{cases} (e - c)[\Psi_{\varepsilon_k}(f) + \alpha_{\varepsilon_k} \sum_{i \in I} \|D_if\|_2 - \beta\Phi_{\varepsilon_k}(g)], if\ \Phi_{\varepsilon_k}(f) - \beta\Phi_{\varepsilon_k}(g) \geq 0, \\ (c + e)[\Psi_{\varepsilon_k}(f) + \alpha_{\varepsilon_k} \sum_{i \in I} \|D_if\|_2 - \beta\Phi_{\varepsilon_k}(g)], otherwise, \end{cases} \tag{12}$$

where $\Psi_{\varepsilon_k}(f) = \sum_{i \in I} \psi_{\varepsilon_k}(\|D_if\|_2)$. Moreover, we denote $TV(f) = \sum_{i \in I} \|D_if\|_2$ since the term $\sum_{i \in I} \|D_if\|_2$ amounts to the TV regularization by the definition isotropic total variation when D_i are discrete gradients.

To solve the problem including TV term, an auxiliary variable $u \in R^l$ is used to cope with the nonsmooth TV term as that in [7], i.e., a weighted quadratic fitting term $\omega\|f - u\|^2$ is added to ensure the closeness of f and u, where $\omega > 0$ is weight. Then the augmented $L_{\varepsilon_k}(f, c, e)$ in (12) becomes

$$\hat{L}_{\varepsilon_k}(f, u, c, e) = \|Af - g\|_2^2 + \omega\|f - u\|^2$$
$$- \begin{cases} (e - c)[\Psi_{\varepsilon_k}(f) + \alpha_{\varepsilon_k}TV(u) - \beta\Phi_{\varepsilon_k}(g)], if\ \Phi_{\varepsilon_k}(f) - \beta\Phi_{\varepsilon_k}(g) \geq 0, \\ (c + e)[\Psi_{\varepsilon_k}(f) + \alpha_{\varepsilon_k}TV(u) - \beta\Phi_{\varepsilon_k}(g)], otherwise. \end{cases} \tag{13}$$

Thus the proposed method to solve (13) is stated as follows:

(1) When f is fixed, the first step is a TV denoising problem:

$$u^{(m,\varepsilon_k)} = arg\min_{u \in F} \hat{L}_{\varepsilon_k}(f^{(m-1,\varepsilon_k)}, u, c^{(m,\varepsilon_k)}, e^{(m,\varepsilon_k)}). \tag{14}$$

It is noted that the problem (14) can be solved by many denoising methods [10,11]. Here, we employ the Chambolle's projection algorithm [10] for it.

(2) When u is fixed, the second step is to perform the deblurring, i.e., to solve the optimization problem:

$$f^{(m,\varepsilon_k)} = arg \min_{f \in F} \hat{L}_{\varepsilon_k}(f, u^{(m,\varepsilon_k)}, c^{(m,\varepsilon_k)}, e^{(m,\varepsilon_k)}).$$

Obviously (12) is not differential and the sign of $\Phi_{\varepsilon_k}(f) - \beta\Phi_{\varepsilon_k}(g)$ can not be determined since f is unknown. Noticing that the similarity of $f^{(m,\varepsilon_k)}$ and $u^{(m,\varepsilon_k)}$ must be very high, i.e., $\|f - u\|_2^2$ is very small, so the term $\Phi_{\varepsilon_k}(f) - \beta\Phi_{\varepsilon_k}(g)$ can be approximated by replacing $f^{(m,\varepsilon_k)}$ with $u^{(m,\varepsilon_k)}$.

Now, the object function $\hat{L}_{\varepsilon_k}(., u^{(m,\varepsilon_k)}, c^{(m,\varepsilon_k)}, e^{(m,\varepsilon_k)})$ of the above problem is twice differentiable, many methods based gradient can been applied to deal with it. Here, we use Quasi-Newton's method [7] to solve it, which can be described in details as follows:

if $\varepsilon_k = 0$, solve $(A^\top A + \omega I)f^{(m,\varepsilon_k)} = A^\top g + \omega u^{(m,\varepsilon_k)}$;

otherwise

solve $(2A^\top A + 2\omega I)\Delta f^{(m-1,\varepsilon_k)} = -\nabla_f \hat{L}_{\varepsilon_k}$, update $f^{(m,\varepsilon_k)} = f^{(m-1,\varepsilon_k)} + \tau \Delta f^{(m-1,\varepsilon_k)}$,

where

$$\nabla_f \hat{L}_{\varepsilon_k} = 2H^\top(Af^{(m-1,\varepsilon_k)} - g) + 2\omega(f^{(m-1,\varepsilon_k)} - u^{(m,\varepsilon_k)})$$
$$- \begin{cases} (e^{(m,\varepsilon_k)} - c^{(m,\varepsilon_k)})\nabla\Psi_{\varepsilon_k}, if \;\; \Phi_{\varepsilon_k}(u^{(m,\varepsilon_k)}) - \beta\Phi_{\varepsilon_k}(g) \geq 0, \\ (c^{(m,\varepsilon_k)} + e^{(m,\varepsilon_k)})\nabla\Psi_{\varepsilon_k}, otherwise. \end{cases} \quad (15)$$

In summary, the proposed algorithm is as follows:

Algorithm 1

Step 1. set $\varepsilon_0 = 0$, $\Delta\varepsilon = 1/n$, $f^{(0,0)} = g$, Abs $= 10^{-4}$(absolute error), initialize β, τ;

Step 2. if $\varepsilon_k + \Delta\varepsilon > \varepsilon_n$, then stop. Set $m = 1$ and ReErr=Abs+1(relative error), initialize ω, $c^{(1,\varepsilon_k)}$, $e^{(1,\varepsilon_k)}$;

Step 3. compute $u^{(m,\varepsilon_k)}$ using the Chambolle's method, where

$$\lambda = \begin{cases} \alpha_{\varepsilon_k}(c^{(m,\varepsilon_k)} - e^{(m,\varepsilon_k)})/(2\omega), & if \;\; \Phi_{\varepsilon_k}(f^{(m-1,\varepsilon_k)}) - \beta\Phi_{\varepsilon_k}(g) \geq 0, \\ \alpha_{\varepsilon_k}(-c^{(m,\varepsilon_k)} - e^{(m,\varepsilon_k)})/(2\omega), & otherwise; \end{cases}$$

Step 4. compute $f^{(m,\varepsilon_k)}$ using the Quasi-Newton method above;

Step 5. if $\Phi_{\varepsilon_k}(f^{(m,\varepsilon_k)}) - \beta\Phi_{\varepsilon_k}(g) = 0$, then stop and output $f^{(m,\varepsilon_k)}$;

Step 6. compute ReErr $= \|f^{(m,\varepsilon_k)} - f^{(m-1,\varepsilon_k)}\|_2/\|f^{(m,\varepsilon_k)}\|_2$, if ReErr $>$ Abs, then increase ω and set $m = m + 1$, update parameter c and e using (8), goto step 3;

Step 7. set $f^{(0,\varepsilon_{k+1})} = f^{(m,\varepsilon_k)}$, $\varepsilon_{k+1} = \varepsilon_k + \Delta\varepsilon$, goto step 2.

Remark 1. (a) From Lemma 2, $f^{(m,\varepsilon_k)}$ is an optimum of the ε_kth approximation when the above Algorithm stop.

4 Experimental Results

In this section, some numerical results of two tested images will be provided to show the performance of our algorithms. The tested images are Lena of 256×256 and Cameraman of 512×512(CR).

In all runs, CPU time is used to compare the efficiency of the restoration, Peak signal-to-noise ratio(PSNR):

$$PSNR = -20 log_{10}(\frac{\| f^{(m,\varepsilon_k)} - \hat{f} \|_2}{l_1 l_2}),$$

is used to measure the quality of the restored images. As in [7], ϕ and ϕ_{ε_k} are selected as follows:

$$\phi = \frac{\lambda |t|}{1 + \lambda |t|} \text{ and } \phi_{\varepsilon_k} = \frac{\lambda |t|}{1 + \varepsilon_k \lambda |t|}.$$

Through a lot of experiments, $c^{(1,\varepsilon_k)}$ and $e^{(1,\varepsilon_k)}$ are generated randomly between $[0.015, 0.025]$ and $[0.005, 0.15]$ respectively. Moreover, as in [7], ω is set as 1.1, and its value is updated by 1.8ω at each inner iteration, the step used in the Chambolle's method is 0.25. The regularization parameter is selected as 0.015 in the algorithm of [7]. The tested blurring function is chosen to be truncated 2-D Gaussian function:

$$h(s,t) = exp(\frac{-s^2 - t^2}{2\sigma^2}), \quad -3 \leq s,t \leq 3.$$

Here three sets of parameters are chosen: (1) $\sigma = 1$ and the support being equal to 5×5, the standard deviation is 0.01; (2) $\sigma = 1.5$ and the support being equal to 7×7, the standard deviation is 0.05; (3) $\sigma = 2$ and the support being equal to 9×9, the standard deviation is 0.1, the regularization parameter β is selected as 0.25, 0.23, 0.20 respectively for the three cases. We set Abs=10^{-4}, then the stopping criterion of the algorithms should satisfy the following conditions: $Max\ iterations \leq 5000$, and $ReErr < Abs$.

Figures 1(a) and 2(a) show the original images. Figures 1(b) and 2(b) show the observed images. Figure 1(c) shows the restored Lena image by algorithm in [7], Fig. 1(d) shows the restored Lena image by algorithm in this paper, where the standard deviation of noise is 0.05, the support being equal to 7×7, and $\lambda = 1.5$. Figures 2(c) shows the restored Cameraman image by algorithm in [7], Fig. 2(d) shows the restored Cameraman image by algorithm in this paper, where the standard deviation of noise is 0.1, the support being equal to 9×9, and $\lambda = 2$. Tables 1 and 2 show CPU times and PSNR of algorithms, the support is 5×5, 7×7, 9×9 for noise levels 0.01($\lambda = 1$), 0.05($\lambda = 1.5$), 0.1($\lambda = 2$) respectively.

We can know from Tables 1 and 2 that the efficiency and the restored quality of the algorithm in this paper are higher than the algorithm in [7] in most cases. Next, we will compare the ReErr and iteration number.

(a) (b) (c) (d)

Fig. 1. The restored Lena images by different algorithms with $\lambda = 1.5$, standard deviation of noise is 0.05, and the support is 7×7. (a) Original image. (b) Observed image. (c) Images restored by algorithm in [7]. (d) Images restored by algorithm in this paper.

(a) (b) (c) (d)

Fig. 2. The restored Cameraman images by different algorithms with $\lambda = 2$, standard deviation of noise is 0.1, and the support is 9×9. (a) Original image. (b) Observed image. (c) Images restored by algorithm in [7]. (d) Images restored by algorithm in this paper.

Table 1. Restored PSNR and CPU times of algorithm in [7]

			$\lambda = 1$		$\lambda = 1.5$		$\lambda = 2$	
	Noise	Blur	PSNR	CPU	PSNR	CPU	PSNR	CPU
Lena	0.01	5×5	29.54	6.51	29.08	6.40	28.71	8.17
	0.05	7×7	26.54	9.16	26.52	9.86	26.36	11.68
	0.1	9×9	23.31	11.62	23.37	12.00	24.37	14.91
CR	0.01	5×5	35.03	39.87	34.11	43.17	33.35	49.87
	0.05	7×7	30.03	66.44	30.03	67.14	29.33	69.87
	0.1	9×9	25.41	73.40	26.35	78.73	26.67	91.35

Table 2. Restored PSNR and CPU times of algorithm in this paper

			$\lambda = 1$		$\lambda = 1.5$		$\lambda = 2$	
	Noise	Blur	PSNR	CPU	PSNR	CPU	PSNR	CPU
Lena	0.01	5×5	30.53	6.40	30.32	6.40	30.03	6.16
	0.05	7×7	26.39	8.86	26.52	9.09	26.50	10.75
	0.1	9×9	23.32	10.26	23.74	12.03	24.32	14.32
CR	0.01	5×5	36.01	39.31	35.17	41.08	34.50	46.10
	0.05	7×7	30.24	55.01	29.88	57.03	29.87	57.42
	0.1	9×9	25.39	71.45	27.37	77.74	27.34	81.93

5 Concluding Remark

In this paper, we present a hybrid method based on the GNC method and augmented Lagrangian duality to deal with nonconvex nonsmooth image restoration without the convexity and smoothness. Numerical results show that the efficiency and restored quality of the proposed method. As for the future research work, we would study how to utilize the improvements about GNC method, augmented Lagrangian duality, and subgradient method to improve the performance of this hybrid method.

References

1. Gonzalez, R.C., Woods, R.E.: Digital Image Processing, 2nd edn. Prentice Hall, Upper Saddle River (2002)
2. Guo, X.X., Li, F., Ng, M.K.: A fast $\ell_1 - TV$ algorithm for image restoration. SIAM J. Sci. Comput., 2322–2341 (2009)
3. Geman, D., Reynolds, G.: Constrained restoration and recovery of discontinuities. IEEE Trans. Pattern Anal. Mach. Intell. **14**, 367–383 (1992)
4. Clarke, F.H.: Optimization and Nonsmooth Analysis. Wiley, New York (1983)
5. Bian, W., Xue, X.P.: Subgradient-based neural network for nonsmooth nonconvex optimization problem. IEEE Trans. Neural Netw. **20**, 1024–1038 (2009)
6. Blake, A., Zisserman, A.: Visual Reconstruction. MIT Press, Cambridge (1987)
7. Nikolova, M., Ng, M.K., Tam, C.P.: Fast nonconvex nonsmooth minimization methods for image restoration and reconstruction. IEEE Trans. Image Process. **19**, 3073–3088 (2010)
8. Sun, W.Y., Yuan, Y.X.: Optimization Theory and Method: Nonlinear Programming. Springer, Heidelberg (2006)
9. Rockafellar, R.T.: Lagrange muitipliers and optimality. SIAM Rev. **35**, 183–238 (1993)
10. Chambolle, A.: An algorithm for total variation minimization and applications. J. Math. Imag. Vis. **20**, 89–97 (2004)
11. Chan, T.F., Chen, K.: An optimization based total variation image denoising. SIAM J. Multiscale Model. Sim. **5**, 615–645 (2006)
12. Wang, Y.L., Yang, J.F., Yin, W.T., Zhang, Y.: A new alternating minimization algorithm for total variation image reconstruction. SIAM J. Imag. Sci. **1**, 248–272 (2008)

Posters and Demo Session

Research of Image Preprocessing
in the Recognition System of RMB
Crown Word

GuangJian Zhang[⊠]

Department of Information Engineering,
Sichuan College of Architectural Technology, Deyang, Sichuan, China
zgjppp@126.com

Abstract. A crown word on a Chinese RMB note is a sequence of characters that uniquely identify a bank note. Training set sampling is very important in the recognition system of RMB crown word, which directly affects the accuracy of the recognition system. Image preprocessing operations require a number of properties on the crown characters such as the location, tilt correction, attitude, adjustment, noise reduction, binarization and single character segmentation and so on.

Keywords: Image processing · Image segmentation · The RMB crown word · Pattern recognition

1 Introduction

RMB's crown word number is composed of two parts, "crown word" and "number". "Crown word" is printed on the banknotes to mark printing batches of English letters, according to certain rules layout and printing; "number" is printed on the "crown word" behind the serial number of the Arabic numerals to indicate the notes of each in the same "crown word" batch in order. The crown character of RMB is one of the measures of the Chinese central bank to print production management control.

According to the reference [1], the crown word is the unique identity of the Chinese RMB. Figure 1 shows a 100 Yuan RMB, on which the crown word number is "JD75860888", at the lower left corner of the banknote.

By identification and recording of the crown word of Chinese RMB. The financial department can establish archives for crown word number, make it easy to track the circulation of RMB, and carry out effective supervision, it is conducive to the rapid genuine inquiry of RMB. In the ATM machine deposit and withdraw can be performed through the crown word number recognition the crown word recognition system installed on the ATM machine, it can be used to transaction monitoring, clear responsibility and prevent counterfeiting. It provides clear scientific basis for the disputes between the bank and the customer.

According to the position of RMB image characteristics and character, character extract of the crown word includes image acquisition, tilt correction, attitude adjustment, gray level, localization, binarization, segmentation and normalization. The experiment of this paper uses the software of reference [2].

© Springer International Publishing AG 2017
Y. Chen et al. (Eds.): SG 2015, LNCS 9317, pp. 195–202, 2017.
DOI: 10.1007/978-3-319-53838-9_17

Fig. 1. The RMB crown word is "JD7586088"

Here is the main research method of the RMB crown character image segmentation. According to the fast and accurate demand of the recognition of the characters of the crown, the method of using the histogram threshold for the two valued and single character image segmentation is proposed.

2 Image Segmentation

Image segmentation technology is to follow certain similarity criterion, the use of image feature information (such as intensity, gradient, color, texture, etc.). Image segmentation principle: find an region, its interior features with a very high degree of similarity, but it is very different from other regions. The main purpose of the image segmentation is to divide the image area in order to reduce redundant information and improve subsequent processing operations efficiency, the localization of target, extraction, convenient for the further recognition.

Existing image segmentation methods are mainly divided into the following categories [3]: based on the threshold segmentation method based on region segmentation method, based on edge based segmentation method and segmentation algorithms based on a particular theory. Region segmentation includes region growing method, watershed segmentation, and edge segmentation including line segment, differential operator, canny operator, LOG operator and so on.

The threshold segmentation is a comparison between the gray level and a threshold value, for each pixel in all pixels in the image to achieve the purpose of the segmentation. So the key is to determine the threshold. Commonly used threshold segmentation methods are: Otsu, iterative and two peaks.

2.1 Crown Character Position

Because RMB banknotes acquired images as a whole is rectangular, through the rectangle's four vertices, or all four sides will be able to determine the image's border, namely access to the height and width of the image. If the rectangle image is divided into 4 equal parts, then the RMB crown word is located in the lower left corner of the rectangular image region. Simple processing, MATLAB imcrop function can be used to complete it. If we consider the actual sampling devices are single CIS or double CIS, on the technology there are more factors to consider.

2.2 Image Binary Processing

In the binary image gray value of only two values, 0 and 1, through the threshold, the gray-scale image can be converted to binary image. Assuming that the original image pixel value with, the threshold of T, after the binary image with, the transformation of the relationship between the two, as shown in Eq. 1.

$$g(x,y) = \begin{cases} 1, f(x,y) \geq T \\ 0, f(x,y) < T \end{cases} \tag{1}$$

The gray-value representation of the can significantly reduce the amount of data storage capacity, and reduce the complexity of the subsequent processing. Because in the actual notes, due to wear and other reasons, the gray distribution may not be uniform and minimum gray value of each pixel in the neighborhood, and the value of the pixel threshold segmentation [4, 5]. Here, use the Otsu algorithm. Otsu algorithm is the classic method of dynamic global threshold selection. The Otsu algorithm is acknowledged as the best algorithm. Selecting the global image segmentation threshold is simple in calculation, is not affected by the image brightness and contrast, of the image binary of the algorithm the threshold, in all cases the performance is relatively good, the segmentation quality is guaranteed, is one of the most stable segmentation, it is the more general.

2.3 Single Character Segmentation

Section 2.1 the RMB Crown word of extracted region is positioned at the beginning of the character positions, individual characters are still together, if you want to do character recognition, each character must be segmented. This single character segmentation is required to complete. Single character image can be segmented to identify the crown size. Whether the character segmentation is correct or not directly affects the accuracy of character recognition. It is the most important and difficult step in the recognition system.

At present, there are three kinds of character segmentation methods: gap method, projection method and connected area analysis method.

This subject adopts is easy to realize the projection method is used to realize the single character segmentation. The segmentation strategy is to determine the left and right boundaries of each character, and then determine the upper and lower bounds of each character (The upper and lower bounds of the separate characters are not the same). Steps of the projection method are:

(1) Get a vertical projection image, based on vertically projected the RMB crown word image.
(2) In the vertical projection image, From the left to the right in order to detect the value of each projection, 1th 1 position left boundary that is the 1th characters, and then continue to the right test, detects the 1th to 0 position right boundary that is the 1th characters. According to this method, continue to the right projection

value, to find the remaining 9 projection regions of the left and right boundaries (the RMB crown word is made up of 10 characters).

(3) Using the same algorithm, and horizontal projection of a single character, from the top down to projected value, you can get upper and lower boundary for each character.

Get 4 border values of each character (the left and right borders, the upper boundary, the lower boundary). This can to segment a single character. (Here does not take into account factors such as adhesion and rupture of the character).

3 Experimental Analysis

3.1 Research Sample

The research samples are acquired according to methods presented in Sect. 2.1: I2 = imcrop (I, rect) crops the image I. rect is a four-element position vector [xmin ymin width height] that specifies the size and position of the crop rectangle. Then use the regionprops function to get the two value image of the perimeter, according to MATLAB repeated tests, rect = [23.5100 173.5100 94.9800 24.9800]. As shown in Figs. 2 and 3.

sample 1 sample 2 sample 3

Fig. 2. Crown character sample

Fig. 3. Histogram of sample image

3.2 Results of Binarization

From the histogram [6], the sample has the following characteristics: the target object and the background have obvious two peaks.

At present, there are three kinds of character segmentation methods [7–10]: gap method, projection method and connected area analysis method. In character segmentation method the basic idea is to find out the gap between characters, the RMB crown word is 10 characters, pixel width of each character is basically 7 to 10 pixels, the spacing of each of the two characters is basically three pixels, according to the widths of these constraints,you can judge the single character is a character or characters adhesion together. After load the image to compute memory, select any pixels in the control point manually, do a regional growth or watershed, after the completion of the center point coordinates are all control points of the coordinates of the pixel coordinates. Using MATLAB size function to obtain the length and width of the sample image of the crown size, according to the analysis of the sample character segmentation, the segmentation results are shown. By comparing the fixed position of the crown and the image curve and the edge pixels in the image, it is easy to extract the single character in image of the RMB crown word. After the completion of the first step of the initial segmentation and then use the 2.3 algorithm for accurate segmentation (Figs. 4, 5 and 6).

Otsu . T=0.77255 Two peaks . T=0.70588 Iterative . T= 0.7448

BX47384404 BX47384404 BX47384404

Fig. 4. Sample 1 of binarization

Otsu . T=0.72157 Two peaks . T=0.61438 Iterative . T=0.57151

0T50420106 0T50420106 0T50420106

Fig. 5. Sample 2 of binarization

Otsu . T=0.60784 Two peaks . T=0.66144 Iterative . T=0.58709

JD75860888 JD75860888 JD75860888

Fig. 6. Sample 3 of binarization

Three algorithms for the MATLAB simulation are shown in Table 1. The data is obtained by using the MATLAB program simulation. For each sample, respectively with 3 binarization algorithms, at the beginning and at the end of recording the time the program is run, this time as a binarization algorithm takes time.

Table 1. Comparison of three algorithms for two value treatment

Testing sample	Algorithm	Threshold	Time(s)
Sample 1	Otsu	0.77255	0.0012
	Iterative	0.7448	0.0031
	Two peaks	0.70588	0.0081
Sample 2	Otsu	0.72157	0.0013
	Iterative	0.57151	0.0044
	Two peaks	0.61438	0.0089
Sample 3	Otsu	0.60784	0.0015
	Iterative	0.58709	0.0031
	Two peaks	0.66144	0.0073

3.3 Results of Single Character Segmentation

Method of Sect. 2.3, results of single character segmentation Single character segmentation results are shown in Fig. 7. The single character segmentation of the sample was carried out using the threshold iterative, Otsu and Two peaks algorithm, respectively.

The RMB crown word recognition sample set, it needs to be segment into single characters. the shape of individual characters are not the same, the projection used here is easy to implement method for character segmentation, segmentation strategy is to first determine the upper and lower boundaries of the character, and then through the calculation to determine the left and right boundaries of each character.

Fig. 7. Single character segmentation

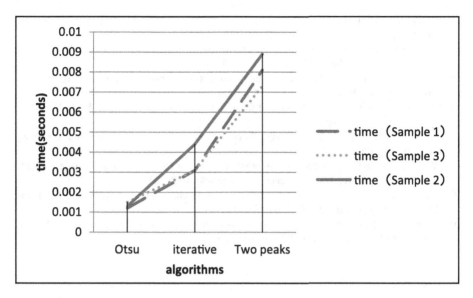

Fig. 8. Time of the three samples

4 Conclusion

From comparison Table 1 of the data and Fig. 7, computation times are reported for the three algorithms in Fig. 8. In which the long line, crossed points and short lines on behalf of the three.

A single character segmentation effect as shown in Fig. 7, describes the different binary result will affect the final effect of a single character segmentation. Otsu algorithm can quickly achieve the best results. 3 samples are split with 3 kinds of algorithms (Otsu, two peaks, iterative), effect as shown in Fig. 8. Data from Table 1.

Image segmentation, there are a lot of study on the method of threshold selection, but the existing methods cannot be common. Pattern recognition system design based on image quality and application requirements, it only by trying different methods, the final choice for best results.

In the recognition system of the RMB crown word, the recognition accuracy of the system is the image capture device and preprocessing of image quality. Comparing three types of processing algorithms (Otsu, two peak, iterative). The Otsu algorithm is best, it uses the least time in binary segmentation.

References

1. The new code of RMB circulation in response to the central bank "counterfeit" question. http://news.163.com/10/1207/01/6N90LA0E00014AED.html
2. Guangjian, Z.: The pretreatment of handwritten computer design and application of GUI. Intell. Comput. Appl. **1**, 98–100 (2015)

3. Pugeng, S., Kaiyu, L., Ping, W.: Improved algorithm. Autom. Technol. Appl. Pap. Curr. Number Recognit. Rate **11**, 74–78 (2014)
4. Trier, O.D., Jain, A.K.: Goal-directed evaluation of binarization methods. IEEE Trans. Pattern Anal. Mach. Intell. **17**, 1191–1201 (1995)
5. Trier, O.D., Taxt, T.: Evaluation of binarization methods for document images. IEEE Trans. Pattern Anal. Mach. Intell. **17**, 312–314 (1995)
6. Otsu, N.: A threshold selection method from gray-level histograms. IEEE Trans. Syst. Man Cybern. **9**(1), 62–66 (1979)
7. Dan, Y., Haibin, Z.: MATLAB Image Processing Detailed Examples. Tsinghua University Press, Beijing (2013)
8. Wei, L.: Research and application of RMB crown word recognition and image authentication. Nanjing University of Science and Technology (2011)
9. Casey, R.G.: A survey of methods and strategies in character segmentation. IEEE Trans. Pattern Anal. Mach. Intell. **18**(7), 690–706 (1999)
10. Xingyan, J.: The paper currency number recognition system. Algorithm Research of Nanjing University of Aeronautics and Astronautics (2008)

SPIDAR-S: A Haptic Interface for Mobile Devices

Shuhan Ma$^{(\boxtimes)}$, Motonori Toshima, Kenji Honda, Katsuhito Akahane,
and Makoto Sato

Precision and Intelligence Laboratory,
Tokyo Institute of Technology, Tokyo, Japan
ma.s.ad@m.titech.ac.jp

Abstract. In order to introduce the haptic technology to more common users outside the academic sphere, this paper proposed a haptic device SPIDAR-S which is able to be attached to mobile devices such as smartphones and tablet PCs. The proposed device provides a user with one degree of freedom force feedback in the way of pulling one of the user's index fingers with a string which is driven by a micro motor. Audio signals are adapted as the control signal for the motor's output torques. Because of its simple structure and compacted size, SPIDAR-S is supposed to be taken around as a portable accessory for mobile devices, enabling a large number of users to enjoy haptic implemented applications in an easier and more casual way.

Keywords: SPIDAR · Multimodal interface · Force feedback · Mobile devices

1 Introduction

Haptic interface is a human-machine interface that can provide feedback based on recreating the sense of touch by applying force, vibrations or motion to the users. Recently, a variety of haptic devices, such as Phantom and Falcon, have been proposed. However, outside the academic sphere, few people feel familiar with either these devices or haptic technology. One possible reason is very likely to be that in order to realize haptic feedback with high quality, most haptic interface devices have to be built in heavy, large and complex forms, which reduces the ease and potential for people to get access to them. Another reason is that for almost all of the haptic devices mentioned above, a desktop or laptop PC is required while using them.

Therefore, in order to introduce haptic technology to more people, this paper paid attention to mobile devices [1], and proposed SPIADAR-S, a string-based, compact haptic device with 1 degree of freedom, which can be mounted on common mobile devices through the 3.5 mm audio jack. Figure 1 shows the overview of SPIDAR-S, and how SPIDAR-S is mounted on mobile devices.

© Springer International Publishing AG 2017
Y. Chen et al. (Eds.): SG 2015, LNCS 9317, pp. 203–206, 2017.
DOI: 10.1007/978-3-319-53838-9_18

Fig. 1. Overview of SPIDAR-S and SPIDAR-S mounted on a mobile device

2 Proposal and Development

2.1 Structure of the Proposed Device

As shown in Fig. 2, SPIDAR-S is a string-based [2], motor-driven device that provides the user with one degree of freedom force feedback. The string is twined around a pulley connected to the rotary axis of a micro motor, so that when the motor rotates there is a tendency for the string to be rolled back toward the pulley. As a result, the length from the string's free end to the pulley decreases. Thus, if a user puts one of his/her index fingers into the finger cap fixed to the free end of the string, he/she will feel a pulling force when the motor is powered on, and the stronger the motor's output torque is, the stronger the force will be. Current flowing through the motor is controlled via audio signal generated by the mobile device on which SPIDAR-S is mounted, and passed to SPIDAR-S through the 3.5 mm earphone jack. The earphone jack is adopted as the interface between the proposed device SPIDAR-S and a mobile device, because it is universally compatible to different mobile devices. The motor used by SPIDAR-S is a micro DC motor which can be stably driven by 2 AAA batteries, providing users with torques up to 0.88 mN·m.

Fig. 2. Inner structure of SPIDAR-S

2.2 Evaluation with the Demonstration Program

A demonstration program had been designed to test the performance of SPIDAR-S. With this program, users can observe their surroundings on the screen of a mobile device, and are provided with a sense of touching as if they could touch objects displayed in the scene.

Figure 3 shows how to use the demonstration application. A user should first hold the mobile device on which SPIDAR-S is mounted by one hand, with the screen of the mobile device facing his/her own face. Then, the user wears SPIDAR-S's finger cap on the index finger of the other hand, and puts this hand behind the backside of the mobile device, then makes sure that the index finger is also taken by the camera, since the user needs to move the index finger to drive a pointer displayed in the scene. Main edges in the scene are extracted at a certain frequency settled in advance, and the position of the finger is traced through tracking the color of the finger cap. When the pointer moves across one of the edges, the program generates control signals to apply a stronger force impulse. In this way, a sense of touching might be simulated, providing the user with feelings as if they could touch objects outside their actual reach.

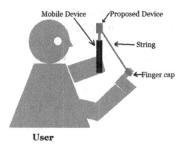

Fig. 3. Posture to use SPIDAR-S

In order to realize more natural force display, when the pointer moves across an edge, the direction of the pointer's movement will also be calculated and compared with the direction of this edge to judge whether the force feedback should be applied. The user's view while using the demonstration program is shown as Fig. 4.

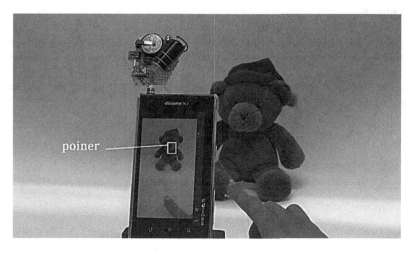

Fig. 4. The user's view while using the demonstration program

3 Discussions

Feedbacks acquired from previous experiments indicated that people generally feel interested in the concept of using haptic devices along with mobile devices, which is possible to offer them a portable, small-scaled, as well as convenient interface that provides force or tactile feedbacks. At the same time, several problems have also been pointed out. First, since the audio jack is used to drive the motor, it cannot be used as the output port for audio devices, such as headphones and earphones; this could be refined by adding a micro speaker into the device. Second, the accuracy of color tracing, which is important to calculate the user's current finger position, has not yet been adequate, since it largely depends on lighting conditions and background colors; spraying the finger cap with luminescent coatings or adapting a pre-designed color pattern may increase the accuracy of color tracing. Also, more continuous and smooth changes in the strength of force display have been required. Besides, user experience of using this device along with common applications for mobile devices, such as games and music players, needs to be investigated to evaluate its general usefulness. Further efforts are being paid in response to these comments.

4 Conclusions

In this research, a string-based haptic interface for mobile devices has been proposed. The device called SPIDAR-S applies one degree of freedom force feedback to one of the user's index fingers. Because of its simple structure and compacted size, SPIDAR-S is supposed to be taken around as a portable accessory for smartphones and tablet PCs, enabling a large number of users to enjoy haptic implemented applications in an easier and more casual way.

References

1. Maclean, K.E.: Using haptics for mobile information display. In: Proceedings of Pervasive Mobile Interaction Devices (PERMID 2008) Workshop, International Conference on Pervasive Computing, pp. 175–179 (2008)
2. Sato, M.: Development of string-based force display: SPIDAR. In: 8th International Conference on Virtual Systems and Multimedia (2002)

An Interactive Haptization System in Video Contents Using SPIDAR-mouse

Kenji Honda[1](\boxtimes), Ma Shuhan[2], Katsuhito Akahane[2], and Makoto Sato[2]

[1] Tokyo University of Marine Science and Technology, Tokyo, Japan
khonda@kaiyodai.ac.jp
[2] Tokyo Institute of Technology, Tokyo, Japan
shuhanm42@gmail.com, kakahane@hi.pi.titech.ac.jp, msato@pi.titech.ac.jp

Abstract. We propose a video haptization system. Several haptic devices have been proposed and are commercially available. However, they are still high price and are used for the researches mainly. In this circumstance, we had proposed the haptic device called Spidar-mouse that can easily construct the interactive system. In this paper, we developed the video haptization system with Spidar-mouse by using the movement information of the object in the video.

Keywords: Haptic motion rendering · Open source haptic interface · Video

1 Introduction

Recently, the video media are widely prevalent. Viewers' experience can be further enhanced if viewers can get the feeling of the movement of the objects in the video through the haptic interface. Several haptic devices have been proposed and are commercially available. However, they are still high price and are used for the researches mainly. In this circumstance, we had proposed the haptic device called Spidar-mouse [1] that can easily construct the interactive system. In this paper, we developed the video haptization system with Spidar-mouse by using the movement information of the object in the video.

2 Proposed Technique

2.1 SPIDAR-mouse

Spidar-mouse is a haptic device, which provides a common mouse with force feedback by mounting the mouse on SPIDAR [2]. Figure 1 shows the system configuration of Spidar-mouse DAs shown in Fig. 1, Spidar-mouse is composed of a PIC controllerChardware part using a mouse, the API to control the devise and the library for application deployment.

Hardware is composed of a PC, a general mouse, the motors, the strings and the control circuit with PIC controller. As the method of haptic presentation,

© Springer International Publishing AG 2017
Y. Chen et al. (Eds.): SG 2015, LNCS 9317, pp. 207–210, 2017.
DOI: 10.1007/978-3-319-53838-9_19

Spidar-mouse has a string-based mechanism using string tension. By the tension of four strings generated by four motors, Spidar-mouse presents the force for the mouse in arbitrary directions on 2D surface.

Software is designed to control for essential functions. Therefore, it has the following three functions.

(1) Initialization function: "OpenSpidarMouse();"
(2) Haptic presentation function: "SetForceSpidarMouse();"
(3) End function: "CloseSpidarMouse();"

Initialization function performs the initialization of Spidar-mouse, the presentation of the minimum tension by the PIC and the calibration. Haptic presentation function has two arguments which are force vector(fx, fy).

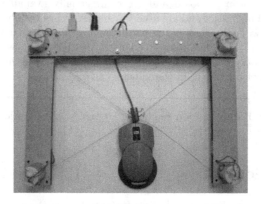

Fig. 1. SPIDAR-mouse

2.2 Haptic Motion Rendering

In our proposed system, the motion information is generated by the velocity of the feature points at each image frame. The velocity of the feature points is calculated by estimating the optical flow. We use the LK algorithm [3] for estimating the optical flow in consideration of the processing time. The velocity of a feature point is calculated using the Eq. (1)

$$V_i(t) = \frac{P_i(t + \Delta t) - P_i(t)}{\Delta t} \tag{1}$$

Here $P_i(t)$ and $P_i(t + \Delta t)$ represent the position of the feature point i in two consecutive frames. In our proposed system, the optical flow is calculated for all the feature point in the image frame. We set the observation region of the optical flow around the mouse pointer. Then, the force vector is given by the average velocity in this region. Therefore, If the motion does not exist at the part which the user wants to touch, user does not feel the haptic. If the motion

exist at the part which the user wants to touch, user can feel the haptic. This method enables the video haptization without a sense of discomfort. In addition, the velocity averaging reduces the noise from the estimation error. If n points exist in the region, the force vector is calculated using the Eq. (2).

$$F = \frac{1}{N} \sum_{i=1}^{n} V_i(t) \tag{2}$$

Our proposed system has the function which stops the movement of the object in the video to enable the interaction between the user and the object in the video. We use the stop function of the video to enable this function. It is decided whether the optical flow exist or not in the observation region. Therefore, if the user does the stop action in the region which does not include the motion, the video does not have the change. And if the user does the stop action in the region which includes the motion, the user can stop the movement of the object. Figure 2 illustrates the composition of the video system.

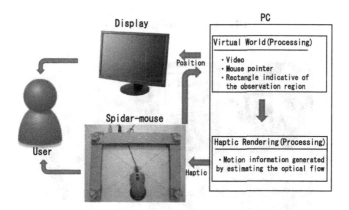

Fig. 2. Composition of video haptization system

3 Implementation and Result

We use the "Youtube" video. This video is about a mother cat playing with her litter of kittens. Figure 3 shows the experimental video and its optical flow. The demonstration set up for this haptization system is shown in Fig. 4 using a 2D video display and the haptic interface SPIDAR-mouse. We could much enjoy the feeling of the movement of the objects in the video.

We also performed some evaluations to show the effects of our proposed system. Questionnaires were used for evaluations. Two conditions used for the evaluations are (1) without force-feedback, (2) with force-feedback. From these results, we could find significant effects of our proposed system.

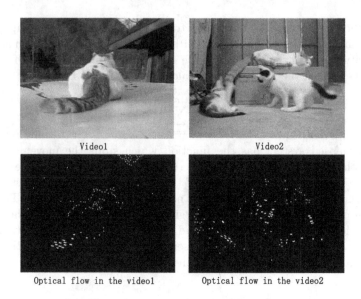

Fig. 3. Experimental video

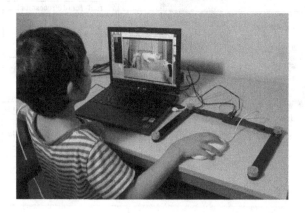

Fig. 4. Users at the exhibition

References

1. Akahane, K., Xiangning, L., Isshiki, M., Liping, L., Sato, M.: Open source haptic interface SPIDAR-mouse. In: ASIAGRAPH 2010, vol. 4, no. 1, pp. 83–88 (2010)
2. Sato, M.: A string-based haptic interface, SPIDAR. In: ISUVR 2006, Yanjin, China, vol. 191, pp. 1–5 (2006)
3. Lucas, B.D., Kanade, T.: An iterative image registration technique with an application to stereo vision. In: Proceedings of International Joint Conference on Artificial Intelligence, pp. 674–679 (1981)

DroneMyo: Proactive Control of Unmanned Aerial Vehicle Based on Wearable Devices

Zhe Li, Yaxi Chen, and Wenrong Tan$^{(\boxtimes)}$

Department of Computer Science and Technology,
Southwest University for Nationalities, Chengdu, China
lizhedm@icloud.com, yaxichen@swun.cn, tan1781@sina.com

Abstract. Wearable devices promise a full immersion in the usage environment and most of these devices are mainly passive information receivers. We believe that integration of proactive wearable devices in general can bring more advantages for more natural user interactions. This paper explores proactive control of Unmanned Aerial Vehicle (UAV) based on a smart phone and a smart wristband. We have conducted indoor and outdoor trial flights and gained encouraging results as well as valuable ideas for future research.

Keywords: Wearable devices · Proactive control · Naturally user interaction · UAV

1 Introduction

Recently wearable devices have become a fashion especially in the fields of sports, design and entertainment. With natural interactions and freedom of both hands, the user may receive a better experience of immersion in the environment. Currently there are different classification criteria for wearable devices [1]. According to the functions of the devices, we divide wearable devices into the following two categories.

Passive Information Receivers: Most of current wearable devices belong to the first category of passive information receivers. El-Bendary et al. [2] designed a monitoring system for the elderly. However, without user proactive control, it was difficult to determine whether it was an occasional fall or just a swing of the elders arm. ShoeSense [3] installs Kinect into ordinary shoes and thus detects user hand gestures from the angle of foot, which innovatively brings higher mobility for systems employing cameras. Similar to smart watches, the detection and cognition of user gestures in ShoeSense required device stability [4,5].

Proactive Controllers: Different from passive information receivers enabling few active user controls, several wearable devices with proactive controlling technologies emerge recently. Myo [6], a smart wristband, is the most representative proactive controller. It recognizes the user's natural gestures by analyzing muscles biological signals.

© Springer International Publishing AG 2017
Y. Chen et al. (Eds.): SG 2015, LNCS 9317, pp. 211–214, 2017.
DOI: 10.1007/978-3-319-53838-9_20

Wrist-mounted Bio-acoustic Fingertip Gesture Interface [7] promises higher recognition accuracy by capturing the internal sounds generated by bone movements.

Comparing with passive information receivers, proactive controlling devices allow more active user interactions and thus enhance the users feeling of control. M. Foertsch et al. [8] made use of a desktop to control the ARDrone. Engel et al. [9] presented a ARDrone Control system to estimate the absolute scale of the generated visual map based on front camera embedded in ARDrone.

In this paper we investigated proactive control of Unmanned Aerial Vehicle (UAV) based on the usage of iPhone and Myo.

2 Proactive Control of UVA with DroneMyo

Figure 1 illustrates the system configuration. In order to improve the system portability, we replace the regularly used laptop by an iPhone. In addition to the built-in components such as accelerometer, gyroscope and magnetometer, EMG sensor is another hardware embedded in Myo armband. It allows us to collect data of arm movement, including magnetic field direction, spatial position data of wrist and other bioelectrical data. All these data is transmitted via Bluetooth to the iPhone and recognized by MyoKit library [10]. Corresponding flight control command is then generated and transmitted by the iPhone to the UVA via UDP packets.

User Gestures: As shown in Fig. 2, currently 4 fundamental gestures can be recognized by DroneMyo. Tap-tap gesture is recognized by bioelectrical sensor and corresponding recognition algorithm. This gesture is used to activate Myo. The same with fist gesture that is used as UAV taking-off and landing commands. Based on the positive and negative changes in the value of magnetic field data with magnetometer, left/right gestures can be recognized and used as left/right flying direction control commands. Similarly, based on the calculation of the arms horizontal angle range, swing forward/backward gestures are determined to control UAV flying forward/backward. Gyroscope data is collected to exclude swings in other directions.

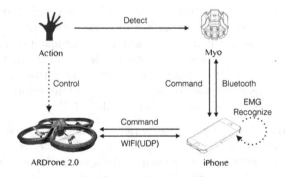

Fig. 1. System configuration of DroneMyo

Fig. 2. Gestures that can be recognized by DroneMyo: from left to right: Fist, tap-tap, left/right swipe, swing forward/backward

3 Discussions and Future Work

We have conducted indoor and outdoor trial flights (see Fig. 3, recorded video can be found here: http://v.youku.com/v_show/id_XOTUyOTg1NzM2.html) and gained encouraging results as well as valuable ideas for future research.

Fig. 3. Indoor (left) and outdoor (right) trial flights

The employment of iPhone as a transit equipment improves the portability of DroneMyo. The wearable armband and relevant gestures promise easy and direct controls of the UAV. Our prototype is still in the infant phase and thus needs further improvements:

1. Command conflicts: In order to prevent possible command conflict, in a sequence of control gestures the user has to make additional gestures as explicit separator. A prediction of the users arm and hand movements may help to achieve more nature and comfortable user experience.
2. Arm fatigue: Continuing hovering arm in the air brings the user inevitable feeling of fatigue. Instead of current continuous input, the system should allow intermittent user interactions. For example, the UAV keeps current flying status until next user gesture is detected.
3. Limited accuracy: DroneMyo may control the direction of UAV movement, but lacks accurate distance measurement, which may be improved by hardware with higher precision and controlling algorithms.
4. User study: Although indoor and outdoor tests have been executed, a formal user study should be conducted aiming at gaining more insights for future improvements.

Acknowledgments. This research was funded by the Sichuan Provincial Technology Support Program (2014GZ0006) and the Special funds for basic scientific research business of Central University-Youth Project, Southwest University for Nationalities (13NZYQN19).

References

1. Jiang, H., Chen, X., Zhang, S., Zhang, X., Kong, W., Zhang, T.: Software for wearable devices: challenges and opportunities. arXiv preprint arXiv:1504.00747 (2015)
2. El-Bendary, N., Tan, Q., Pivot, F.C., Lam, A.: Fall detection, prevention for the elderly: a review of trends and challenges. Int. J. Smart Sens. Intell. Syst. 6(3), 1230–1266 (2013)
3. Bally, G., Müller, J., Rohs, M., Wigdor, D., Kratz, S.: ShoeSense: a new perspective on hand gestures and wearable applications. In: Proceedings of CHI, vol. 12 (2012)
4. Amft, O., Amstutz, R., Smailagic, A., Siewiorek, D., Tröster, G.: Gesture-controlled user input to complete questionnaires on wrist-worn watches. In: Jacko, J.A. (ed.) HCI 2009. LNCS, vol. 5611, pp. 131–140. Springer, Heidelberg (2009). doi:10.1007/978-3-642-02577-8_15
5. Xiao, R., Laput, G., Harrison, C.: Expanding the input expressivity of smartwatches with mechanical pan, twist, tilt and click. In: Proceedings of the 32nd Annual ACM Conference on Human factors in computing systems, pp. 193–196. ACM (2014)
6. Phelan, I., Arden, M., Garcia, C., Roast, C.: Exploring virtual reality and prosthetic training (2015)
7. Amento, B., Hill, W., Terveen, L.: The sound of one hand: a wrist-mounted bioacoustic fingertip gesture interface. In: CHI 2002 Extended Abstracts on Human Factors in Computing Systems, pp. 724–725. ACM (2002)
8. Perceptual Computing: Computers Came to their Senses (2014). http://iq.intel.com/the-year-computers-came-to-their-senses-2/
9. Engel, J., Sturm, J., Cremers, D.: Camera-based navigation of a low-cost quadrocopter. In: IEEE/RSJ International Conference on Intelligent Robots and Systems (IROS), pp. 2815–2821. IEEE (2012)
10. The Myo SDK (2015). https://developer.thalmic.com/docs/api_reference/platform/the-sdk.html

Author Index

Printed in the United States
By Bookmasters